COLLAGE

FROM

SEEDS, LEAVES
AND FLOWERS

JOAN CARVER

GUILD OF MASTER CRAFTSMAN PUBLICATIONS LTD

First published 1997 by
Guild of Master Craftsman Publications Ltd,
166 High Street, Lewes,
East Sussex BN7 1XU

Reprinted 1998

© Joan Carver 1997

ISBN 1 86108 051 4

Photography by Dennis Bunn
Line drawings by John Yates
Collage designs by Joan Carver

Designed by Ian Hunt Design
Typeface: Sabon
Colour separation by Global Colour (Malaysia)
Printed in Hong Kong by H & Y Printing Ltd

*Dedicated to
my husband John
and my sister Hilary*

ACKNOWLEDGEMENTS

I would like to offer thanks to my husband John, as without his co-operation this book could not have been written; to Kent Garden Centres Ltd, Maidstone, Kent, for the use of their logo as the basis for the collage on page 147; to the National Association of Flower Arrangement Societies (NAFAS) for the photograph of 'Yesteryear' on page 58, and for permission to quote from the *NAFAS Handbook of Schedule Definitions* on page 1; to Joan Hale for her interest and encouragement; to Margaret and Christine for their enthusiasm; and to Artizan of Wisbech, Cambridgeshire, for the card selection featured on page 5 and the photograph of frame mouldings on page 152.

MEASUREMENTS

Although care has been taken to ensure that imperial measurements are true and accurate, they are only conversions from metric. Throughout the book instances may be found where a metric measurement has slightly varying imperial equivalents, because in each particular case the closest imperial equivalent has been given. Care should be taken to use either imperial or metric measurements consistently.

About the Author

Joan Carver spent her childhood in Burton-on-Trent and Coventry, where she met her future husband, John. After his retirement from the Royal Navy and their marriage, they moved to Kent, where they owned three retail businesses and a Sub-Post Office. Now both retired, Joan and her husband live in Cambridgeshire.

Joan was first encouraged to become interested in flowers and flower arranging by her sister, and subsequently joined a number of flower clubs. As her enthusiasm for collage designs grew, she successfully took part in many national and international competitions, including winning a first prize in a Bermuda competition and two first prizes in NAFAS national competitions.

Her collages have been the main attraction in flower festivals around the country, and she has given instruction in the art of collage to students from NAFAS-affiliated flower clubs, including overseas members from India and Germany. Among other special requests over the years, she has created a collage presented by NAFAS to the flower arrangers of Russia, which is now in St Petersburg.

CONTENTS

AUTHOR'S NOTE *viii*

INTRODUCTION *I*

1 ESSENTIAL MATERIALS *3*

2 PLANT MATERIAL *7*

3 METHODS OF WORK *27*

PROJECTS

4 FLAT COLLAGE *44*

5 RAISED COLLAGE *58*

6 SEED COLLAGE *83*

7 EMBELLISHMENT *97*

8 EMBROIDERY EFFECTS *112*

9 FANTASIES *146*

APPENDIX 1: FRAMING *152*

APPENDIX 2: COMMON AND
BOTANICAL PLANT NAMES *155*

APPENDIX 3: FULL-SIZE PATTERNS *158*

FURTHER READING AND SUPPLIERS *164*

INDEX *165*

AUTHOR'S NOTE

In 1974 I was persuaded to take an interest in flower arranging when my sister, Hilary, asked me to help organize a flower festival in a church near Maidstone, Kent. It was a new experience for me, but gave me a great deal of satisfaction and led to further activities within the world of flowers.

Two years later a new garden centre opened nearby and their attractive logo gave me an idea for recreating the stylized scene in a collage of plant material. After several attempts I successfully accomplished the task using the original logo colours of brown and cream. I went on to develop this into a colourful collage picture (*see* page 147) and soon discovered that I preferred to create pictures rather than design large flower arrangements.

As a schoolgirl I had been interested in embroidery with silks. My parents had given me a book of needlework containing pictures of Jacobean embroidery and I was fascinated by the grotesque shapes and forms of the unrealistic flowers and leaves. The design possibilities were endless, and once I had become involved with flower arranging and collage, I realized that I could use plant material instead of wool and silks

to achieve similar embroidery effects. And so the experimentation began.

Creating collage pictures and decoration from plant material is not a new concept, but it can be immensely satisfying to make up even a simple bookmark or card from pressed flowers and preserved leaves. Moving on from this more traditional approach to collage and using seeds and stems to recreate the effect of embroidery is rather more unusual, and is a pastime I find absorbing and enchanting. My sources of inspiration are varied. Having taken my first collage ideas from a garden centre logo, my designs have been prompted by the exquisite work of Fabergé, calligraphy, heraldry, modern sculpture and traditional embroidery transfers as well as the Jacobean embroidery already mentioned.

This book is written in response to many requests from the members of flower clubs affiliated to NAFAS (National Association of Flower Arrangement Societies) whom I have instructed in the art of collage and 'embroidery' with plant material. I would like to encourage them to continue with this creative hobby, and invite others to appreciate and enjoy its endless possibilities.

INTRODUCTION

COLLAGE

The expression 'collage' is derived from the French word *coller*, meaning to stick or glue. Simply put, collage means a picture made up of various materials glued to a background. *Collins English Dictionary* states that a collage is 'an art form in which compositions are made out of pieces of paper, cloth, photographs, and other miscellaneous objects, juxtaposed and pasted on a dry ground'. In terms of using plant material, the *NAFAS Handbook of Schedule Definitions* defines a collage as 'an exhibit in which all components are fixed to a backing with adhesive'.

In the nineteenth century coloured and printed papers were cut and laid out to form artistic compositions known as *papier collé* (literally 'glued paper'). The technique was adopted by many early Cubist artists, with Pablo Picasso and Georges Braque incorporating collage into their paintings in the early twentieth century. Since then, collage has continued to hold a place in modern art.

Any materials can be used to make a collage, be it wood, paper, fabric, metal or plant material. Strictly speaking, if more than one type of material is used, the piece is called an 'assemblage'. Whatever you choose to call it, collage work has no age restriction: children can be amused on a wet day during school holidays and many adults find it a relaxing and creative occupation.

PLANT MATERIAL COLLAGE

This book concentrates on the types of collage which can be created using a wide choice of plant material, including pressed and dried flowers, preserved leaves and grasses, plant stems, whole seed heads, and many different seeds. As the examples in the book demonstrate, there is really no limit to the designs which are possible; it all depends on your imagination, taste, and the materials available to you.

If you have never made a collage, some of the work in this book may appear daunting, especially the intricate, embroidery-style seed collage. It is, however, very much easier than the finished pieces suggest. Apart from a few basic tools and plant material, all you need is imagination, patience and spare time. You will soon start to look at flowers and leaves with a new eye, seeing a particular leaf as a distant hill in a landscape scene, or a tiny heather flower as a miniature hollyhock bloom in a garden picture, or different combinations of seeds as elegant embroidery 'stitches'.

GETTING STARTED

The first three chapters of the book set out all you need to know about essential equipment and techniques, including collecting, preserving and fixing plant material, and planning designs. You will probably find most of the necessary tools

(*see* pages 3–5) somewhere in your home, or if not they will be inexpensive to buy. The optional tools are more expensive, so give these careful consideration before splashing out, as you will probably only need them occasionally.

Plant material (*see* pages 7–13) is obtainable from various sources, but collecting from your own garden if you have one can be the most rewarding. It is worth enlisting the help of friends with gardens as well. Flowers and leaves can be preserved throughout the year providing that they are dry and in good condition. Seeds can be saved while dead-heading plants.

PROJECTS

There is no need to worry if you feel you are not artistic, or if you have done nothing like it before. The flowers, leaves and seeds you collect will create designs for you. The projects which follow in the second part of the book, from Chapter 4 onwards, offer a variety of ideas and styles to get you started, and they show what sort of effects can be achieved, from the simplest bookmark or decorated box to complicated 'embroidery' pictures and elaborate lettering. For each project a photograph of the finished piece is accompanied by step-by-step instructions and a clear, labelled pattern.

Making an attractive bookmark from a piece of coloured card and a few pressed flowers will give you confidence to make up a special greetings card for an anniversary or a friend who is unwell. Then why not impress your guests with decorated place cards and napkin rings for a celebration dinner? As you progress, you will find your imagination working faster than your fingers, and you will press on to greater challenges. There may be opportunities for you to make a distinctive collage for an exhibition, a church flower festival or a wedding, or you may prefer to stick to making unique, personal gifts for friends. Why not get started, have a go, and see where your imagination takes you?

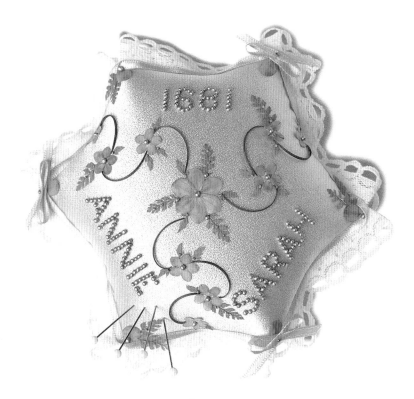

ESSENTIAL MATERIALS

TOOLS AND EQUIPMENT

The tools and equipment needed for collage work are simple, inexpensive and generally available within the home. The following list contains all the necessary tools and basic materials (*see* Fig 1.1), with an extra list for optional items (*see* Fig 1.2) which you will find helpful if you intend to spend a lot of time on the hobby. Stationers and art materials shops should be able to supply any items you do not already have.

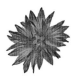

○○○○○○○○○○○○○○○○○○○○○○○
HELPFUL HINT
It is best to keep a special pair of scissors for cutting fabric. Using scissors to cut card or paper will dull the blades, which could cause fabric to tear or end up with a rough edge.
○○○○○○○○○○○○○○○○○○○○○○○

ESSENTIAL ITEMS

- ○ Pencils – HB, H, 2H, 6B
- ○ Fine black fibre tip pen (blue, green and brown pens will also be useful)
- ○ Plain white paper
- ○ Graph paper
- ○ Ruler
- ○ Compass
- ○ French curve plastic outline
- ○ Plastic cocktail sticks
- ○ Large darning needle
- ○ Pair of scissors for cutting paper and card
- ○ Pair of scissors for cutting fabric
- ○ Small pair of scissors for cutting dried stems, leaves, etc.
- ○ Pointed tweezers
- ○ Craft knife
- ○ Small plastic dish
- ○ Liquid PVA glue
- ○ Solid stick glue
- ○ All-purpose clear glue
- ○ Self-adhesive transparent film
- ○ Colourless, low odour fixative
- ○ Hardboard
- ○ Card – both thick and thin (*see* page 5)
- ○ Fabrics – various (*see* page 6)

Fig 1.1 **A selection of essential tools and equipment.**

OPTIONAL ITEMS

○ Precision cutter
○ Old pinking shears
○ Serrated edge scissors
○ Glue gun
○ Compass cutter

Fig 1.2 **Optional equipment.**

HELPFUL HINT

Take care when using glue on card: it is not easily removed without leaving a mark.

CARD AND FABRICS

CARD

For most of the flat and raised collage projects in Chapters 4 and 5 (bookmarks, greetings cards, place cards, etc.) you will need to use various thicknesses of white or coloured card as your backing material. A huge variety of card can be bought from stationers, art shops or photographic shops.

The thin card from stationers is available in many colours (*see* Fig 1.3), but I do not recommend using fluorescent card as it is not easy on the eye and will most likely detract too much from the design. Thin card is suitable for lightweight items such as bookmarks and greetings cards, or for a collage which is then to be mounted on to a secondary backing.

Thick card is available from art and photographic shops and is often used by artists or photographers to surround a picture within a frame. This type of card is ideal for use as the backing within a fabric cover when the design is to be placed in a recessed frame.

Coloured card placed beneath semi-transparent fabric will provide a slight change of colour to the background of your work, and it is worthwhile experimenting with this for the different effects which can be achieved.

Fig 1.3 **Use different colours of thin card as a background to offset the colours of your collage material.**

FABRICS

Most of the collage projects are easier to create on fabric rather than card, largely because PVA glue can be removed from fabric without trace, whereas it can leave a mark on card. Fig 1.4 pictures various fabrics which I have found most useful. When selecting fabrics, bear in mind the finished design and its intended setting: both colour and texture are important. Plain fabrics are generally preferable, although a self-embossed fabric may be suitable for some projects. Patterned fabrics detract too much from the plant materials being used in the collage.

Almost any closely woven fabric would be suitable. The most convenient fabrics are those through which a fibre tip pen line drawing can be seen (*see* Pattern Preparation, pages 27–30), although this is not essential. You can make sure of the fabric's transparency before purchasing by placing the price label beneath a single layer. If the print is visible, then a fibre tip pen will be too.

If you particularly wish to use hessian or another loosely woven fabric as a backing because the texture is just right, it is more practical to fix the collage to a closely woven fabric or very thin card in a suitable colour and appliqué this to the hessian. Very soft fabrics such as nylon jersey are much easier to handle when reinforced with iron-on Vilene interfacing. Without this, the fabric might be stretched or pushed out of alignment while you are fixing the collage, resulting in a distorted design.

HELPFUL HINT

For some designs, a background of velvet or felt may give just the effect you want, but beware: any misplaced glue will matt the fine fibres and remain visible, so these materials are not the ideal choice for the inexperienced.

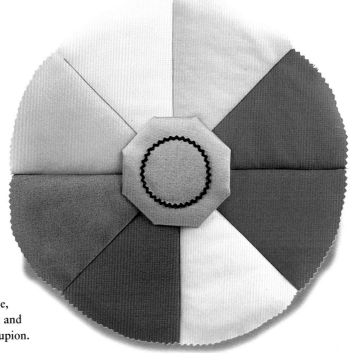

Fig 1.4 **A wide variety of fabrics can be used as collage backgrounds.** *Clockwise from the yellow swatch*: cotton drill, cotton, cotton sheeting, polyester crepe, polycotton, cotton, silk and acrylic. *Centre*: gold dupion.

PLANT MATERIAL

COLLECTING

Collecting plant material for your collages is part of the fun. Once you start to look out for suitable components, you will realize the extent and variety of the possibilities. The garden is the obvious place to begin, but walks in the countryside will also yield rich pickings – although great care must be taken not to pick rare and protected species (a leaflet listing protected species – entitled *Wildlife and Countryside Act 1981, Schedule 8* – is available from Her Majesty's Stationery Office). Finding what you want growing in the garden or countryside naturally depends on the season, and you will need to take the chance to gather suitable items while they are available. Other excellent sources, especially for more exotic species not available in your garden, are florists, seed

merchants, pet shops, health shops, supermarkets and garden centres. Many of these will offer opportunities for the collage maker all year round.

Instructions for preserving freshly picked plant material are given on pages 13–24. Below is advice on the types of flowers, leaves, grasses, seeds and seed heads which can easily be collected from gardens or the countryside, and which respond well to the different methods of preserving.

FLOWERS

Fresh flowers will only preserve well if picked in prime condition and dealt with immediately (*see* Fig 2.1). Pressing or preserving in a desiccant are the best methods, but a few species respond well to air drying.

a French marigold
b Candytuft
c Masterwort
d Pansy
e French marigold
f Geranium

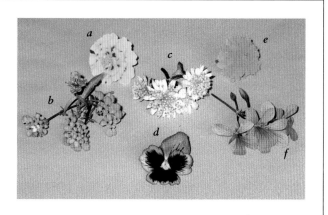

Fig 2.1 Fresh flowers for preserving must be picked in perfect condition for best results.

Most readers will probably have tried pressing
flowers at some stage. Using a desiccant instead
(*see* pages 16–19) demands a bit more care, but
means that the flower will retain its shape and
texture rather than being pressed flat, and usually
results in more colour being kept as well. Most
flowers are suitable for this method, but drying
time varies according to the size and composition
of the flower.

Pressing (*see* pages 22–4) is not a suitable
preserving method for all flowers, but it is little
trouble to do and produces suitable material for
complete simple collages (*see* pages 44–57) and
occasionally for the more complicated collages
involving seeds.

Commonly available blooms such as
chrysanthemum, cornflower and pinks press well,
but should be dissected and each petal pressed
separately. Other flowers may also be best cut
carefully in order to flatten them out. Forget-me-
not, snowball bush flowers and other tiny blooms

are best removed from their stems and pressed
individually. The various shapes and lengths of
sweet pea tendrils and vegetable pea tendrils are
enormously useful in collage, press well and are
worth collecting in some numbers.

Air drying (*see* pages 13–15) is another simple
method of preserving, but only some flowers lend
themselves to this approach. Keeping the flowers
covered during drying will assist with colour
retention. Among the flowers most suited to air
drying are larkspur, delphinium, strawflower,
pearl everlasting, lavender, sea lavender, annual
statice and yarrow.

LEAVES

Leaves can be collected from almost any plant,
tree or shrub and at any stage of growth, but for
preserving it is essential that they are absolutely
dry. It is possible to find a use for any size leaf
(*see* Fig 2.2), from the tiny leaflets of the soft
shield fern to the large, thick leaves of a rubber
plant. Smaller leaves can often be used whole,
while the larger ones can be cut to shape and used
in sections.

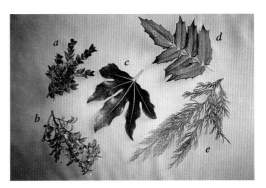

a Box *d* Mahonia
b Pittosporum *e* Leyland cypress
c Japanese aralia

Fig 2.2 **Almost all varieties of leaf, big or small, can be
used in some way.**

Preserving leaves in glycerine (*see* pages 19–21) makes them less brittle, but there will be a significant colour change. The absorption of glycerine can produce beautiful shades of cream, yellow, brown and nearly black. Evergreens can be preserved successfully in glycerine at any time of year, depending on weather conditions, but for deciduous foliage, better results will be obtained if the leaves are picked between July and September. Again all foliage must be absolutely dry when picked. If damp sprays of foliage must be picked, then bring them indoors and stand in a jar containing a small amount of water. After about 36 to 48 hours the foliage should be properly dry and ready for preserving, although you may need to wipe the bottom of the stems dry first.

Leaves can also be pressed or dried in a desiccant but, although green leaves preserved in these ways will keep their colour for a short while, they do tend to brown or fade over time. Autumnal leaves will retain their rich colouring for a much longer period.

GRASSES

A large collection of grasses is probably not essential for collage designs unless you have a specific purpose in mind for them, but a small selection will come in useful. They are best stored in large boxes or hung in bunches.

I always keep a stock of cat's-tail and foxtail, several species of which can be found in different areas throughout Great Britain. Rye and couch grass are both very common and there are many species of brome which can be put to good use. Quaking grass is delightful, but needs careful handling once dried as it disintegrates quite easily.

Grasses collected from the countryside and air dried produce muted shades of beige, cream and pale green, depending on their stage of growth and conditions during the drying-out process. Dried in direct sunlight, the grasses will become beige or cream but, if placed in a paper bag and hung up to dry in a garage or shed, they will retain a certain amount of the colour they had when fresh.

After air drying, and if the natural shades are not what is required, the grasses can be dyed with food colouring, ink or a cold water dye. This can be a messy occupation, however, and the most convenient source of coloured grasses is a florist or garden centre, where ready-dyed products are sold (*see* Fig 2.3).

An alternative to air drying is to use glycerine to preserve the grasses, which should be gathered at an early stage. This will prevent 'blowing', which happens when a grass becomes over-ripe and disintegrates, most noticeable in bulrushes.

SEEDS

The samples pictured on pages 84, 113 and 114 will show what can be achieved with a variety of seeds. It is important to amass a fairly large collection of seed types in order to create the most intricate and intriguing designs. With so many different colours, shapes and sizes readily available, however, the task is not a difficult one (*see* Fig 2.4).

Seeds from the garden or countryside should be gathered when ripe (mostly in summer and early autumn) and after 48 hours of dry, warm weather. They should be placed in a paper napkin and left in a warm, dry, airy spot for a few days. Useful garden varieties include hollyhock, marigold, French marigold, grape hyacinth, honesty and shoo-fly. It is worth looking in unlikely places: even an undesirable garden weed such as goat's beard yields a desirable seed head. From the countryside the seeds of field penny-cress, cow parsley, common mallow and alexanders are abundant in many areas.

From the kitchen it is well worth saving seeds and pips from apples, quinces, peppers, melon and marrow. These must be thoroughly washed and dried on a piece of cloth before being placed in a warm, dry atmosphere to dry out completely prior to storing or using.

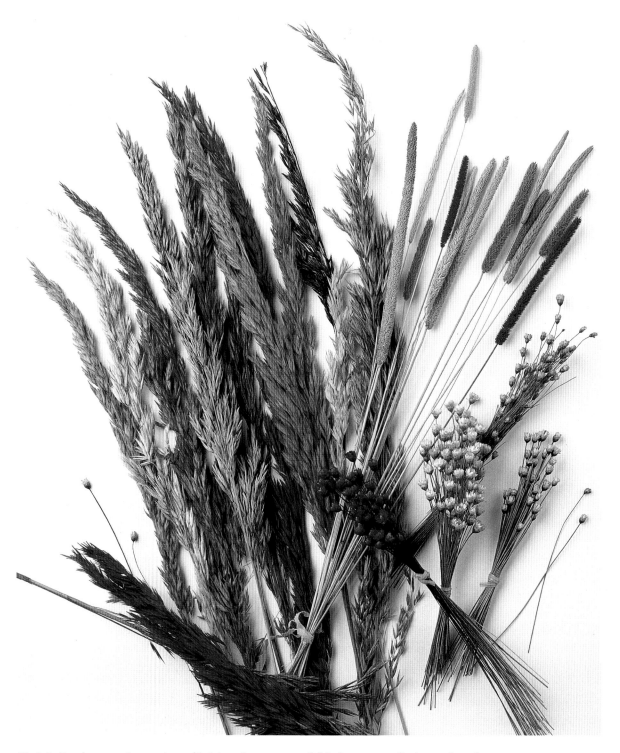

Fig 2.3 Dyed grasses in a variety of bright colours are available from many florists and garden centres. Ampolodermus (*left*) and cat's-tails (*right*) are shown here, with some dyed glixia flowers (*bottom right*).

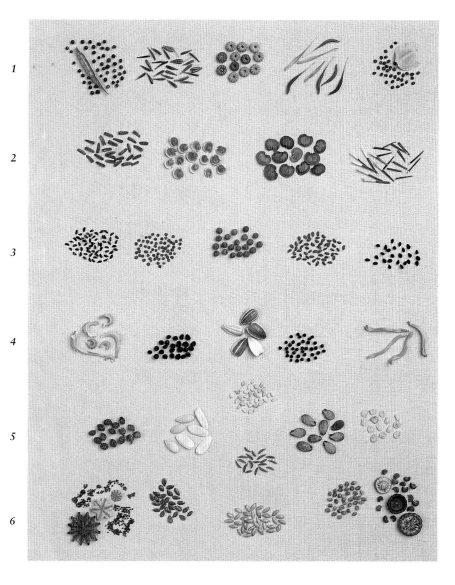

ROW 1 (LEFT TO RIGHT):

Rape, cow parsley, common mallow, goat's beard, field penny-cress.

ROW 2:

Coneflower, hollyhock, honesty, French marigold.

ROW 3:

Columbine, shoo-fly, Peruvian lily, cress, love-in-a-mist.

ROW 4:

Marigold, Allium, sunflower, grape hyacinth, bear's breeches.

ROW 5:

Paw-paw, melon, sesame, caraway, water melon, pepper.

ROW 6:

Poppy, linseed, mazagan canary, millet, mallow.

Fig 2.4 Seeds of all shapes and sizes are easy to collect and keep.

Health shops or supermarkets are good sources of interesting seeds also, offering cress, fenugreek, sesame, alfalfa, coriander and caraway seeds. Even tapioca is useful. A measure of 'canary conditioner' from a pet shop will yield hemp, rape, linseed, millet and mazagan canary seeds.

All seeds should be stored in airtight containers once cleaned and dried (*see* Fig 2.5).

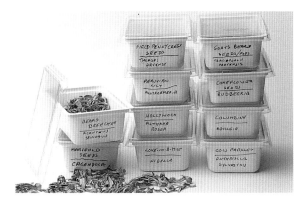

Fig 2.5 **Store seeds in airtight boxes, clearly labelled for easy reference. Old margarine tubs are perfect for this purpose.**

CONES, SEED HEADS AND SEED PODS

There are many different shapes and sizes of cones, seed heads and seed pods (*see* Fig 2.6). All can add an extra dimension to a collage, and are especially useful for giving bulk to swags or larger wall banners and murals. Once collected, the cones and heads simply need to be left to dry on a wooden tray in a garage or shed.

The flower or seed heads of Jerusalem sage, giant scabious, globe thistle and sea holly and *Centaurea macrocephala* are all worth collecting as they are fascinating to look at and easy to care for. Collect the seed heads from poppies, Peruvian lily and love-in-a-mist while they still contain seeds. Hang them up in a paper bag to dry, and then the seeds will fall out of the heads into the bag. The seeds can either be used in a collage, or planted out in the garden.

Lupin, sweet pea, broom and tufted vetch seed pods should be removed from their stems before being placed in a paper bag. As the seeds burst out during the drying process, the empty pods form an attractive twist.

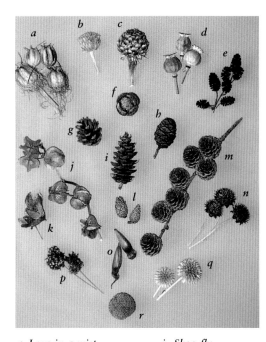

a Love-in-a-mist	j Shoo-fly
b Jerusalem sage	k Beech
c Centaurea macrocephala	l Pine
d Poppy	m Larch
e Alder	n Giant scabious
f Cypress	o Monkey puzzle
g Pine	p Allium
h Pine	q Globe thistle
i Pine	r Plane

Fig 2.6 **Cones and seed heads come in all shapes and sizes.**

HELPFUL HINT

Spray cones with gold or silver paint for inclusion in Christmas arrangements.

Most small to medium sized cones are useful, but very large cones have a limited use in collage. Pine, spruce, cypress and larch all produce cones in a variety of shapes, sizes and colours. Gather cones from the ground after they fall from trees in the autumn, and dry as described on page 15. Store them in a dry place and they will keep indefinitely.

You will need to obtain permission to collect cones in areas cultivated by the Forestry Commission, but it is permissible to gather them freely from other areas of countryside.

PRESERVING

There are four main methods of preserving plant material: air drying, using desiccants, using glycerine and pressing. You should select whichever method seems most suitable for the plant material and is most convenient to locate during the process. If free surface areas are limited, for example, you would probably be wise to avoid using large open trays and to hang materials in paper bags to dry instead.

AIR DRYING

Air drying is perhaps the simplest means of preservation, but the plant material does not always lend itself to this method. Seed heads and grasses work well, and some flowers (*see* Figs 2.7, 2.8 and 2.9), but leaves often tend to shrivel and curl, becoming brittle and cracked. Depending on the type of plant material to be air dried, there are three possible approaches, described on page 15. The first two methods are more suited to long stemmed grasses and flowers, the third for seed heads and pods.

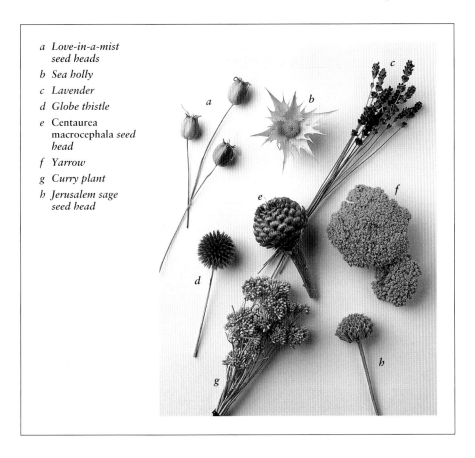

a Love-in-a-mist
seed heads

b Sea holly

c Lavender

d Globe thistle

e Centaurea
macrocephala *seed
head*

f Yarrow

g Curry plant

h Jerusalem sage
seed head

Fig 2.7 **A selection of plant material after air drying.**

Fig 2.8 **The vibrant
colours of statice and
strawflower last well
when air dried. Bunches
of such material should
be hung in a cool place
to dry out.**

You should allow between one and six weeks for the drying process to be completed. The speed of drying will depend on the type of plant material and the conditions during the process. Trial and error is really the only way to find out how long various items will take.

1 Tie the plant material in small bunches with plastic covered wire. The wire is easy to tighten as the stems shrink. Hang the bunches in a cool, dry place. Paper bags can be used to cover the bunches, keeping them dust free and assisting with colour retention. The colours of some flowers are well worth preserving, especially the glorious hues of statice and strawflower (*see* Fig 2.8).

2 Stand the plant material in an old jam jar, but do not pack it too tightly (*see* Fig 2.9). It is important to allow the air to circulate freely. Place the jar in a cool, dry and dark part of a garage or shed.

3 Spread a single layer of cones, stemless seed heads or pods on a wooden tray (*see* Fig 2.10). Air circulation is again important, so do not pile them on top of each other. Another suitable method for seed heads is to hang them up in a paper bag to dry (*see* page 12).

Once dried, the material should be stored carefully in roomy cardboard boxes. Do not overpack the boxes, to avoid damaging or crushing delicate items.

HELPFUL HINT

To refresh crumpled air dried flowers and leaves, hold above the spout of a boiling kettle for a few seconds and then re-dry for several days before using.

Fig 2.9 **Long stemmed flowers such as Chinese lantern, or grasses, can be placed in a large jar to dry. Make sure each individual piece has plenty of air around it.**

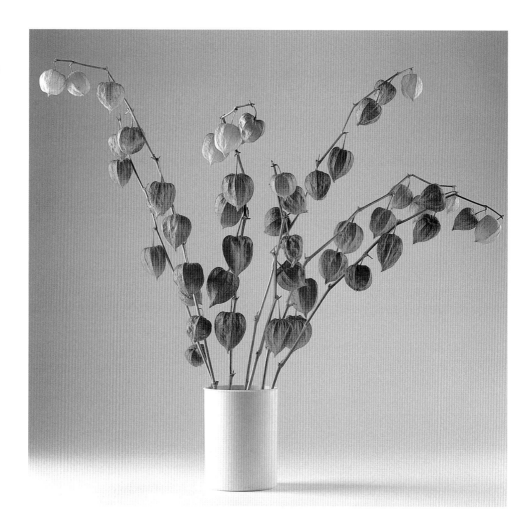

DESICCANTS

A desiccant is a substance which absorbs moisture. A number of products are suitable for preserving plant material, including sand, borax powder, alum and silica gel. Almost all flowers and leaves can be preserved using a desiccant (*see* Fig 2.11).

Silica gel crystals sold by chemists are usually too large and are likely to cause damage to delicate petals and leaves. One excellent type of silica gel is available by mail order from a well known artist and expert in the preservation and use of dried plant material (*see* page 164). The crystals can be reactivated in a warm oven and used repeatedly.

Very fine silver sand, which can be purchased from garden centres, filters easily down between flower petals, providing good coverage. Like silica gel, it can also be used repeatedly. To reactivate, place it on a shallow baking tray in a low oven for between three and five hours, depending on the depth of sand and the amount of moisture present.

HELPFUL HINT

A small amount of bicarbonate of soda mixed with the sand helps fix petal colours.

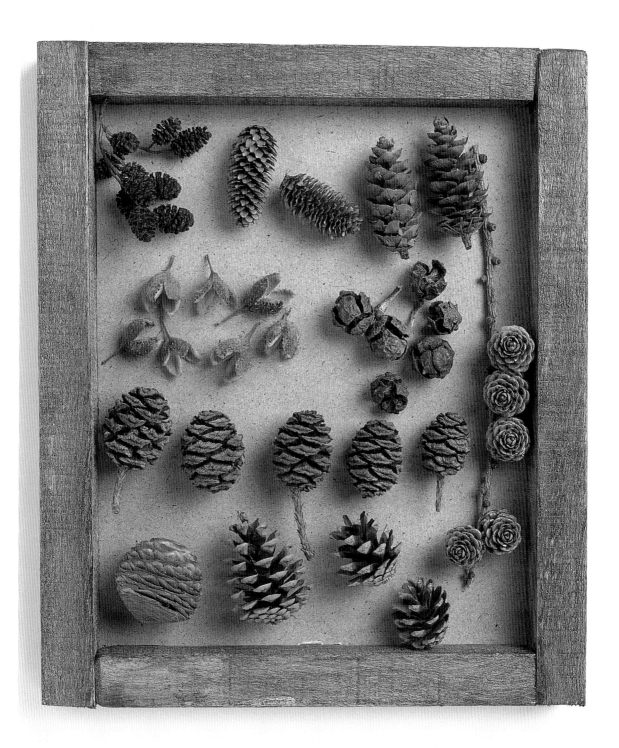

Fig 2.10 Cones and seed heads are best laid out on a wooden tray in a single layer to dry.

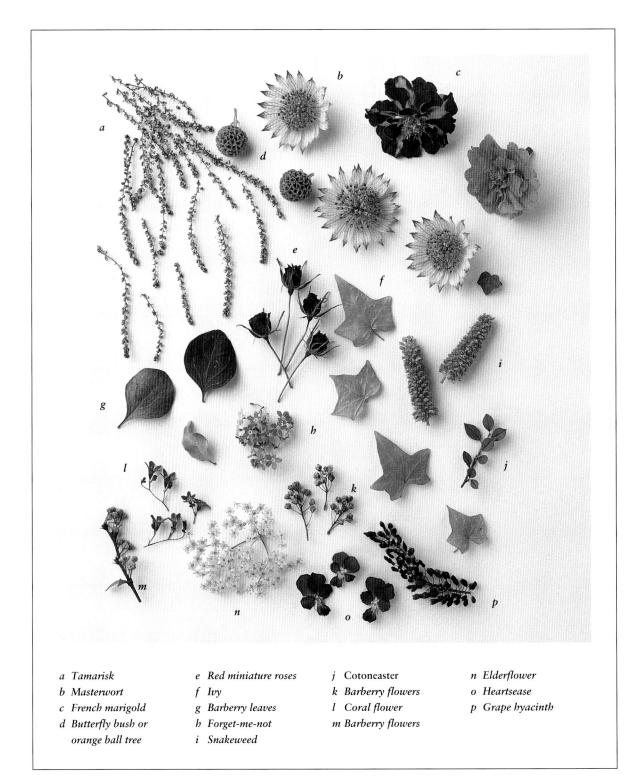

a Tamarisk	*e* Red miniature roses	*j* Cotoneaster	*n* Elderflower
b Masterwort	*f* Ivy	*k* Barberry flowers	*o* Heartsease
c French marigold	*g* Barberry leaves	*l* Coral flower	*p* Grape hyacinth
d Butterfly bush or orange ball tree	*h* Forget-me-not	*m* Barberry flowers	
	i Snakeweed		

Fig 2.11 **A selection of plant material preserved in a desiccant.**

Silver sand is rather heavy, however, so care must be taken when sprinkling it over easily bruised flowers. Beach sand has a high salt content and is not suitable.

Borax and alum can both be purchased from a chemist. Borax alone is not always successful and should be mixed with sand and/or alum at a ratio of three parts sand or alum to one part borax.

Whatever type of desiccant you use, the method is always the same.

1 Depending on the size and quantity of plant material to be preserved, select an adequately sized tin, box or polythene container with an airtight lid. Only one type of plant material should be preserved in each container.

2 Cover the bottom of the container with the desiccant to a depth of 2.5cm (1in).

3 Place the plant material on top of this layer and gently cover with more desiccant (*see* Fig 2.12). It is vital not to crumple or displace any part of

the material at this stage, as it will remain that way once dried.

4 When the plant material is completely covered, label the container clearly with the contents and date. If you are using silica gel, replace the lid now, but for sand, alum or borax, the lid should be left off during preserving time.

5 Do not shake or tilt the container during preserving time as this might damage the contents. The time varies according to the plant material: thin leaves may take only two or three days, but miniature roses, for example, may need up to six days.

6 To test if the material is ready, remove one piece from the container. Give it a very gentle flick. If it feels firm and sounds crisp, then it is ready. If this is not the case, a little more preserving time is required.

7 Carefully remove the material from the desiccant and store in small, shallow cardboard boxes in a warm, dry atmosphere.

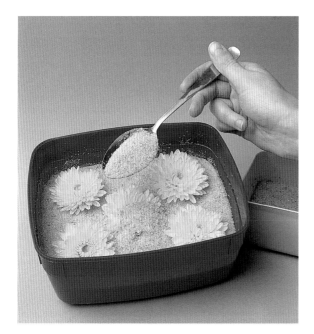

Fig 2.12 **Use a spoon to cover the plant material very gently with more desiccant.**

HELPFUL HINT

Plant material preserved with a desiccant is extremely fragile and requires special care when handling and storing. If it is allowed to stand in a warm room for a few hours before use, it will absorb enough moisture from the air to make it more manageable.

GLYCERINE

Glycerine is a sweet, colourless liquid obtained from oils. It replaces the water contained in plant material with a fluid which does not evaporate, keeping the material naturally firm. You can buy glycerine from most chemists.

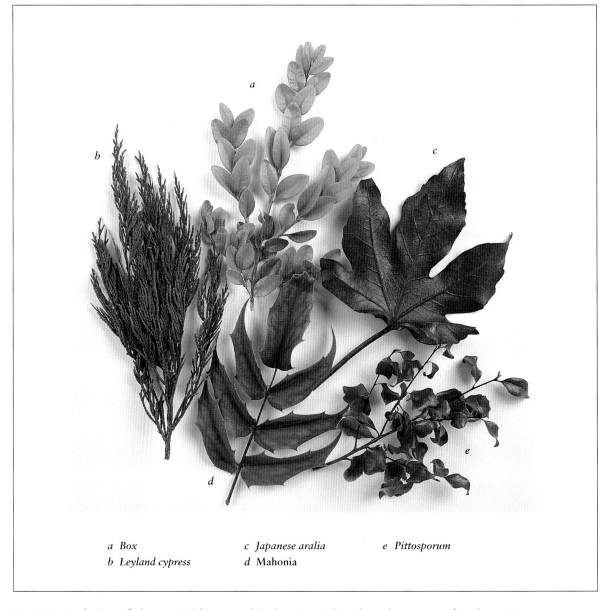

a Box
b Leyland cypress
c Japanese aralia
d Mahonia
e Pittosporum

Fig 2.13 **A selection of plant material preserved in glycerine. The colour changes are often dramatic.**

Plant material preserved using glycerine is much more pliable and easier to handle than that preserved in a desiccant. It is most suitable for leaves and small, whole branches (*see* Fig 2.13), but is not ideal for preserving flowers, lady's mantle being one of the few exceptions. The method for using glycerine is straightforward.

1 Find a jar which is large enough to accommodate the plant material without crowding, and tall enough to take at least 8cm (3⅛in) of liquid. If the jar is likely to be unstable, stand it in a bucket or large pot and place pebbles round the base of the jar for support (*see* Fig 2.14).

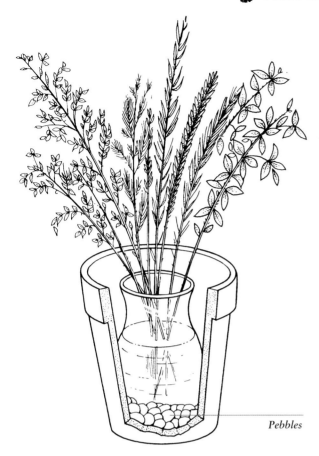

Pebbles

Fig 2.14 **If the jar is likely to be unstable when full of glycerine mixture and long stemmed leaves, place it in a larger bucket for support.**

2 Mix together one part glycerine to two parts hot water and stir well until the mixture looks clear. Pour this into the jar to a depth of about 8cm (3⅛in).

3 It is advisable to pick foliage and place it immediately into the hot mixture, because the glycerine will travel more quickly through a very fresh stem. All stems should be cut at an angle, and any woody stems should be split first, up to about 2.5cm (1in) from the bottom, to obtain the maximum area of absorption.

4 Preserving time will vary according to the type of foliage and the thickness and texture of the leaves. Small branches of pittosporum and cotoneaster will be ready within a few days, but

leathery leaves such as laurel can take anything up to several weeks.

5 Take care not to overglycerine. This becomes obvious when tiny globules of glycerine appear on the surface of the leaves.

6 Very large leaves, such as Japanese aralia, or any large, soft-stemmed leaf, should be floated directly in the mixture (*see* Fig 2.15) and turned over daily.

7 Once glycerining is complete, store the foliage in a cardboard box, but do not pack too tightly as this could encourage the formation of mould. The stems which have been sitting directly in the liquid should be wiped dry before storage.

Fig 2.15 **It is best to float very large leaves directly in the glycerine mixture.**

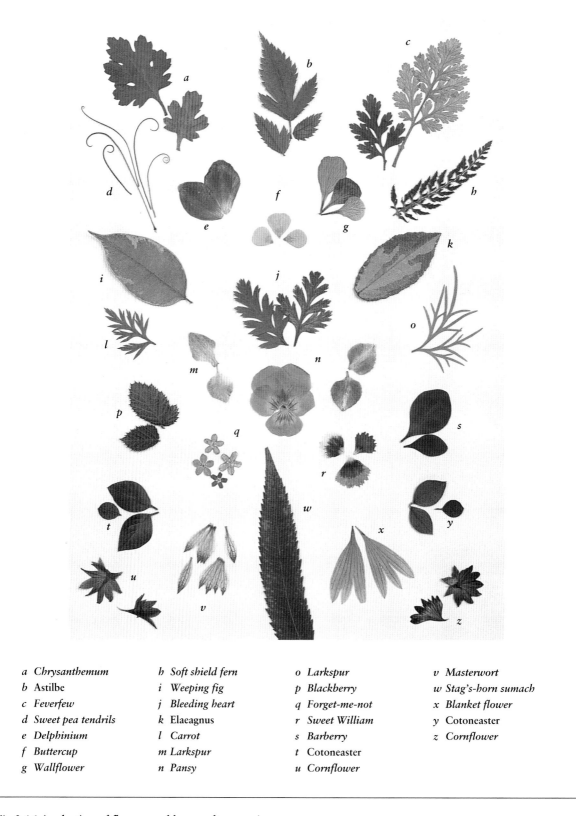

a	Chrysanthemum	h Soft shield fern	o Larkspur	v Masterwort
b	Astilbe	i Weeping fig	p Blackberry	w Stag's-horn sumach
c	Feverfew	j Bleeding heart	q Forget-me-not	x Blanket flower
d	Sweet pea tendrils	k Elaeagnus	r Sweet William	y Cotoneaster
e	Delphinium	l Carrot	s Barberry	z Cornflower
f	Buttercup	m Larkspur	t Cotoneaster	
g	Wallflower	n Pansy	u Cornflower	

Fig 2.16 A selection of flowers and leaves after pressing.

PRESSING

Fig 2.16 shows a variety of pressed flowers and leaves. Flower presses are obtainable from most craft shops, but an old telephone directory is a cheaper option and works just as well with a heavy weight on top. For very small quantities of plant material, any book can be used, providing that the pages are absorbent.

Avoid using any smooth, glossy paper, as the moisture will not be taken up from the flowers and leaves, which will inevitably lead to mould. Corrugated card is entirely unsuitable for pressing, as the ridges will leave bruise marks on the plant material. Blotting paper is ideal, whether you are using a proper press or a book.

Flowers and leaves for pressing must be picked when dry. The middle of the day is the best time, because the blooms will be fully open and dried after the early morning moisture has dispersed. Press as soon as possible after picking, and only use material which is in perfect condition. Bruising and tearing will show up after pressing and look unsightly, although naturally twisted and distorted petals can be used to good effect, as long as they are not damaged in any way.

Preparing flowers for pressing can be finicky work, but the end result will be worthwhile if you take time to do what is necessary beforehand. Many flowers can simply be pressed as they are, but very tiny flowers are best removed from their stems. Tubular flowers such as primrose and tobacco plant should be cut just below the point where the petals join, so that they can be pressed as a circle. For best results, flowers with many petals, such as marigold and blanket flower, should be dissected and each petal pressed separately.

Leaves can be pressed at any time of year, from the bright young growth during spring to the beautiful tints of autumn. It is worth remembering, however, that pressed green leaves will tend to turn cream or brown, although the silver and grey leaves of wormwood and silverweed keep their colour indefinitely, looking superb against a dark background. As with flowers, twisted or naturally folded leaves can add an eye-catching shape to a collage, so keep an eye out for unusual specimens. For most leaves, the thick, central vein should be cut out with a craft knife before pressing.

The method for pressing plant material is the same whether you are using a press or a book. If using a book, you will need a suitable heavy weight to place on top.

1 Collect and prepare your plant material.

2 Position the material in the press, or between sheets of blotting paper in a book. Take care not to overlap any of the petals or leaves, or an unwanted impression will be left (*see* Fig 2.17). It is also important not to mix flowers and leaves of different thicknesses on the same sheet, because this will make the pressing uneven and some of the material will not be properly preserved.

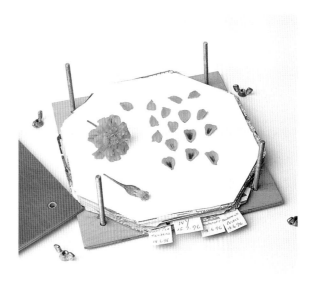

Fig 2.17 **When placing material in the press, avoid overlapping the pieces and keep flowers and leaves of the same thickness together.**

3 Label each section of the press or book clearly, and then tighten the screws on the press (*see* Fig 2.18) or place a heavy weight on the book. Leave undisturbed for at least six to ten weeks in a sunny, airy room free from damp. An airing cupboard is too warm and delicate petals will dry out too quickly, becoming brittle and easily cracked.

4 Once pressing is complete, remove the flowers and leaves very carefully from the press and store between pieces of folded card or thick paper, placed in labelled envelopes. The envelopes should be kept stacked in a box to avoid accidental bending and crushing.

HELPFUL HINT

If pressed foliage has faded it can be touched up with a fibre tip pen or watercolour paint if strictly necessary, but there are times when a faded leaf can be used to advantage.

GILDING

For many collages you are likely to be quite content with preserved flowers, leaves and seeds in their natural colours. You can always add a touch of exotic brightness with some shop-bought dyed grasses. For some special occasions, however, and to give extra sophistication and richness to a collage, gilded leaves and seeds are the perfect option (*see* Fig 2.19). The cans of gold, silver and copper metallic spray paint available today make the process an easy one.

HELPFUL HINT

Make sure that all paint spraying is carried out in a well-ventilated place.

Fig 2.18 **Label each section of the press before tightening the screws, to keep track of the contents.**

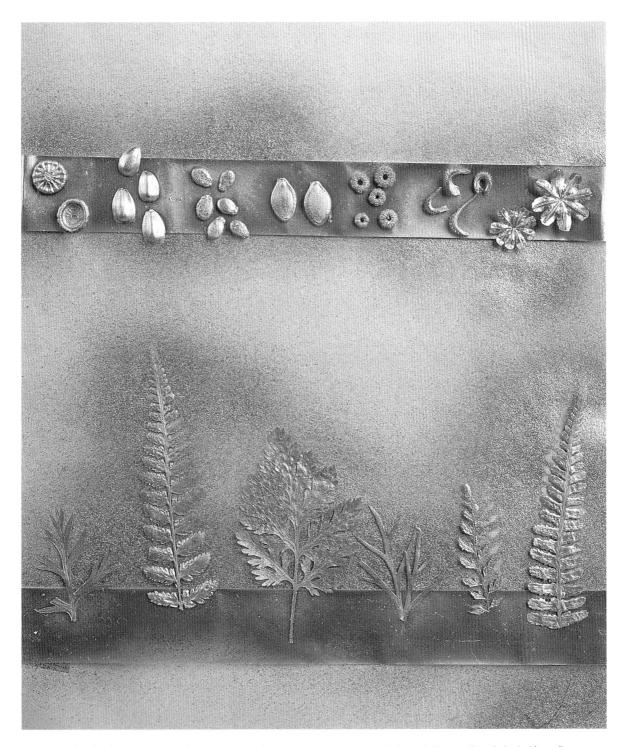

Fig 2.19 **A selection of preserved plant material after gilding.** *Top row (left to right)*: mallow lids, half sunflower seeds, water melon pips, marrow seeds, common mallow seeds, marigold seeds, poppy capsule lids. *Bottom row (left to right)*: carrot leaf, buckler fern, feverfew, larkspur, soft shield fern, male fern.

SEEDS

The collages pictured on pages 103, 115 and 117 demonstrate the stunning effects which can be achieved using gilded seeds. After spraying, seeds with a smooth surface such as rape, mustard and linseed will acquire a high gloss appearance, but those with a rough surface such as Peruvian lily and marigold will take on a more antique effect.

To help an even coating with the paint, it is best not to try to spray too many seeds at once, so place about a dessertspoonful of the seeds into a jar or plastic container (margarine cartons are ideal). Spray the seeds with your chosen metallic paint – two or three squirts will be enough. Put the lid securely on the container and shake gently for one or two minutes. This will prevent the seeds sticking together while the paint dries. Repeat the process if the seeds are not completely coated with paint.

Larger seeds such as pumpkin, sunflower or marrow should be pressed individually on to the sticky side of Sellotape or masking tape and then sprayed (*see* Fig 2.20, *also* Fig 2.19). You will find it easier if the strips of sticky tape are fastened to a larger sheet of paper. All surfaces within the range of the spray must be protected.

OTHER ITEMS

Much larger items such as sprays of fern leaves, lids of poppy seed capsules and sycamore wings are also best secured to sticky tape and sprayed (*see* Fig 2.20). Only one side of each item need be sprayed. Once dry, store in the same way as for naturally coloured material.

It is possible to use acrylic car paint on the larger leaves, but for best results, stick to the metallic spray paints available from art materials suppliers.

HELPFUL HINT

Shades of metallic paint vary quite considerably between manufacturers. When more than one can of paint has been used, store the sprayed material in separate containers to avoid ending up with sudden changes of shade in the middle of a collage.

Fig 2.20 **Attach larger seeds and other material individually to strips of sticky tape before spraying.**
Left to right: Chrysanthemum leaf, larkspur leaf, carrot leaves, soft shield fern, male fern, feverfew leaves, sycamore wings, marigold seeds, mallow lids, bear's breeches seeds, half sunflower seeds, water melon pips.

CHAPTER

3

METHODS
OF WORK

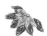

PATTERN PREPARATION

Now that you have spent some time collecting and preserving potential components for collage creations, you can set your imagination rolling. Before gluing anything down, however, you need to have your proposed design clear in your mind. For collage using a wide variety of plant materials (*see* Chapters 4 and 5 on flat and raised collage) it is not so necessary to draw a detailed pattern. The designs for the bookmarks and greetings cards detailed on pages 46 and 49, for example, will be determined largely by the shapes and combinations of the plant material. However, for lettering and the more elaborate collages made from seeds (*see* Chapters 6, 7 and 8), sketching out a pattern to follow is invaluable.

A few simple lines will be enough to keep the shape of your collage on course as you begin to fix the components in place. If, for example, you are preparing a pattern for the Jacobean picture on page 139, you only need draw the main shapes. As long as you have the basic outline to follow, the exact details can be fitted into this 'freehand', allowing for the natural variations of size and shape in the plant material.

Using a pencil and plain paper, roughly sketch out what you have in mind, then strengthen all

the main outlines with a black fibre tip pen (*see* Fig 3.1). Depending on the type of fabric (or card) being used as a background to the collage, this pattern can be slipped between the fabric and the hardboard backing, transferred on to the fabric itself, or made into a template. Instructions for all these methods are given below.

CREATING A PATTERN CARD
FOR TRANSPARENT FABRIC

If your chosen background fabric is thin enough to reveal the lines of a drawing placed beneath it, draw your pattern with a black fibre tip pen on to a piece of white card or paper. This can be slipped between the fabric and the stiff backing (*see* Fig 3.2), and removed once the collage is completed.

The fabric should be secured to the backing (hardboard, plywood or very thick card) on three sides only, with the last side being finished off after removal of the pattern card.

If the finished design is to be properly framed (*see* Appendix 1, pages 152–4), simply glue the fabric to the edges of the front surface of the backing (*see* Fig 3.3), trimming away any excess fabric. The raw edges will be covered by the frame. Remember not to cover the entire surface of the backing with glue, because the pattern card

Fig 3.1 A sketched pattern with the main lines
strengthened in black fibre tip pen.

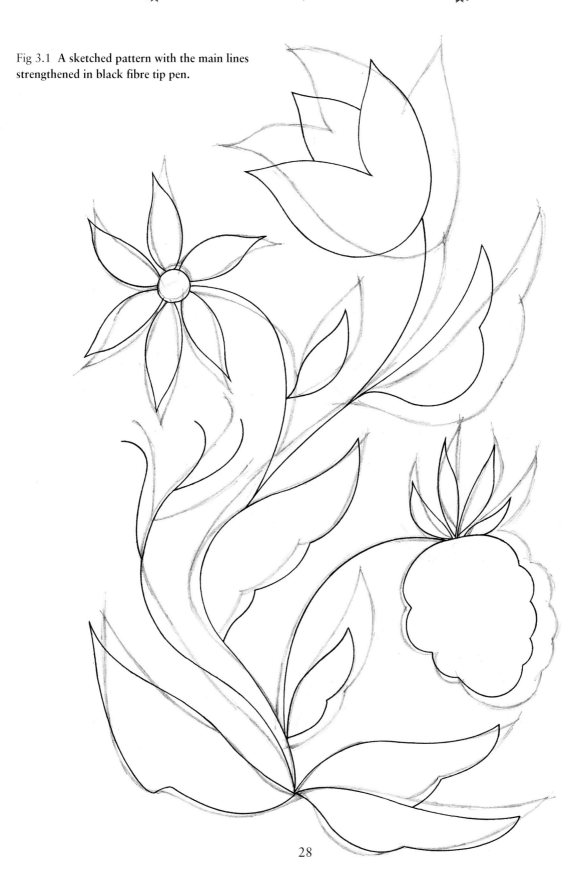

needs to be slipped in. Run a line of all-purpose glue along three sides of the backing only, about 5mm (¼in) from the edge, align the fabric and press carefully into place.

If you intend to mount the finished collage on to a secondary backing rather than framing it, the fabric should be turned over to the reverse side of the backing (on three sides only), with the corners neatly mitred (*see* Fig 3.4 for the method). Again, do not turn over and mitre the final edge until the collage is complete and the pattern card removed.

HELPFUL HINT

If your fabric has a distinct weave, make sure that it is cut squarely, in line with the threads. To do this, gently pull out one thread and then cut along the line of the missing thread. Press to remove any creases before fixing as squarely as possible to the backing.

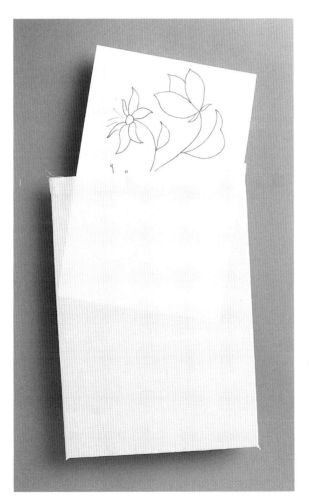

Fig 3.2 **A paper pattern slipped between the fabric and the backing. Once in position, the outlines of the pattern are easy to follow.**

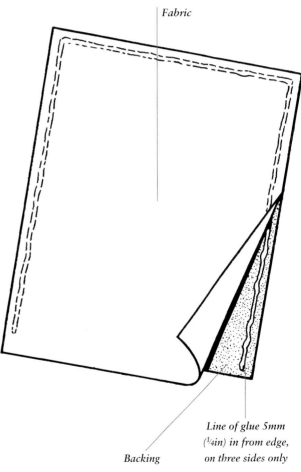

Fabric

Line of glue 5mm (¼in) in from edge, on three sides only

Backing

Fig 3.3 For a framed design, the fabric can be glued directly on to the front of the backing board. Run a line of glue along three sides only to allow space for the paper pattern to be slipped in.

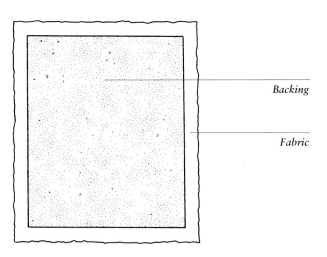

(a) Cut the backing to the exact size. Cut the fabric 2.5cm (1in) larger than the backing all round. Turn the fabric over to the reverse side of the backing on three sides only.

Backing

Fabric

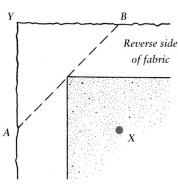

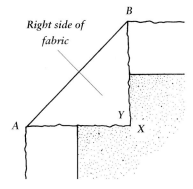

(b) To ensure a perfect angle on the mitred corners, first mark points 'A' and 'B' equidistant from point 'Y' as shown.

(c) Fold the corner of the fabric down along the line from 'A' to 'B'. Dab a spot of glue at point 'X' to hold point 'Y' in place.

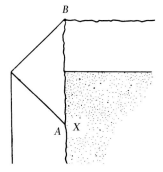

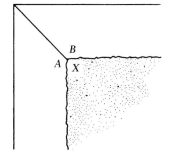

(d) Fold corner 'A' in to meet point 'X' and glue down.

(e) Finally fold corner 'B' in to meet point 'X' also, and glue.

Fig 3.4 How to mitre a corner.

TRANSFERRING A PATTERN TO OPAQUE FABRIC

If your background is a more solid fabric, such as satin or linen, which will not reveal the outlines of a pattern placed beneath it, a different approach is necessary. This is also the method to use if you are using card as a background.

If you are using a fabric background, follow the same methods for securing the fabric to the backing board as demonstrated in Figs 3.3 and 3.4, but fix the fabric down on all four sides this time.

Make the basic pattern using a pencil and paper as before, sketching the outlines of your design and strengthening the main lines with a black fibre tip pen. Then rub the reverse side of the paper with a soft pencil (6B) and lay the pattern **reverse side down** on to the prepared fabric or card background. When you are sure that the pattern is centrally placed, trace over the lines with a hard pencil (H). These traced lines will show faintly on the surface of the fabric or card, enabling the pattern to be followed accurately. When the collage is finished, any lines still visible can be carefully removed using a pencil eraser.

MAKING AND USING A TEMPLATE

Using a template is the best way to follow a pattern if your chosen background is a dark fabric or card, when neither of the two methods described above will be very practical. Again, start off by preparing the fabric or card and securing it on all four sides to the backing board.

Fig 3.5 shows an example of a seed collage design created using a template, and Fig 3.6 sets out the stages involved. Care must be taken not to cut away too much of the template card at each stage. It may help to number the parts of the template as shown in Fig 3.6a. The same method can be used for any collage using a template.

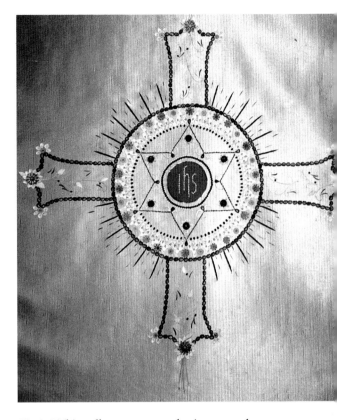

Fig 3.5 **This collage was created using a template. (The cross was part of a larger design for an altar frontal.) Fig 3.6 shows the stages.**

First draw the outlines of the design clearly on a piece of paper or thin card (a) and cut carefully along the outer lines only, thus forming a silhouette of the whole design. Pin the template to the fabric or card and glue the seeds (or other material) around the edge (b), making sure that they are stuck only to the background and not to the template. Remove the template from the background and cut away the outer section, thus forming the next section of the pattern. Glue seeds around this second section, remove the template and cut away the unwanted parts (c). Repeat this process until all the main lines of the design have been formed (d and e), then complete the collage freehand (f).

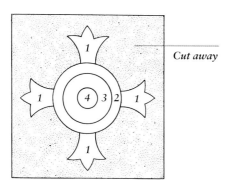

(a) Draw the design accurately on to paper or card and cut around the outer edge. Number the parts of the design in the intended order of work.

(b) Pin the template to the collage backing and glue the seeds round the outside edges. Remove the template and cut away the outer sections (marked '1') which are no longer needed.

(c) Replace the template on the collage and glue the seeds round the next section (marked '2'). Cut away the unwanted parts of the template as above.

(d) Follow the same procedure for the next section (marked '3'), remove the template and cut away the unwanted parts.

(e) Replace the template and glue seeds round the final, central section (marked '4') and remove the remains of the template.

(f) The details of the design can now be completed freehand.

Fig 3.6 The stages of using a template.

LETTERING

Seeds, especially gilded ones, are perfect for picking out words and letters in a larger plant material collage. Figs 3.7 and 3.8 show two examples of this, one created for a flower festival, the other for a Harvest Festival celebration. For the adventurous, elaborate calligraphy letters can produce stunning effects (*see* Fig 3.9; *also* wedding pew ends, pages 109–10). Simpler forms of lettering can also be added to bookmarks and greetings cards (*see* pages 63 and 65), using dry transfer lettering which is available from stationery and art shops.

Despite the best intentions, however, lettering can ruin an otherwise attractive collage if it ends up uneven, sloping or badly spaced. If you plan to include lettering formed from seeds, you may think you can keep it all level just by eye, but it is far from easy. To avoid frustration, the most foolproof and reliable way of producing perfect seed collage lettering is to make a template using the following method. Fig 3.10 shows the three stages involved.

HELPFUL HINT

It is wise to fix on seed collage lettering first, before completing the rest of the collage. This allows the template to be placed flat on the background without risk of damaging other parts of the collage. Dry transfer lettering can be applied either before or after the main collage is completed, depending on its position within the design.

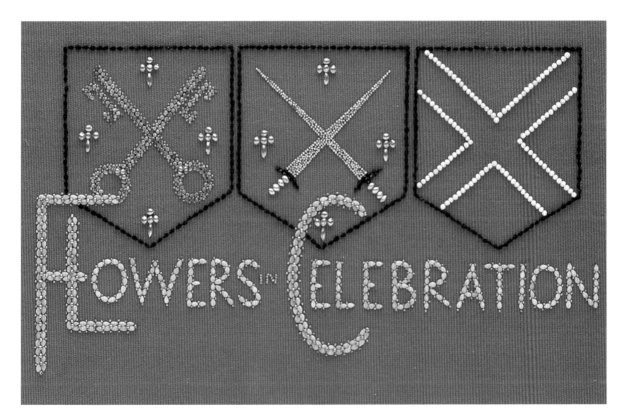

Fig 3.7 Elaborate lettering using various seeds creates an impact on this flower festival banner.

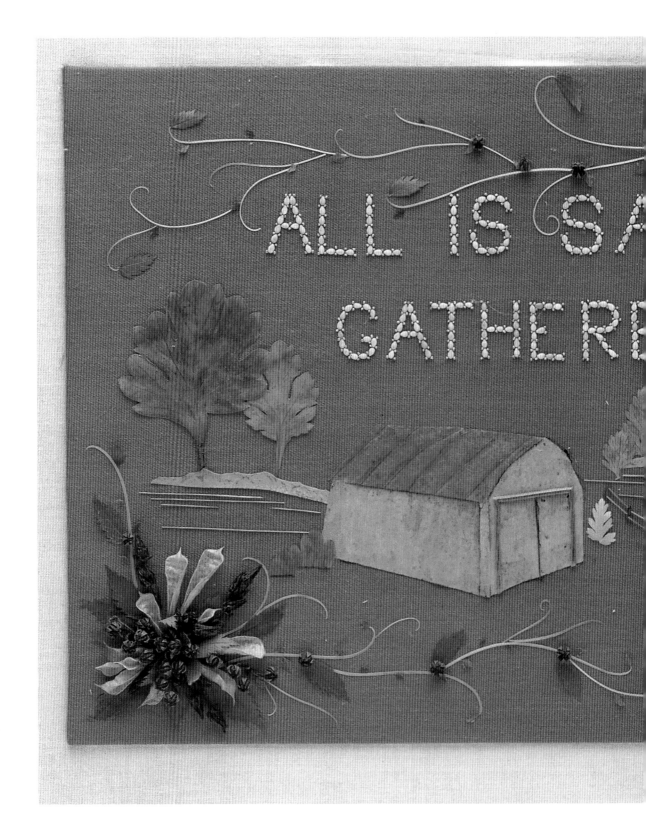

Using a thin piece of card, draw two parallel lines (a), the distance apart being determined by the height of lettering you require. Print the word(s) between the lines, checking that you are satisfied with the spacing and balance of the letters. Draw short lines extending above and below the parallel lines, marking the extent of each letter (b). To avoid any danger of missing out a letter on the collage, print small letters as appropriate above the top parallel line as an aide memoire. Cut away the section between the parallel lines containing the word(s). Pin the template into position on your background fabric or card, and glue the seeds for each letter freehand, using the extension lines on the template as a guide (c). When all letters or words are complete, carefully remove the template and admire your perfectly balanced lettering!

If you wish to include more than one line of wording, make one template for the whole thing, to ensure that all the lettering will be equally balanced and level (*see* Fig 3.11).

HELPFUL HINT

Seeds vary in size, even those from the same seed pod, so make a careful selection for use in lettering before you start. Seeds of a uniform size will give a much more satisfactory result. If you wish to create a thicker line for emphasis, use a double row of seeds (*see* Fig 3.7), or try out combinations of different seeds (*see* Fig 3.8).

Fig 3.8 **An example of lettering used as part of a larger collage.**

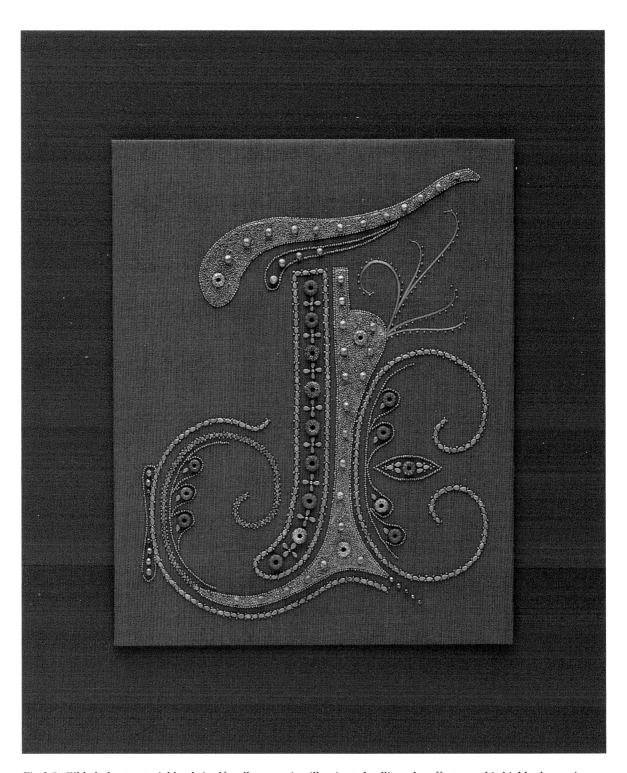

Fig 3.9 Gilded plant material lends itself well to creating illuminated calligraphy effects, as this highly decorative letter J demonstrates.

(a) On thin card draw two parallel lines to mark the top and bottom of the letters. Print the word(s) between these lines, making sure the letters are evenly spaced and shaped.

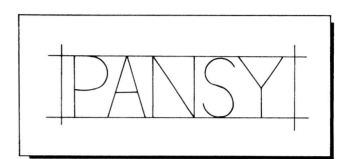

(b) Above and below the parallel lines mark short extension lines to show the extent of each letter. Write each letter in place above the top line as a reminder.

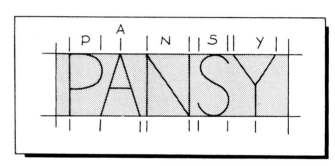

(c) Cut away the section between the parallel lines, pin the template in position and glue on the seeds for each letter freehand, guided by the extension lines.

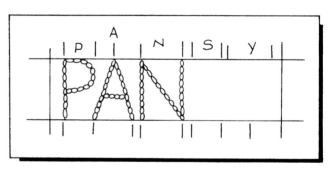

Fig 3.10 Making and using a lettering template.

Fig 3.11 For a longer phrase taking up more than one line, make one template for the whole thing to make sure that the lines are parallel and the words pleasingly arranged.

FIXING PLANT MATERIAL

Dried plant material is very fragile (although glycerined leaves are more robust) and must be handled carefully to avoid damage. Only minute amounts of glue – liquid PVA glue is best – are required to fix the material to any surface. There are various ways of handling the plant material, depending on whether you are dealing with delicate flowers, larger leaves, tiny seeds and so on. The different methods are explained below.

HELPFUL HINT

Do not fix anything into place until you are sure it is correct. It is always wise to practise a design in a 'dry run' before using any glue, because making changes later is usually impossible. This will also enable you to pick out in advance the very best seeds, flowers or leaves to suit your design.

FIXING PRESSED FLOWERS AND LEAVES

Pressed flowers are very fragile and must be handled with extreme care. Larger petals, whole flowers and leaves can usually be picked up gently between finger and thumb, but with any smaller pressed items, tweezers make handling easier and safer.

Never cover the entire area of the plant material with glue. It is simply not necessary, and too much glue will make the piece soft, more easily damaged and harder to handle.

When fixing entire pressed flowers or large leaves, place a minute amount of PVA glue in the centre of the flower, on the reverse side, and set in position on the collage. When the glue is dry, gently lift the edge of the flower or leaf, dip a

darning needle into glue and just touch the underside of the piece, near the edge, letting it fall back into place. This extra dab of glue should hold the flower or leaf firmly in place. The self-adhesive transparent film used to cover pressed plant material collages has a magnetic substance in the film which very quickly attracts the flower or leaf. If the plant material is not fully fixed down, it could easily be distorted or damaged and cannot be repaired.

For individual petals and small to medium sized leaves, place a small amount of PVA glue on a shallow plastic dish – a pea-sized drop is enough at one time. Very gently pick up the petal or leaf with pointed tweezers and dip the stem end into the glue (*see* Fig 3.12a). Manoeuvre the piece into position on your collage (*see* Fig 3.12b). Allow the glue to dry, then finish off by applying a small dot of glue to the opposite end with a darning needle as described above.

HELPFUL HINT

Cover pressed flowers and leaves closely with glass or transparent film to prevent distortion and curling.

FIXING WHOLE DRIED FLOWERS, GRASSES AND LARGE SEEDS

It is important to take great care not to crush or split flowers and leaves which have been air dried or preserved in a desiccant. Once again a pair of pointed tweezers is an ideal tool, enabling you to pick the piece up by touching only a very small part of it. Handling individual seeds is more fiddly, but after finding it slow going to begin with, you will soon become adept at transferring even the tiniest seeds between their storage box, the glue and your collage. You may wish to try out your dexterity with some of the larger seeds first.

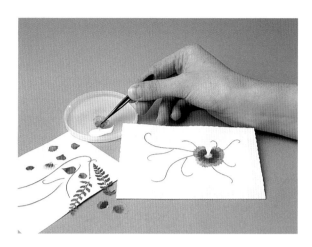

Fig 3.12a **Pick up the petal very gently with the tweezers and dip lightly into the glue.**

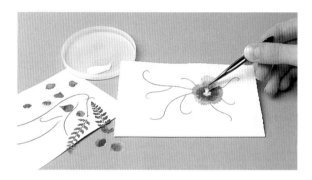

Fig 3.12b **Place the piece in position on the collage.**

HELPFUL HINT

With very fragile, air dried flowers, leaves and grasses (and those preserved in a desiccant), take care not to press them into place on the collage, or they will be damaged. The glue will do the job for you.

With a pair of pointed tweezers, dip the selected flower or seed very lightly into the glue as described earlier (*see* Fig 3.12) and place it into position on the collage. A dry cocktail stick or

dressmaking pin can be used to push the piece exactly into alignment if necessary. The trick is to dip the piece into the glue at exactly the right angle to enable the often awkwardly shaped flower or seed to adhere properly to the collage backing or to a piece of previously placed plant material.

HELPFUL HINT

If the flower, grass or seed is accidentally dropped into the glue, do not attempt to retrieve and use it. It is better to select another piece.

FIXING SMALL SEEDS

If the individual seeds are too small to be handled comfortably with tweezers, a more successful method is to use a cocktail stick (or darning needle). This applies to most seeds, including poppy, linseed and sesame seeds. Fig 3.13 shows the method.

Place a pea-sized amount of glue in a shallow plastic dish as above. Dip the tip of a cocktail stick into the glue (a) and place a dot of glue on to the collage background in the required position (b). Then pick up one seed by touching it lightly with the same end of the stick (c) and place it in position on the dot of glue (d).

It is vital not to use too much glue, and to avoid pressing the plant material down firmly. The fragile flower or seed could be damaged, and if too much glue is used on a fabric background there is a risk of the glue spreading and seeping through it. This could cause difficulties when trying to adjust or remove a pattern card placed beneath the fabric. If this does happen, the easiest and least disruptive thing to do is to slide a palette knife very smoothly between the fabric and the pattern card.

(a) Dip the tip of a cocktail stick into glue.

(b) Place a dot of glue in position on the collage.

(c) Pick up one seed with the sticky end of the cocktail stick.

(d) Transfer to the dot of glue on the collage.

Fig 3.13 Handling and fixing small seeds.

FILLING A LARGE AREA WITH TINY SEEDS

Tiny seeds, such as poppy and foxglove, can be used advantageously to cover a sizeable area of a collage. It would be a waste of effort, however, to glue each seed down individually, and on these occasions it is easier to spoon or shake the seeds over the desired area which has been spread with glue (*see* Fig 3.14).

PVA glue is usually supplied with a brush and you will need to use this to spread glue thinly and evenly over the area of the collage to be covered with the tiny seeds (a). If dense coverage is required, spoon the seeds generously over the glued area (b) until it is entirely covered (c). Leave

untouched until the glue is dry, then gently shake off the surplus seeds, which can be retained for future use (d). The glued area should now be covered in an even layer of seeds (e). For a lighter coverage, use an old pepper shaker to sprinkle the seeds instead.

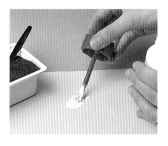 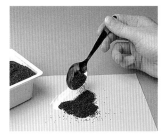 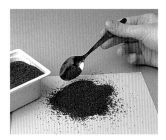

(a) Brush glue evenly over the area to be covered.

(b) Spoon the seeds generously over the glued area . . .

(c) . . . until all the glue is well covered. Leave to dry.

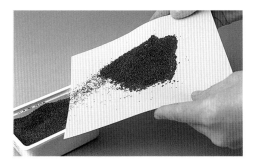

(d) Gently shake the surplus seeds back into their container.

(e) The glued area should be covered with an even layer of seeds.

Fig 3.14 **Filling a large area with tiny seeds.**

SCATTERING SEEDS

If you want to achieve a more controlled effect of scattered seeds over a certain area, rather than simply shaking them randomly as in the method shown above, they will need to be glued in place individually. This will mean that you have absolute control over the density of the seeds and you can then graduate the 'shading' if you wish (*see* Fig 3.15). To glue the seeds in place, use a cocktail stick dipped in glue as shown in Fig 3.13.

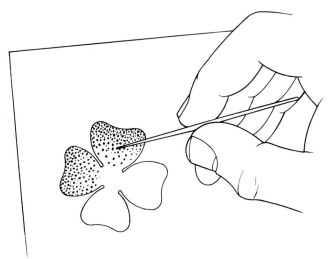

HELPFUL HINT

Do not try to hurry the creation of a collage. Better results will be achieved if you go slowly at every stage.

Fig 3.15 **To achieve a controlled, graduated shading effect the seeds will need to be fixed on individually using a pair of tweezers or cocktail stick dipped in glue.**

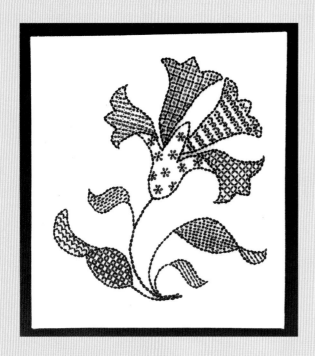

PROJECTS

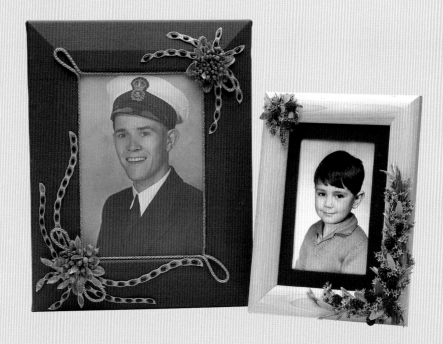

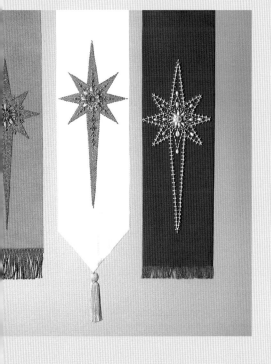
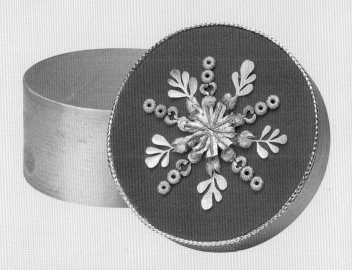

FLAT COLLAGE

A flat collage is usually made from pressed plant material and protected either by a covering of self-adhesive transparent film, or beneath closely fitting glass or acetate.

Flowers, petals, leaves or tendrils should be placed in a press and left undisturbed for at least six weeks, and preferably longer, before use (*see* pages 23–4).

When the pressed material is ready, and you are planning a bookmark or greetings card, look at the colours, shapes and sizes of the material rather than thinking of it just as a flower or leaf, and allow what you see to suggest a design.

The designs featured in this chapter are not complicated, but will offer ideas for creating pleasingly balanced collage designs. The most successful designs, as you will find with practice, do not overcrowd the plant material, but allow some distance between each piece.

───── ◆ PROJECT ◆ ─────

BOOKMARKS

The simplest bookmarks are made with pressed flowers and leaves, glued to a piece of card and covered with self-adhesive transparent film. These are very easy to make, offering an excellent starting point for experimenting with collage ideas and practising the handling and fixing of plant material.

Bookmarks made with pressed material only can be tucked inside the book to mark the place, with one end sticking out, and this is the type of bookmark described overleaf (*see* Chapter 5 for more elaborate, raised collage bookmarks on a fabric backing). A selection of designs is shown in Fig 4.1. Fig 4.2 is a close-up of one of these bookmarks, with Fig 4.3 showing a plan of the collage components. The specific pressed flowers and leaves given in the list on page 46 are for this particular design, but the general materials and method apply to any bookmark.

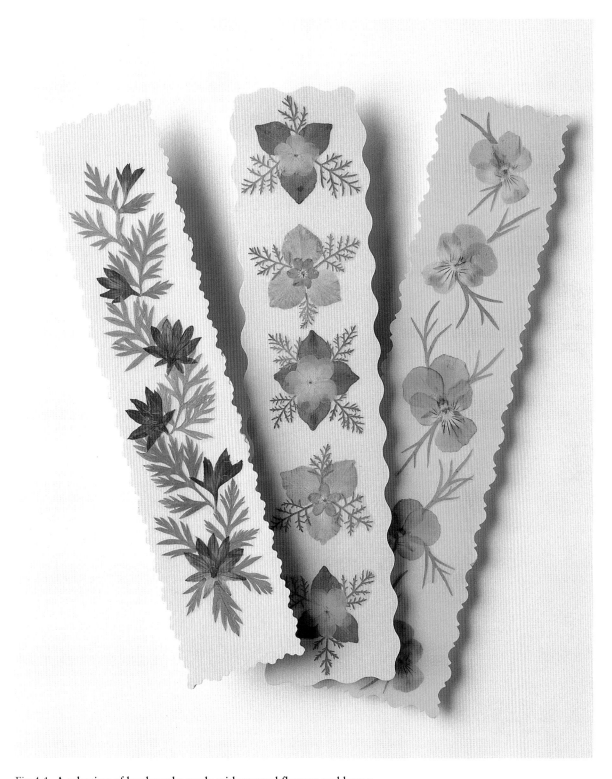

Fig 4.1 A selection of bookmarks made with pressed flowers and leaves.

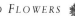

with the transparent film. Cut a piece of film to the exact size required and peel away about 2.5cm (1in) of the backing. Place the film precisely in position over the collage, allowing only the unpeeled backing to touch the design at this stage. Press the peeled area gently into place, then lift the rest of the film and peel away the backing while gradually pressing the film into position. Do not attempt to remove or reposition the film, because the collage will inevitably be damaged.

After covering with the film, trim the edges of the bookmark with serrated edge scissors or old pinking shears if desired.

METHOD

First cut the card to size. Arrange the flowers and leaves on the bookmark in a 'dry run' according to your intended design. When you are happy with the positioning of the material, begin in the centre and remove each piece of plant material in turn. Apply a minute amount of PVA glue as described on page 38 and replace the piece in its correct position.

When all elements in the design have been securely stuck down and the glue is dry, cover the bookmark

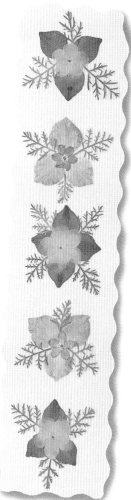

Fig 4.2 A simple bookmark design using larkspur petals and the tiny florets of forget-me-not, snowball bush and wormwood leaves.

Fig 4.3 Pattern of material used for the bookmark design.

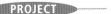

GREETINGS CARDS

Homemade greetings cards can add an extra, personal touch to a special message, and they need not be complicated to make. The possibilities are endless, depending on what material you have available and the occasion for sending the card. Fig 4.4 shows a selection of ideas. Instructions follow for making two cards, one a simple floral design (*see* Fig 4.5) and the other a landscape scene (*see* Fig 4.7).

Fig 4.4 **A variety of greetings cards made using pressed flowers and leaves.**

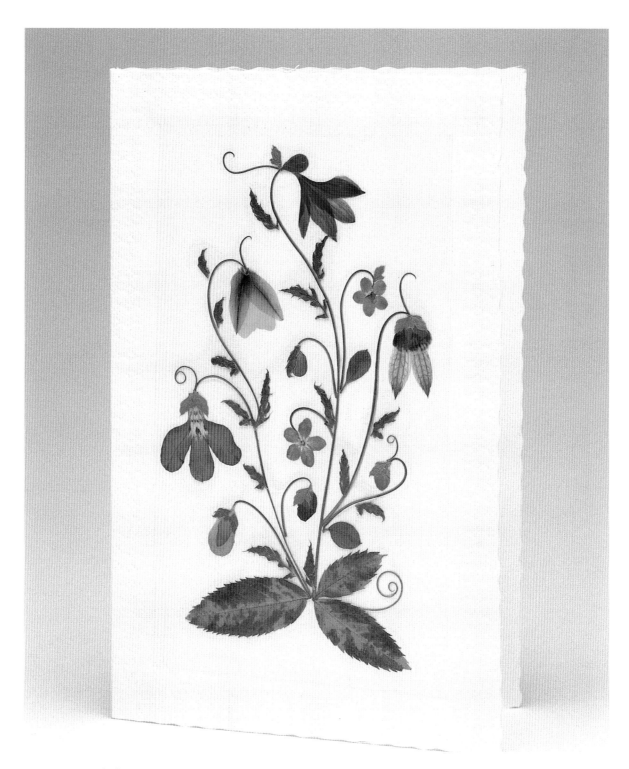

Fig 4.5 A simple floral card such as this can be used for any occasion and the design is infinitely adaptable to whatever flowers and leaves you have available.

FLORAL DESIGN

MATERIALS

Blank greetings card with recess
PVA glue
Self-adhesive transparent film (enough to fit card recess)

PRESSED PLANT MATERIAL

Sweet pea tendrils	*Cotoneaster*	Vegetable pea tendrils	Barrenwort
Rosa rubrifolia leaves	Lobelia	Soft shield fern leaves	Buttercup
Forget-me-not	Masterwort	Sweet William	
	Cornflower	Candytuft	

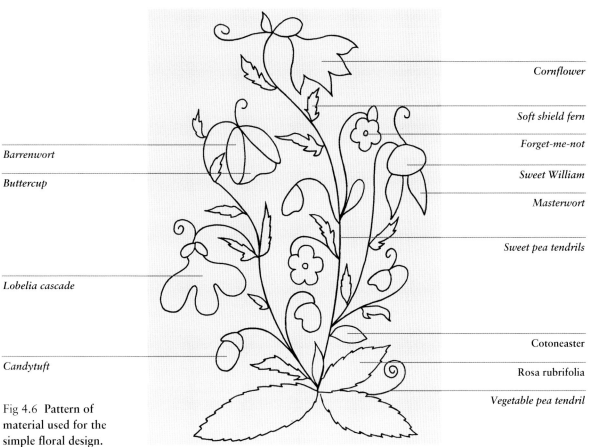

Barrenwort

Buttercup

Lobelia cascade

Candytuft

Fig 4.6 Pattern of
material used for the
simple floral design.

Cornflower

Soft shield fern

Forget-me-not

Sweet William

Masterwort

Sweet pea tendrils

Cotoneaster

Rosa rubrifolia

Vegetable pea tendril

METHOD

This type of design is created entirely by the natural shapes of the plant material, and you will never make two completely identical cards. The pattern in Fig 4.6 is simply there as a guide, showing how the flowers and leaves can be put together to make the card shown in Fig 4.5.

After ascertaining the best layout in a 'dry run', glue on the main shapes first – in this case the sweet pea tendrils and the *Rosa rubrifolia* leaves. Then work through all the flowers and petals, finishing off with the flourishes of soft shield fern and vegetable pea tendrils.

When the glue has dried, cut a piece of self-adhesive transparent film exactly the size of the recess on the card. Cover the design with the film using the method outlined on page 46.

HELPFUL HINT

When fixing sweet pea and vegetable pea tendrils, dip the stem end only into the glue and manoeuvre this into place on the card. Allow the glue to dry. Dip the point of a darning needle into the glue, then gently raise the tip of the tendril, allow it to touch the glue on the needle and fall back into place. Never spread glue along the entire length of the tendril – it is not necessary and would make the tendril less easy to manoeuvre, possibly resulting in trails of glue being left on the backing.

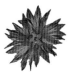

LANDSCAPE SCENE

The shapes and colours of pressed leaves lend themselves to the creation of a variety of landscape scenes ideal for greetings cards. Once you have tried one or two, you will see how a combination of leaves can easily be transformed into a range of hills, with others representing trees, bushes and so on. As no two leaves are identical, each landscape you create will be unique. Fig 4.8 shows the stages of putting together a scene like the one in Fig 4.7.

MATERIALS

Blank greetings card with oval
or round aperture
White poster paint
Blue, green and brown fibre tip pens
PVA glue
Thin, pale blue card

PRESSED LEAVES

Elaeagnus
Weeping fig
Pyrethrum
Soft shield fern
Larkspur

METHOD

Cut an oval or circle from the blue card slightly larger than the aperture in the blank greetings card. The smooth edged leaves intended for the hills (in the pattern given here these are the *Elaeagnus* and weeping fig leaves) should be cut in half along the central vein, and the remains of the central vein carefully removed.

Decide on the arrangement of your landscape before gluing anything down, and then fix the leaves for the hills first as the basis for the collage (Fig 4.8a). Allow the leaves to extend over the edge of the card, and then cut away the excess when the collage is completed.

When the hills have been fixed in place, paint in the clouds with white poster paint, and colour the reflection of the hills in the water with blue, green and brown fibre tip pens. Finally glue on the pyrethrum, soft shield fern and larkspur leaves to represent the trees (Fig 4.8b).

When the glue and paint are completely dry, cover the oval with transparent film using the method described on page 46, and then your scene is ready to mount on the greetings card. First close the card to ensure that it is folded correctly. With the card closed, place small dots of glue in the aperture. Open the card and position the picture, pressing down gently. Smear a small amount of glue around the reverse side of the aperture and around the edges of the central section of the card. Close the card to reveal the picture in the aperture and press the edges firmly together.

HELPFUL HINT

Place dots of glue in the centre only of the leaves being used as hills. This will allow some of the 'trees' to be tucked in behind them.

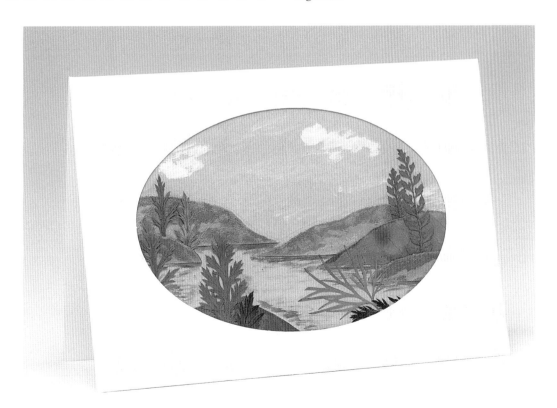

Fig 4.7 **A small landscape scene in collage makes a change from the more usual floral collages used for greetings cards.**

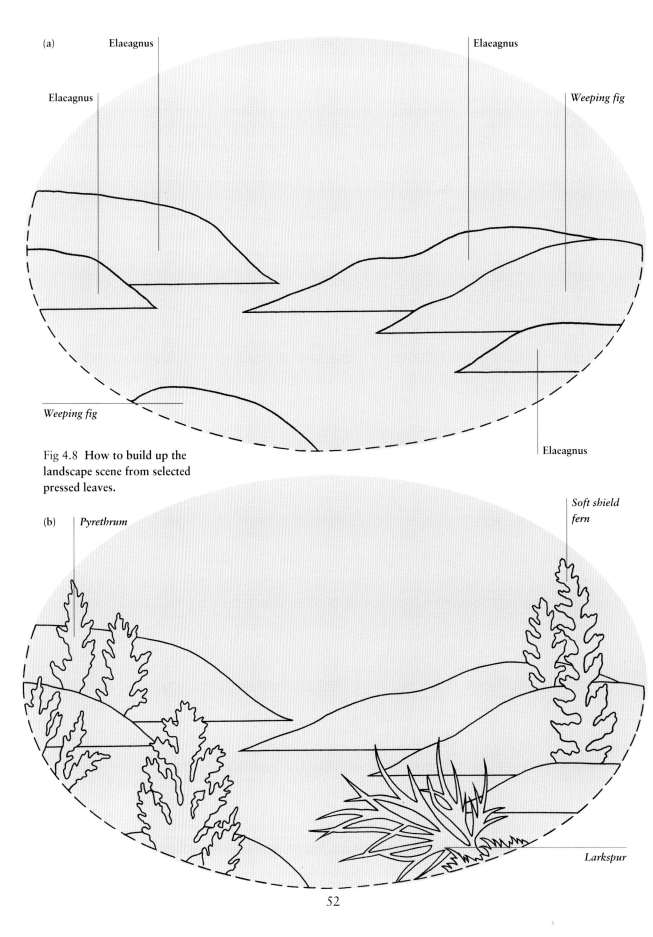

(a)

Elaeagnus

Elaeagnus

Elaeagnus

Weeping fig

Weeping fig

Elaeagnus

Fig 4.8 How to build up the
landscape scene from selected
pressed leaves.

(b) Pyrethrum

Soft shield
fern

Larkspur

52

ALTERNATIVE IDEAS

The type of flat collage used on greetings cards can be adapted to many other uses. Why not try decorating the lid of a plain wooden box as a special gift (*see* Fig 4.9)? Spray the finished collage with colourless, low odour fixative and allow to dry. Repeat this process until the plant material is completely covered, allowing a drying time between each coat. Depending on the thickness of the plant material used, it will probably take about four or five coats before the varnish builds up sufficiently to embed the collage properly. It will then be well protected from damage.

Gilt picture frames also make excellent settings for flat collage designs, and smaller designs made into pendants can be very attractive and unusual (*see* Fig 4.10). There are so many possibilities and

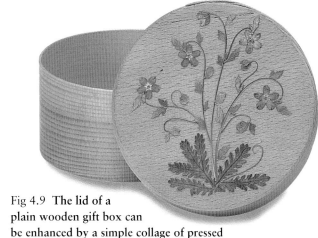

Fig 4.9 **The lid of a plain wooden gift box can be enhanced by a simple collage of pressed flowers and leaves.**

even the simplest collage ideas are readily adaptable to a wide range of uses and styles of presentation. Experiment a little and find out what you like best.

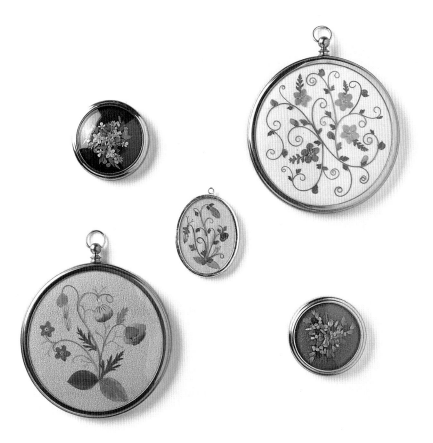

Fig 4.10 **Tiny collages can be created for round and oval pendant frames, or for decorating the lids of miniature pots and boxes.**

GLASS TOPPED TRAY

A flat collage design of pressed flowers and leaves can also be used to give a new look to an old household item. The elderly, glass topped tray shown here was transformed by the addition of a cheerful collage in harmonious colours (*see* Fig 4.11). The pattern details in Fig 4.12 show that the design is simply a larger version of something I might just as easily have used on a greetings card. Other candidates for such freshening up could be old, glass backed hairbrushes and hand mirrors, or a glass topped coffee table.

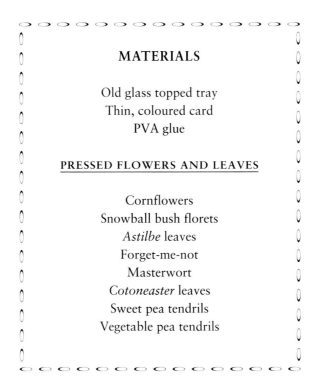

MATERIALS

Old glass topped tray
Thin, coloured card
PVA glue

PRESSED FLOWERS AND LEAVES

Cornflowers
Snowball bush florets
Astilbe leaves
Forget-me-not
Masterwort
Cotoneaster leaves
Sweet pea tendrils
Vegetable pea tendrils

METHOD

Remove the glass from the tray and use this as a template to cut out a piece of coloured card to the correct size and shape to fit the bottom of the tray.

Put your design together with a 'dry run' first, using the sweet pea tendrils to mark out the main lines before filling in the detail with the various flowers and leaves. In general, collage designs look best with a focal point and in the pattern in Fig 4.12, the large circle of masterwort petals forms the hub, with the long sweet pea tendrils offering the chance to sweep the design out into an elegant 'tail'.

When you are satisfied with the placing of the plant material, start by gluing down the sweet pea tendrils (*see* page 50), followed by the central circle of masterwort petals. Complete the first circle of masterwort before working round again,

gluing on a second circle of petals alternately
overlapping the first, as shown in the photograph.
A forget-me-not floret on top of a snowball bush
floret completes this central 'flower'. The rest of
the flowers and leaves can then be fixed in place,
finishing up with the little *Cotoneaster* leaves and
a few final flourishes of vegetable pea tendrils.

When the glue is dry, reassemble the tray,
making sure that the glass top covers the collage
closely to avoid the chance of any petal or leaf
curling up.

Fig 4.11 **This tray was given a new lease of life with an
elegant collage beneath the glass.**

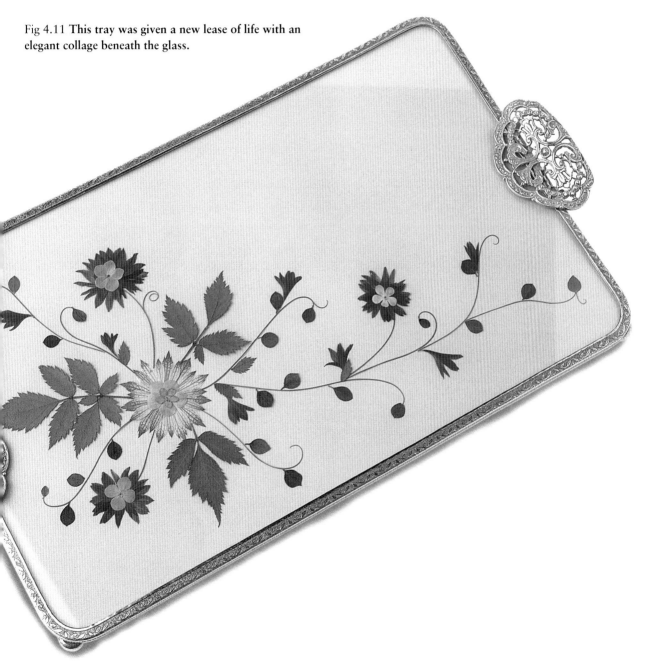

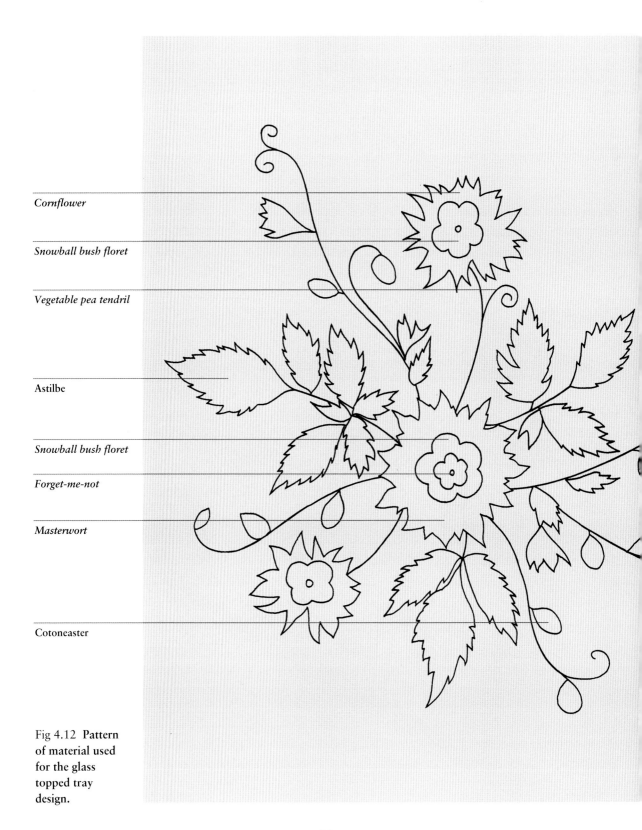

Cornflower

Snowball bush floret

Vegetable pea tendril

Astilbe

Snowball bush floret

Forget-me-not

Masterwort

Cotoneaster

Fig 4.12 **Pattern of material used for the glass topped tray design.**

Sweet pea tendril

Cornflower

RAISED COLLAGE

Raised collage is created from plant material preserved in a desiccant or glycerine, or air dried. Preserving by these methods retains most of the original shape, making three-dimensional designs possible and involving a wider selection of plant material, including seeds and seed pods. It is a little more complex than flat collage but produces a more natural effect. As with all collages a 'dry run' is beneficial.

Raised collage is not always easy to protect against possible damage from rough handling, but can be treated with a low odour fixative sprayed over the completed design. For complete protection suitable items can be placed in a recessed frame behind glass.

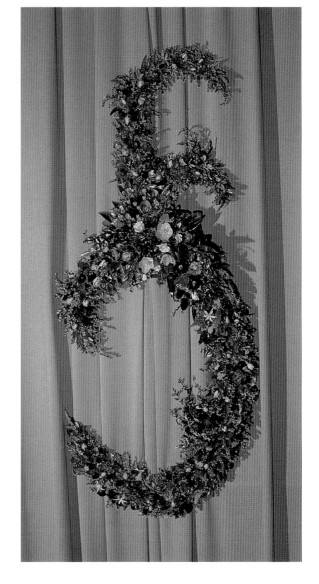

Fig 5.1 I made this raised collage design, called 'Yesteryear', for a NAFAS national competition in 1989. A basic shape cut from hardboard holds the plant material swag. Nearly all the flowers and leaves were grown in my garden and air dried, glycerined or preserved in desiccant.

BOOKMARKS

As with flat collage, making a bookmark is the simplest way to practise a new technique: it is not a large piece, and you can try out different effects without having to spend a lot of time on completing a design.

Fig 5.2 shows a selection of raised collage bookmarks and you will see that they have been constructed in a different way from the simple bookmarks in Chapter 4. Not only do they have a fabric backing rather than plain card (*see* method below), but the collage design is intended to be displayed over the front of the book, while the rest of the bookmark, of plain fabric only, marks the place.

This type of bookmark is purely decorative and a possible conversation piece. It could be an unusual gift, or an attractive addition to a plainly covered book which is lying on a coffee table, as an alternative to a flower arrangement. For longevity, it will need careful handling.

MAKING A FABRIC BOOKMARK

MATERIALS

Fabric of your choice 45 x 15cm (17¾ x 6in)
Matching sewing thread
Thin, white card 30 x 6cm
(11¾ x 2⅜in)

Note: the dimensions of fabric and card can be changed to suit whatever size of bookmark you have in mind.

METHOD

Fold the fabric in half lengthwise, with the wrong side facing outwards, and sew the long edges together. Press the seam open. Turn the tube right side out and, with the seam at the centre back, press flat. Fringe both ends, using a needle to remove a few threads from the edge of the fabric.

Slip the piece of card inside the fabric tube and secure the end just above the bottom fringe with a few discreet stitches of matching thread. The part of the bookmark containing the card is the part used for the collage design.

The designs for these fabric bookmarks can be as simple or as complicated as you like. Two designs are given in detail here, the first being an easy design of just a few leaves and seeds, the second being rather more complex and incorporating some lettering as an additional feature (*see also* pages 33–7).

SIMPLE LEAVES AND SEEDS

The simple design shown in Fig 5.3 uses just three types of plant material (*see* the diagram in Fig 5.4). It does not take much to make an attractive and satisfying collage.

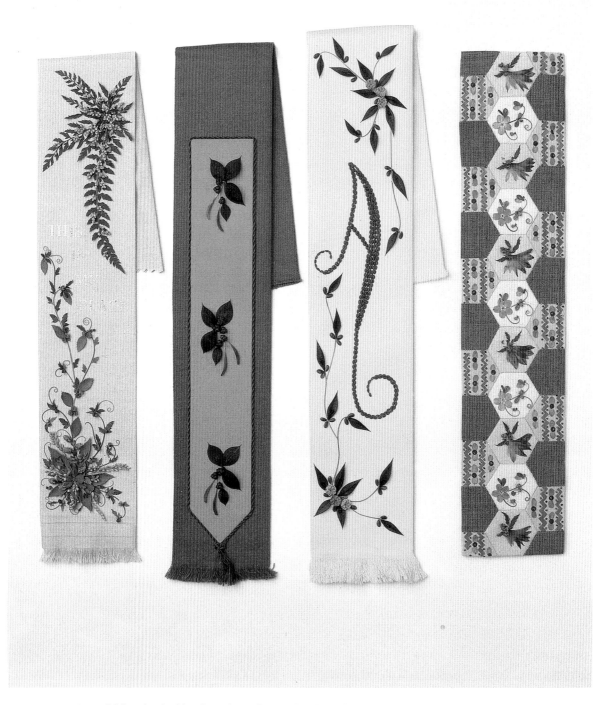

Fig 5.2 **A variety of fabric backed bookmarks with raised collage designs.**

MATERIALS

Basic fabric bookmark in your chosen colour
(*see* page 59)
Contrasting coloured fabric
24 x 5cm (9½ x 2in)
Thin, white card
23 x 4cm (9 x 1⅝in)
Thin piping cord to match
PVA glue
All-purpose clear glue

PLANT MATERIAL

GLYCERINED

Butcher's broom leaves

AIR DRIED

Ceanothus seeds
Goat's beard seed pods

METHOD

Cover the white card with the contrasting fabric (by folding and gluing as described on page 30) and use all-purpose glue to stick this panel on to the basic fabric bookmark (*see* Fig 5.3). You can choose whether to make the inset piece with a point at the bottom end or leave it square. Measure off enough piping cord to go all the way round the inset piece and fix this on with all-purpose glue also. It is best to apply the glue to the cord rather than the fabric, as excess glue is more easily removed from the cord, whereas it may leave a mark on the fabric.

Position the three bunches of plant material evenly apart on the inset piece before gluing on with PVA glue. Each bunch consists of four butcher's broom leaves, three *Ceanothus* seeds and two goat's beard seed pods. As Fig 5.3 shows, the design can be balanced out by varying the way the bunches 'hang'.

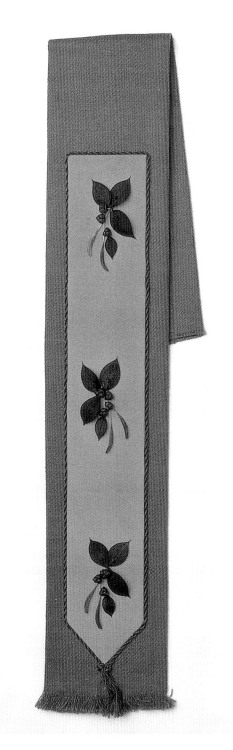

Fig 5.3 'Leaves and seeds': a simple raised collage bookmark design.

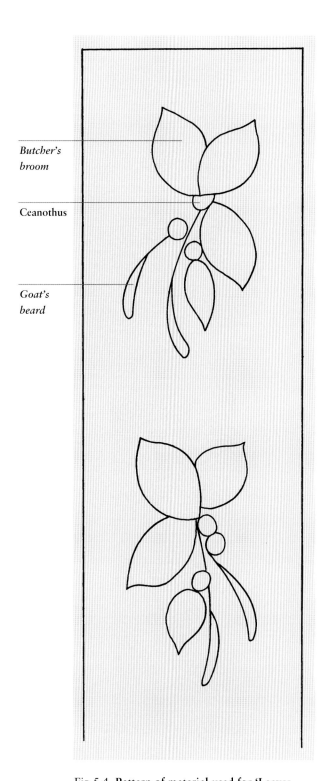

Butcher's broom

Ceanothus

Goat's beard

Fig 5.4 **Pattern of material used for 'Leaves and seeds' design.**

LETTERING DESIGN

The bookmark in Fig 5.5 is a rather more elaborate design (I originally made it for a competition), but is not difficult to achieve as long as care is taken and the material is glued on in a logical order.

Details of the components which make up this particular design are given in Fig 5.6. The lettering is optional, but adds another element to the design. I used dry transfer lettering, which is the most reliable method and readily available from art and stationery shops. Very closely woven fabric will take dry transfer lettering without a problem. If you are an artist, then fabric paint could be used instead, but avoid using ink as it will bleed into the threads of the fabric.

MATERIALS

Basic fabric bookmark (*see* page 59)
PVA glue
Dry transfer lettering (optional)

PLANT MATERIAL

PRESSED
Soft shield fern leaves
Sweet pea tendrils

PRESERVED IN DESICCANT
Holodiscus discolor flower buds
Golden rod (individual sprays)
Heather flowers
Spiraea bumalda leaves
Lonicera nitida leaves
Barberry flowers
Hebe flower buds

METHOD

Mark out the place for the lettering first and apply the dry transfer lettering.

Then deal with the smaller design in the top right hand corner, gluing on small leaf sprays of soft shield fern followed by the *Holodiscus discolor* and further individual leaflets of soft shield fern.

Use the sweet pea tendrils to form the outline of the main design for the bottom left hand corner, then add the five *Spiraea bumalda* leaves and seven *Lonicera nitida* leaves to create the focal point. Once these main points have been established, glue on all the smaller elements as shown in Fig 5.6 to complete the design.

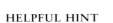

Fig 5.5 'This is my place': a more elaborate bookmark with lettering.

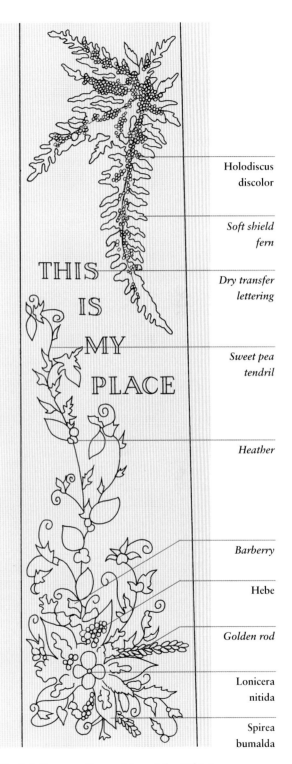

Holodiscus discolor

Soft shield fern

Dry transfer lettering

Sweet pea tendril

Heather

Barberry

Hebe

Golden rod

Lonicera nitida

Spirea bumalda

Fig 5.6 **Pattern of material used for 'This is my place' design.**

GREETINGS CARDS

Raised collage greetings cards are fun to make and a pleasure to receive. They stand out from the more usual flat collage designs of pressed flowers, and open up all sorts of decorative possibilities. Fig 5.7 shows a selection of ideas. It is important to remember, however, that these cards will not travel well in a normal envelope: to protect the fragile plant material it is best to pack them in a suitably sized box.

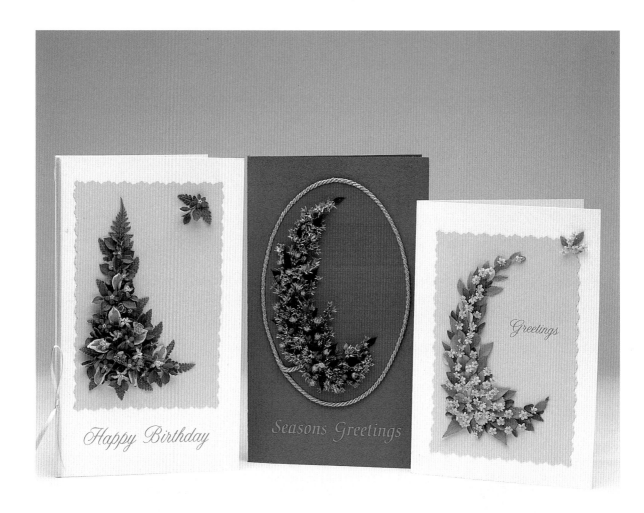

Fig 5.7 **A selection of greetings cards made using raised collage techniques.**

CHRISTMAS CARD

All the plant material used in the Christmas card design (*see* Fig 5.8) can be purchased from a florist or garden centre, so even if you decide at short notice to make your own collage Christmas cards and you have no appropriate material to hand, all it will take is a quick trip to the shops. Fig 5.9 sets out how the elements of the design are built up.

MATERIALS

Thin, green card 19.5 x 24cm
(7¾ x 9½in)
Thin, red card 15 x 10cm
(6 x 4in)
Red fabric (optional) 15 x 10cm (6 x 4in)
Gold piping cord 45cm (17¾in)
Dry transfer lettering (optional)
PVA glue
Presentation box

PLANT MATERIAL

GILDED

Sea lavender

DYED

Butcher's broom leaves (glycerined)
Red and green glixia flowers

METHOD

Fold the green card in half to form a rectangle 19.5cm tall by 12cm wide (7¾ x 4¾in). Pencil in and cut out an oval from the red card, measuring 13cm (5⅛in) at its tallest point and 9cm (3½in) at its widest.

Cover the oval with red fabric for a plusher effect if desired. To cover an oval shape smoothly,

cut the fabric slightly larger than the card and snip tiny wedge-shaped pieces out of the excess fabric to create 'teeth' which can be neatly folded over and glued to the back of the card.

Glue the oval in the centre front of the green card and cover the join with gold cord.

Following the stages shown in Fig 5.9, build up the collage design. First mark out the main outline with gilded sea lavender (a), then fill this in with more sea lavender (b) to form a solid basis for the design. Dip the stem end of the butcher's broom

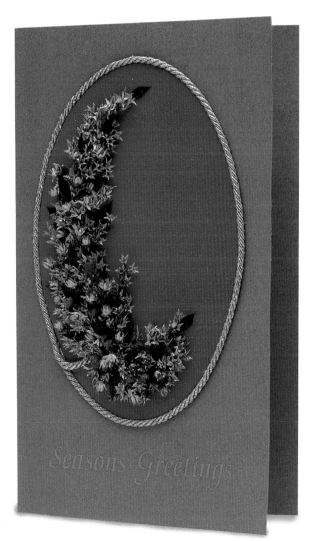

Fig 5.8 'Season's greetings': a warm and festive Christmas card collage.

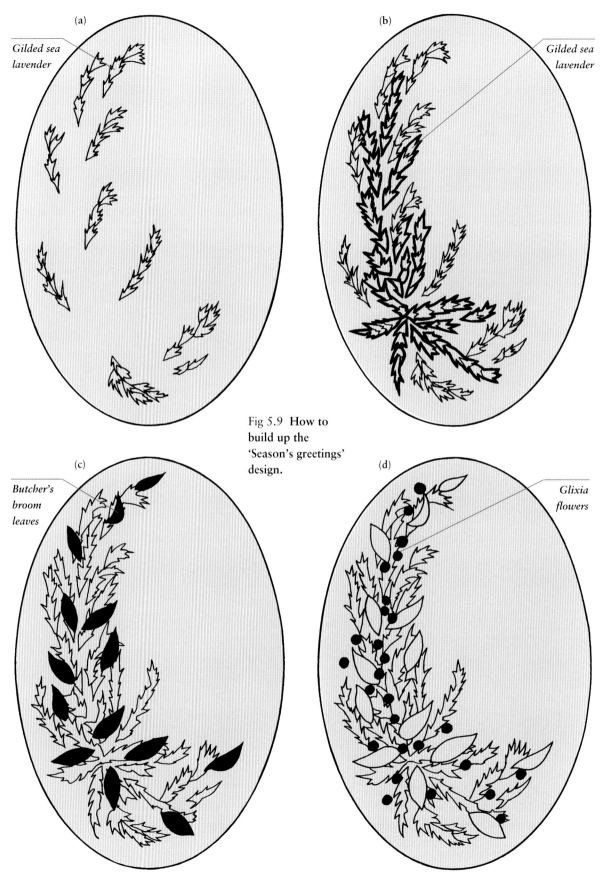

(a)

Gilded sea
lavender

(b)

Gilded sea
lavender

Fig 5.9 How to
build up the
'Season's greetings'
design.

(c)

Butcher's
broom
leaves

(d)

Glixia
flowers

leaves lightly into the glue and tuck these into the spaces within the sea lavender (c). Finally dip the stems of the red and green glixia flowers into the glue and tuck these also into the sea lavender at intervals (d).

As a final touch, apply your dry transfer 'Season's Greetings' message in the space below the oval.

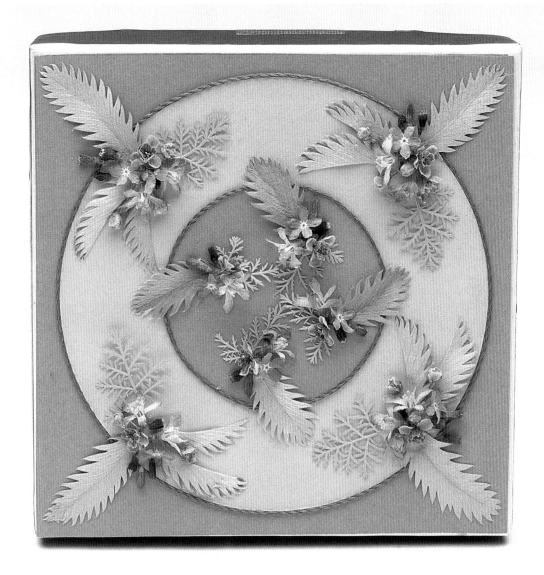

Fig 5.10 **Adapt greetings card designs to liven up a plain gift box: assemble your collage on a circle of card and glue this to the lid of the box, edging the perimeter of the card with thin piping cord.**

DECORATED PICTURE FRAMES

Have you ever bought a simple wooden picture frame which turned out to be just too plain? It does not take long to add interest and texture to a plain frame with some carefully chosen preserved leaves and flowers. I decided to give the two picture frames shown in Fig 5.11 particularly special treatment, as the photographs they display are of my husband and nephew.

Fig 5.11 Two plain picture frames with added collage decoration.

FRAME 1

MATERIALS

Plain wooden picture frame
All-purpose clear glue

<u>PLANT MATERIAL</u>

PRESERVED IN DESICCANT
Copper beech leaf buds

AIR DRIED
Sea lavender
Alder cones

GLYCERINED
Box leaves
Pittosporum leaves

METHOD

Follow the stages shown in Fig 5.12 to build up the collage, starting off with the copper beech buds to set out the main shape of the design (a). The sprigs of sea lavender should be positioned next (b), between the copper beech buds. Fill in further with the box and pittosporum leaves (c), adding the alder cones as a finishing touch (d).

FRAME 2

MATERIALS

Plain wooden picture frame
Thin, gold cord
All-purpose clear glue

<u>PLANT MATERIAL</u>

Acacia seed pods
Acacia seeds
Very small gum tree seed pods

METHOD

Follow the stages shown in Fig 5.13 to build up the collage. Begin by fixing on the gold cord (using all-purpose glue) around the aperture of the frame, making a decorative loop at each corner (a). Join at the bottom left hand corner, where it will be hidden by the plant material.

Next glue on various lengths of *Acacia* seed pods at the top right and bottom left hand corners (b). Add sprays of gum tree seed pods in both corners (c), then attach some more small *Acacia* pods, flanked by loops of gold cord (d). Finish the design by gluing individual *Acacia* seeds into the recesses of the longer *Acacia* pods.

<u>**HELPFUL HINT**</u>

Keep the decorated picture frame free of dust by brushing gently with a child's soft paintbrush.

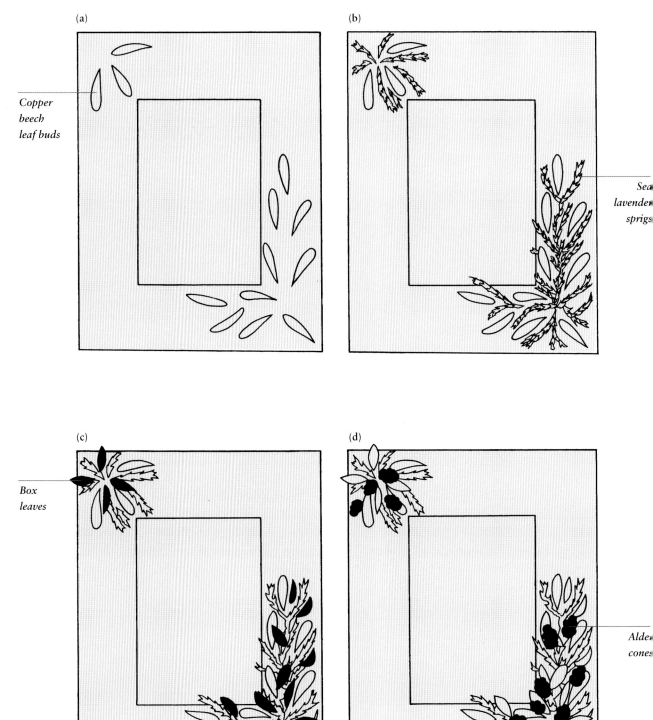

(a)

Copper
beech
leaf buds

(b)

Sea
lavender
sprigs

(c)

Box
leaves

Pittosporum
leaves

(d)

Alder
cones

Fig 5.12 Frame 1: how to build up the collage design.

(a)

(b)

Gold
cord

Acacia
seed pods

(c)

(d)

Small Acacia
pods

Acacia
seeds

Gold cord

Gum tree
pods

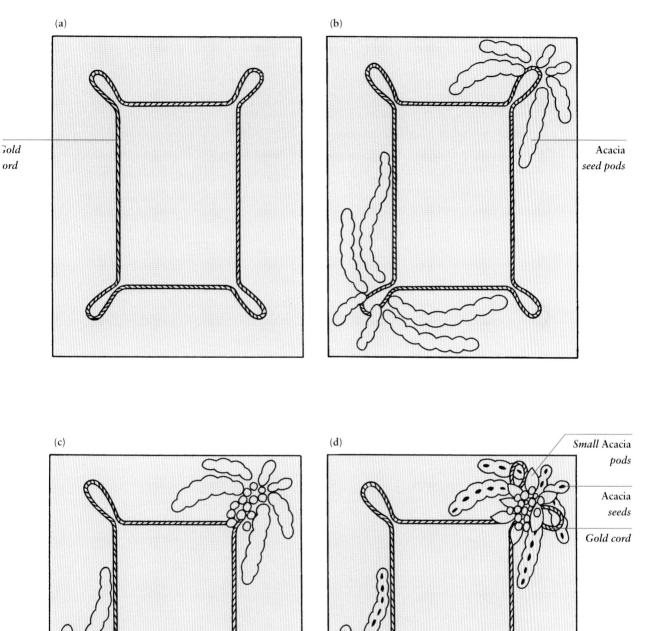

Fig 5.13 Frame 2: how to build up the collage design.

NAPKIN RINGS AND PLACE CARDS

In the run-up to a big family celebration, birthday dinner, wedding, or even perhaps just a special dinner for two, it is well worth finding time to make your own napkin rings and place cards. They add a very personal touch to the dinner table, and if there is a large number to be made, other family members can always be roped in to help. Both rings and cards are simple to make and need not involve elaborate quantities or arrangements of plant material. Once you have successfully completed a few rings or cards, you will find the whole process speeding up very satisfactorily.

The samples shown in Fig 5.14 are made to only one possible design among many, but the patterns given on the following pages can be adapted to fit in with the occasion and other table decorations. For a wedding, the napkin rings could be trimmed with silver cord or decorated to reflect the bride's bouquet and bridesmaids' dresses.

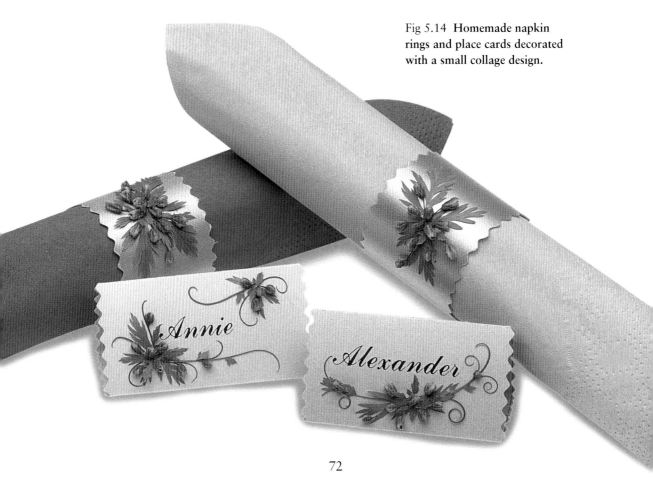

Fig 5.14 **Homemade napkin rings and place cards decorated with a small collage design.**

NAPKIN RING

METHOD

Fig 5.15 shows each stage involved in making up the napkin ring.

To make an average sized ring, cut the coloured card to the dimensions shown in (a). Bend to make a tube and glue the ends together with all-purpose glue, allowing about 1cm (⅜in) overlap (b). Cover the card tube tightly with a 13cm (5⅛in) length of florist's ribbon (c), applying glue only to the overlap. Trim the edges of the covered tube with pinking shears if desired (d), or decorate the edge with cord if you prefer.

The rest is simple: using PVA glue, fix a few pressed carrot leaves into position (e) as the basis for the collage, then highlight this with the barberry flowers (f). Carrot leaves make an excellent foundation for such small collages, but you can replace the barberry flowers with whatever is most suitable for the occasion.

(a) 4cm (1⅝in) 13cm (5⅛in)

(b) 1cm (⅜in) overlap Card

(c) Florist's ribbon

(d) Edge trimmed with pinking shears

(e) Carrot leaves

(f) Barberry flowers

Fig 5.15 Creating and decorating the napkin ring.

PLACE CARD

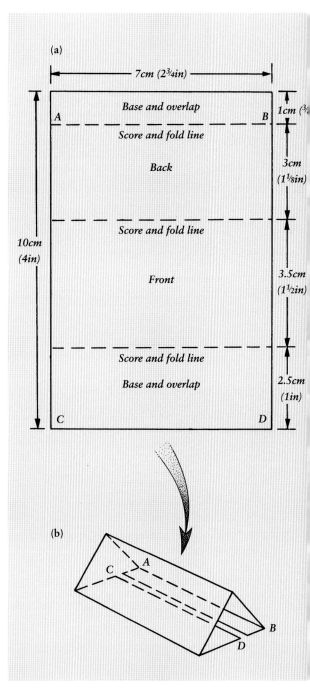

(a)

7cm (2¾in)

A — Base and overlap — B 1cm (¾

Score and fold line

Back

3cm (1⅛in)

Score and fold line

10cm (4in)

Front

3.5cm (1½in)

Score and fold line

Base and overlap

2.5cm (1in)

C D

(b)

METHOD

All the stages involved in making up a place card are shown in Fig 5.16.

Cut a piece of coloured card to the overall dimensions of 10 x 7cm (4 x 2¾in) shown in (a) and trim the edges with serrated paper scissors if desired.

Using a craft knife, score gently along the three fold lines indicated, taking care not to cut through the card completely. Note that the front section is slightly larger than the back. Test the card out by folding along the lines (b) – the two base flaps will be glued together right at the end – and then open out flat once again.

Print the name in the centre front of the place card (c), using dry transfer lettering or writing by hand. Position a few sweet pea tendrils around the lettering (d) to give the main lines of the collage, followed by small pressed carrot leaves in the centre of each flourish (e). Complete the collage with the barberry flowers (f).

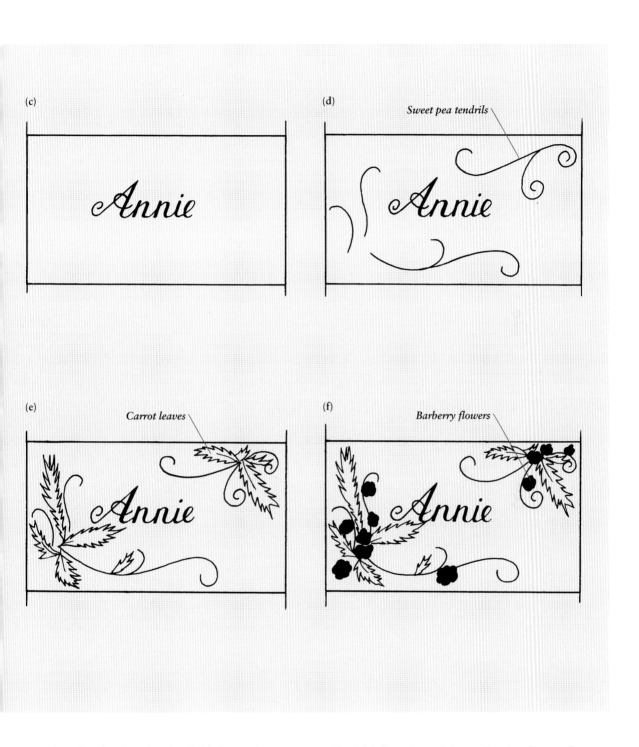

Fig 5.16 **Creating and decorating the place card.**

When the glue has dried, refold the card as shown in Fig 5.16b and glue the two base flaps together with all-purpose glue, making sure that points A and C, and B and D, meet exactly.

BASKETWARE DECORATION

The muted colours of basketweave boxes lend themselves very well to additional decoration with preserved plant material (*see* Fig 5.17), and offer the opportunity to make a simple gift into something more special.

MATERIALS

Circular basketweave box
Thin card in an appropriate colour
All-purpose clear glue
Sewing thread
(optional)
Strong needle
(optional)

PLANT MATERIAL

GLYCERINED

Leyland cypress
Box
Butcher's broom

AIR DRIED

Golden chain seed pods
Delphinium seed pods
Beech nut shells
Small alder cones
Larch cone

Fig 5.17 **A decorated basketweave box.**

METHOD

Cut a circle of thin card measuring approximately one-third of the diameter of the box lid, then follow the stages shown in Fig 5.18 to build up the collage.

First fix the card circle to the centre of the box lid (a). If a temporary arrangement is desired,

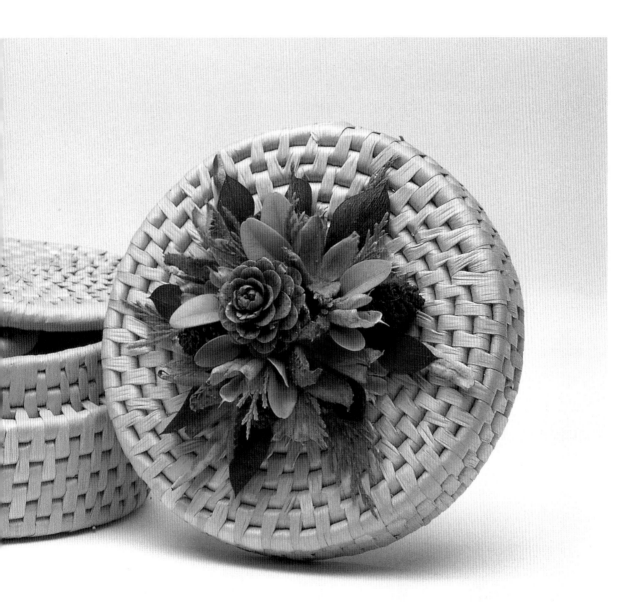

stitch the card to the lid with a couple of stitches through the centre of the card, but if the collage is to be permanent, use a strong, quick drying glue instead.

Start the collage off by gluing a balanced base ring of plant material to the card (b) – using three small sprigs of leyland cypress, three golden chain seed pods and six delphinium seed pods. Then begin to fill in the central part of the card (c) with beech nut shells and alder cones.

Complete the design with leaves of butcher's broom and box, placing the larch cone last of all in the centre (d).

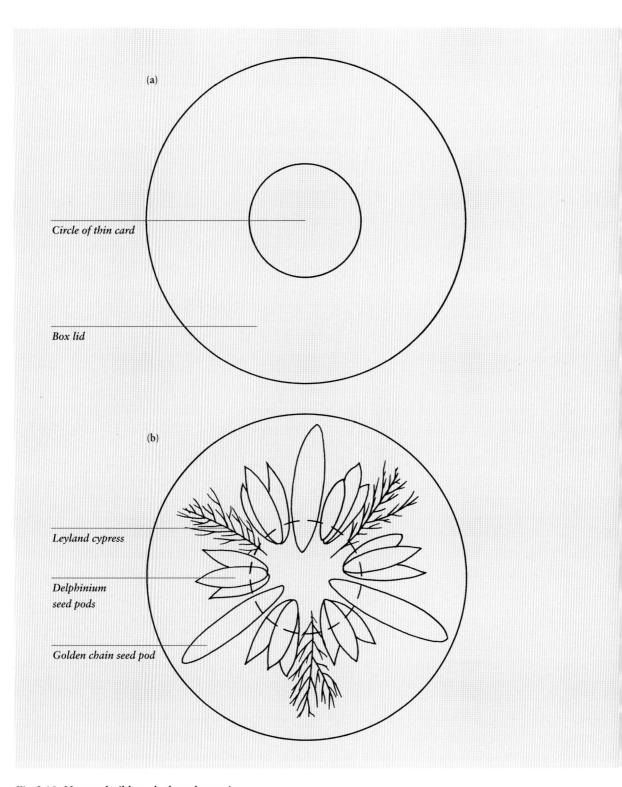

(a)

Circle of thin card

Box lid

(b)

Leyland cypress

Delphinium
seed pods

Golden chain seed pod

Fig 5.18 How to build up the box decoration.

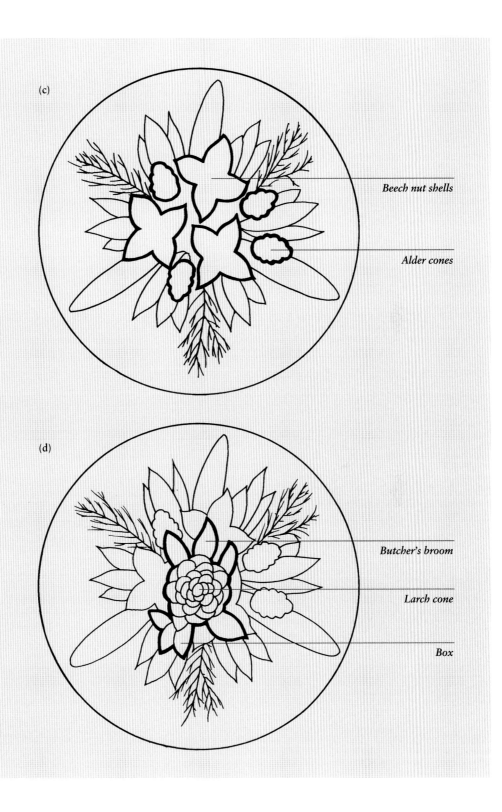

(c)

Beech nut shells

Alder cones

(d)

Butcher's broom

Larch cone

Box

PINCUSHION

Pincushions are often dull and utilitarian objects, but it can be fun to decorate one with real flowers and leaves. Such an unexpected present can give real pleasure, and you can guarantee that there won't be another one like it. Remember, however, to exercise restraint with the collage and leave room for the pins!

I made the pincushion shown in Fig 5.19 in 1991 for a national exhibition and competition in the class entitled 'One Hundred Years Ago'. The names are those of my mother and mother-in-law. Of course, you can adapt the design to suit whatever you have in mind.

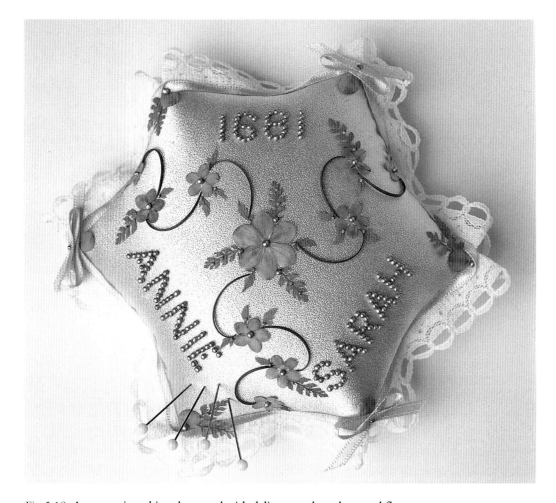

Fig 5.19 **A pretty pincushion decorated with delicate seeds and pressed flowers.**

MATERIALS

Cream satin 40 x 20cm (16 x 8in)
Cream lace 70cm long and 1.5cm wide ($27^5/8$ x $^5/8$in)
Coloured ribbon 1m long and 5mm wide (40 x $^3/16$in)
Filling (wadding or sawdust)
White paper 20 x 20cm (8 x 8in)
Cream sewing thread
PVA glue
Dressmaking pins

PLANT MATERIAL

PRESSED	AIR DRIED
Forget-me-not flowers	Crane's bill seed pods
Soft shield fern	Rape seeds (silver gilded)
Sweet pea tendrils	Poppy seeds
Lilac flowers	

METHOD

Fig 5.20 shows the stages of putting together and decorating the pincushion.

First make a template for the hexagon shape shown in (a) and then cut out two hexagons from the cream satin. Place the two pieces with right sides together and hand sew or machine them together on five sides only. Turn right side out and stuff the shape as tightly as possible with either wadding or sawdust. Sew the sixth side of the hexagon together with very close stitches so that none of the tightly packed filling can escape.

Stitch lace all the way round the edge of the pincushion to cover the seams (b) and then glue coloured ribbon along the top edge of the lace (*see also* Fig 5.19). Make three tiny bows of ribbon and use dressmaking pins to fix these on alternate corners.

Make a template for each word you want to include (in my case two names and a date) according to the method given on page 37, and use the templates (c) to guide the placing of silver gilded rape seeds to form the letters (*see also* the section on fixing small seeds on page 39). If you make the templates from paper not card, they can be pinned accurately on to the stuffed pincushion. Remove the templates when the glue is dry.

Complete the pincushion decoration with the central design (d) using sweet pea tendrils, soft shield fern leaves, lilac and forget-me-not flowers and crane's bill seed pods.

If you are giving the pincushion as a gift, you could decorate the presentation box lid with a matching collage.

HELPFUL HINT

Sawdust will make a much firmer filling for a pincushion than wadding, but it must be completely dry before use.

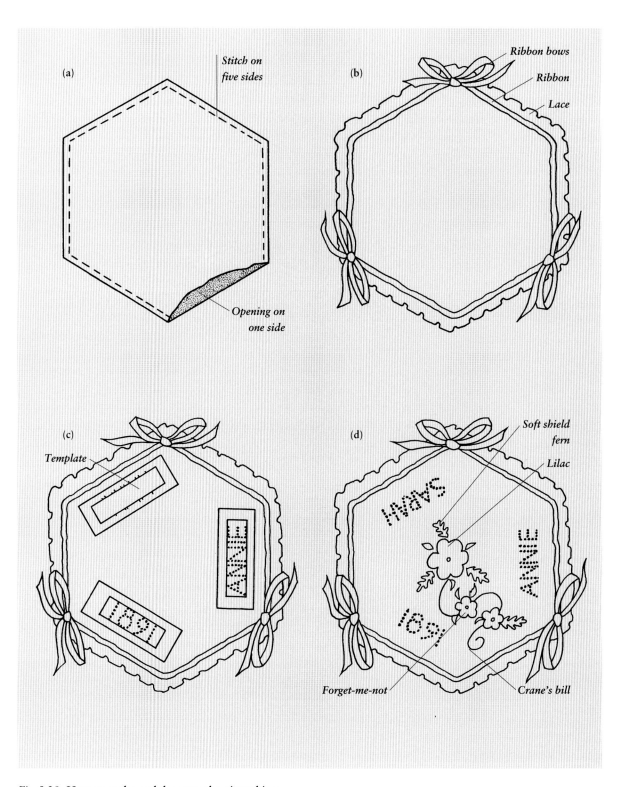

Fig 5.20 **How to make and decorate the pincushion.**

SEED COLLAGE

The use of seeds in a collage offers much more potential for creativity than simply sticking to flowers and leaves. Seeds can produce narrow, straight lines, shaded areas or stylized flowers (*see* Fig 6.1). Why not try your own experiments?

The enormous variety in colour, shape and size of seeds makes it possible to create intricate-looking collages from basically simple patterns (*see* 'Twosome', pages 86–7, and 'Patience', pages 90–1). Contrasting fabric and gilded seeds will add extra interest to a design (*see* 'Blue Rhapsody', page 94), and a few gilded seeds can highlight a plain fabric bookmark.

The seed collage designs in this chapter are only the beginning of the possibilities opened up by the use of seeds. As you progress through the next few chapters you will find that the projects require

many different techniques of increasing complexity. There is always something new to discover and enjoy, whether it is placing seeds in an even line, gilding, shading, using contrasting fabrics, shaping seed covered card or imitating embroidery effects. Once you have mastered the art of handling the tiny seeds (*see* page 39), anything is possible with a little imagination.

HELPFUL HINT

Do not fix anything down until you are satisfied that it is in the right place. Once glued on, the seed cannot be moved without leaving an unsightly mark.

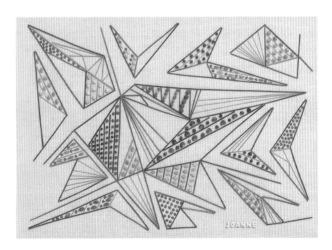

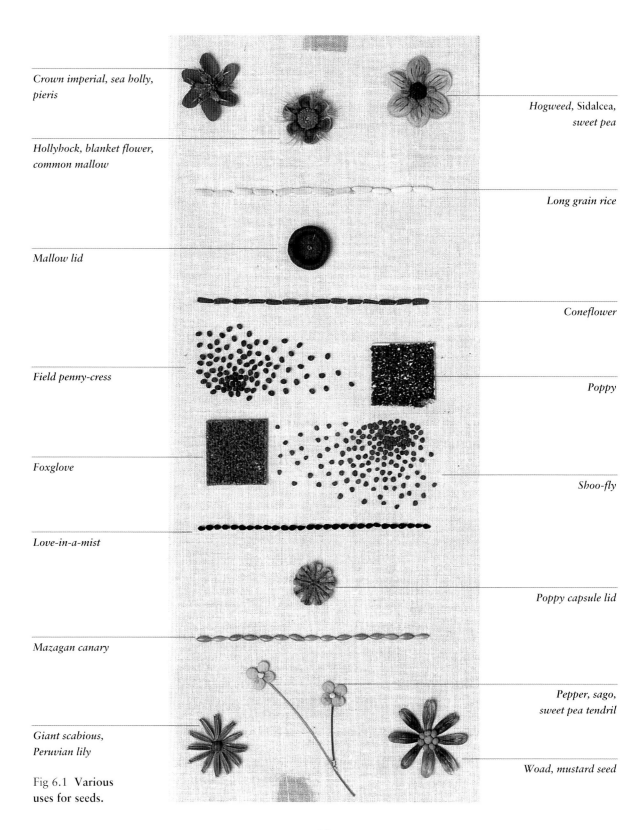

Crown imperial, sea holly, pieris

Hogweed, Sidalcea, sweet pea

Hollyhock, blanket flower, common mallow

Long grain rice

Mallow lid

Coneflower

Field penny-cress

Poppy

Foxglove

Shoo-fly

Love-in-a-mist

Poppy capsule lid

Mazagan canary

Pepper, sago, sweet pea tendril

Giant scabious, Peruvian lily

Woad, mustard seed

Fig 6.1 Various uses for seeds.

SEED 'PICTURES: 'TWOSOME'

The seed collage pictures I have hanging in my house invariably draw the eyes of guests because they are so unusual. A closer look has them wondering at the intricacy that has been achieved from such easily overlooked products of the garden.

You need not use exactly the same selection of seeds as I did to create the two complementary collages shown in Fig 6.2. The fun is in playing around with the effects produced by different combinations of seeds. I made these collages as experimental designs, and my only guidelines were the basic outlines shown in Figs 6.3a and 6.3b. The details of each design were filled in 'freehand', determined by the shapes and shades of the seeds I had.

MATERIALS

FOR EACH COLLAGE

Thick card or hardboard 20 x 15cm
(8 x 6in)
Cream cotton fabric 25 x 20cm (9¾ x 8in)
White paper 15 x 10cm (6 x 4in)
All-purpose clear glue
PVA glue
Glazed, recessed picture frame or box

PLANT MATERIAL

SEEDS	GILDED SEEDS
Love-in-a-mist	Shoo-fly
Linseed	Millet
Summer hyacinth	Mazagan canary
Alexanders	
Watermelon pips	STEMS
Black sunflower seeds	Glixia
Poppy capsule lids	Cat's-tail

METHOD

The two patterns in Figs 6.3a and 6.3b set out all the details of the seed combinations, but the method is the same for each picture.

First prepare the backing, covering the card or hardboard with the cream fabric as described on pages 27–30. Secure the fabric on three sides only, leaving the fourth open so that the pattern can be slipped in. Trace the main shapes of the design from Fig 6.3a or 6.3b and strengthen the pattern with a black fibre tip pen. Slide this underneath the fabric and make sure the pattern is centrally placed.

Glue love-in-a-mist seeds over the main lines of the pattern as indicated. When the glue is dry, remove the paper pattern and secure the final edge of fabric. Complete the design 'freehand' using the seeds indicated on the diagrams or another combination of your choice, depending on what you have to hand. If you are using black sunflower seeds, they are easier to keep in place when sliced in half with a craft knife – but watch your fingers.

See Appendix 1 on pages 152–4 for advice on framing and mounting finished collages.

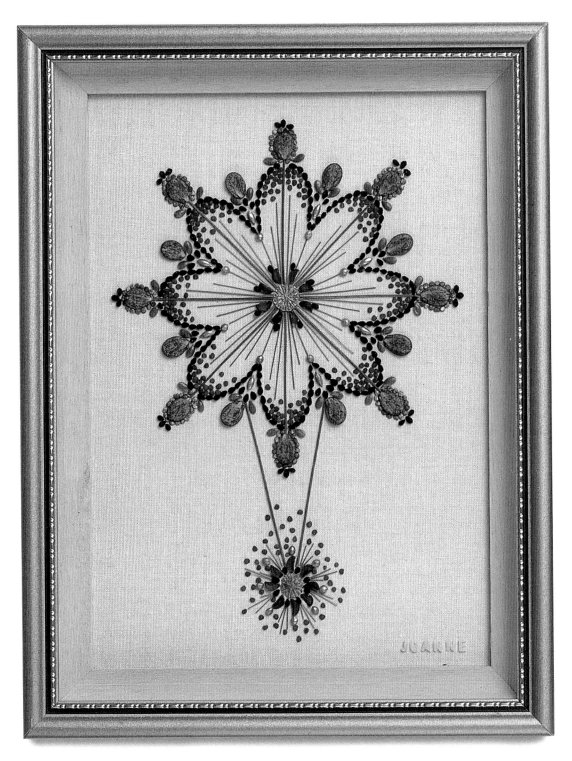

Fig 6.2 'Twosome': this pair of seed collage pictures shows off the variety of effects which can be achieved using different combinations of seeds.

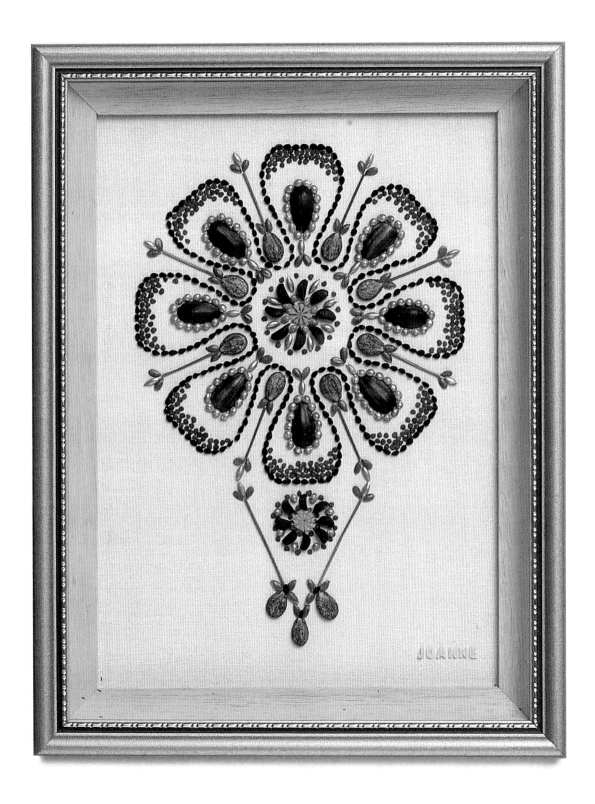

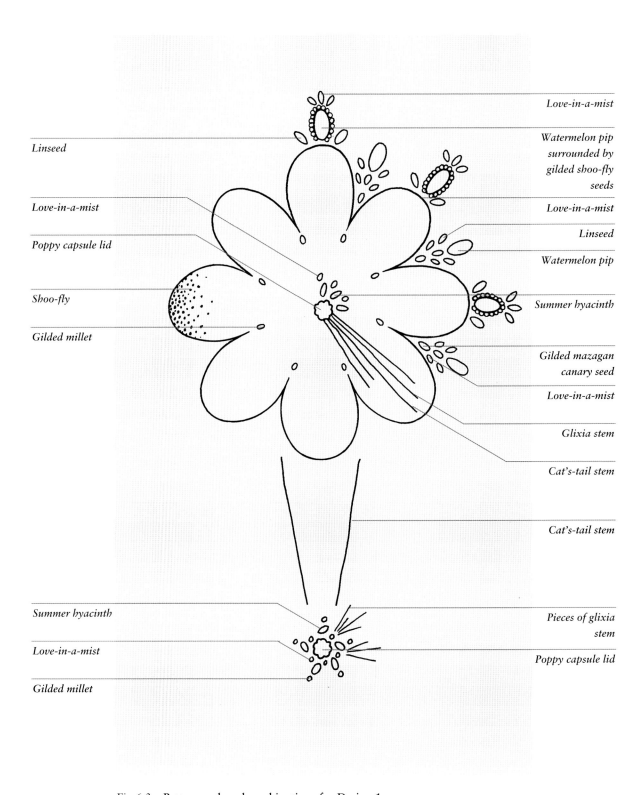

Love-in-a-mist

Watermelon pip
surrounded by
gilded shoo-fly
seeds

Linseed

Love-in-a-mist

Love-in-a-mist

Poppy capsule lid

Linseed

Watermelon pip

Shoo-fly

Summer hyacinth

Gilded millet

Gilded mazagan
canary seed

Love-in-a-mist

Glixia stem

Cat's-tail stem

Cat's-tail stem

Summer hyacinth

Pieces of glixia
stem

Love-in-a-mist

Poppy capsule lid

Gilded millet

Fig 6.3a Pattern and seed combinations for Design 1.

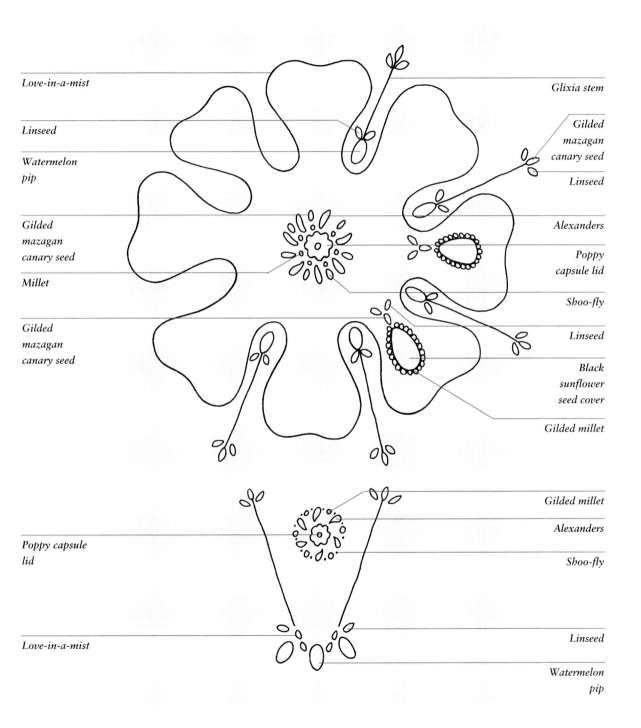

Love-in-a-mist

Linseed

Watermelon
pip

Gilded
mazagan
canary seed

Millet

Gilded
mazagan
canary seed

Glixia stem

Gilded
mazagan
canary seed

Linseed

Alexanders

Poppy
capsule lid

Shoo-fly

Linseed

Black
sunflower
seed cover

Gilded millet

Gilded millet

Alexanders

Shoo-fly

Poppy capsule
lid

Love-in-a-mist

Linseed

Watermelon
pip

Fig 6.3b **Pattern and seed combinations for Design 2.**

SEEDS AND STEMS
DESIGN: 'PATIENCE'

Sometimes seeds on their own are not
enough to create an exciting design, but
using stems as well can help add definition
and structure to a collage, opening up
possibilities of sharp angles and clean lines
as well as the more intricate patterns
formed by the seeds. The collage shown
in Fig 6.4 demonstrates what can be done.
The basic idea is really very simple, but
the stems need to be cut with considerable
accuracy to avoid unsightly overlaps,
hence the title 'Patience'.

MATERIALS

Thick card or hardboard 18 x 23cm
(7 x 9in)
Cream cotton fabric 22 x 27cm
(8¾ x 10⅝in)
PVA glue
All-purpose clear glue
Recessed, glazed frame

PLANT MATERIAL

SEEDS	
Sesame	Rape
Millet (red and	Peruvian lily
white)	Turnip
Mallow	Grape hyacinth
Dill	
Shoo-fly	*STEMS*
Linseed	Cat's-tail
	Glixia

Fig 6.4 'Patience': a geometric collage using stems and
seeds.

90

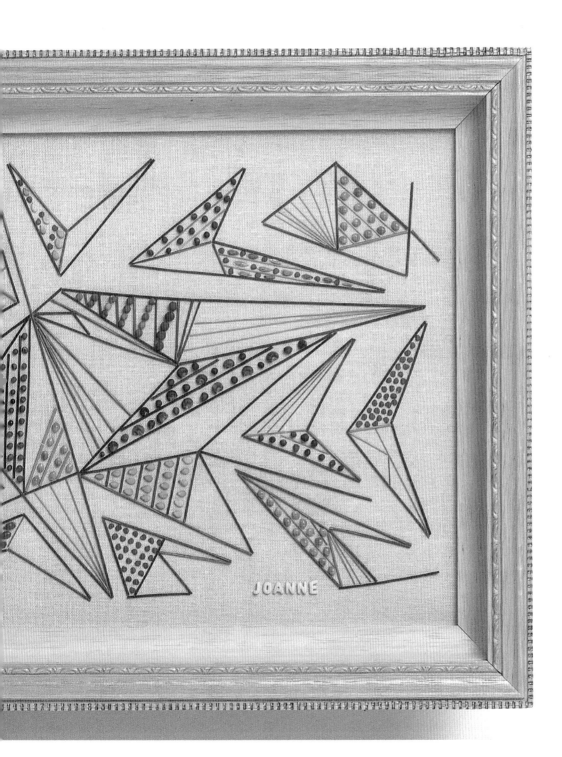

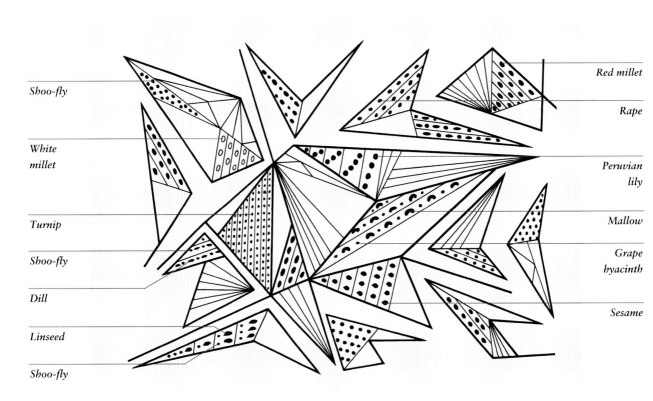

Shoo-fly

White
millet

Turnip

Shoo-fly

Dill

Linseed

Shoo-fly

Red millet

Rape

Peruvian
lily

Mallow

Grape
hyacinth

Sesame

Fig 6.5 Pattern for the 'Patience' design (*see* page 159 for full-size pattern).

METHOD

Cover the card or hardboard with the fabric using the methods described on pages 27–30 and securing the fabric on three sides only. If you wish to follow my design exactly, trace over the shapes made by the cat's-tail stems as shown in Fig 6.5 (a full-size pattern is shown on page 159). Alternatively, sketch out the main lines of a design of your own. Go over the lines with a black fibre tip pen and slip the paper pattern underneath the fabric.

Measure each length of cat's-tail to fit exactly over the lines of the pattern, cutting at an angle where necessary. A 'dry run' is definitely advisable on this occasion, or you will run the risk of sticking a stem down in the middle of the collage, finding it is too long and having to fiddle around with a craft knife trying to cut the end off

without damaging anything else. When you are satisfied that everything will fit, stick the cat's-tail stems down, using a dot of PVA glue just at the ends of each stem (*see* page 50). When the pattern lines are all covered and the glue is dry, remove the paper pattern and secure the final edge of fabric.

Using Figs 6.4 and 6.5 as guidelines, and also your own judgement as to balance, cut and fit glixia stems into the desired areas. Still without using any glue, position the seeds as required to ascertain the best distance apart and the best arrangements between the stems. Glue the pieces down only when you are sure of their placement.

Frame the finished collage as you wish – a natural wood frame tends to set off collages of naturally coloured plant material best. Take care that the recess is deep enough to avoid the danger of crushing the seeds with the glass.

SEED AND FABRIC COMBINATIONS: 'BLUE RHAPSODY'

As with 'Twosome', the 'Blue Rhapsody' design (Fig 6.6) was also experimental. I wanted to create the simplest of designs but use more than one technique. Using a compass and pencil I divided a 15cm (6in) diameter circle into six petal shaped segments and superimposed six smaller petal shapes on an 11.5cm (4½in) diameter. As I gradually added the love-in-a-mist seeds, I felt that the design needed a deeper shade of blue fabric somewhere within it, and this was introduced into the larger petal shapes. Silver painted seeds gave a good contrast to the black.

The design need not be based on blue. Why not try different colour schemes – perhaps brown and gold seeds on cream and rust fabric, brown and copper on two shades of green, or black and silver on two shades of pink?

MATERIALS

Thin card 18 x 18cm (7 x 7in)
Hardboard 23 x 23cm (9 x 9in)
Pale blue polycotton fabric 23 x 23cm (9 x 9in)
Medium blue polycotton fabric 28 x 28cm
(11 x 11in), plus extra for the petal shapes
A scrap of white, iron-on Vilene interfacing
PVA glue
All-purpose glue
Unglazed frame to fit hardboard 23 x 23cm (9 x 9in)

PLANT MATERIAL

SEEDS	*SILVER GILDED SEEDS*
Love-in-a-mist	Millet
Columbine	Sesame
Black sunflower	Mazagan canary
Cow parsley	Poppy
Grape hyacinth	
Crane's bill seed pods	*STEMS*
Oriental poppy capsule lid	Glixia

Fig 6.6 'Blue Rhapsody': a collage of seeds and coloured fabric.

METHOD

Cover the thin card with pale blue polycotton, using the method described on page 30 and securing the fabric on three sides only. Trace the outline of the design as shown in Fig 6.7a, go over the lines with a black fibre tip pen, and slip the paper pattern underneath the fabric. Glue love-in-a-mist seeds over the lines of the larger petal shapes (see Fig 6.8), columbine seeds over the smaller petal shapes and grape hyacinth seeds round the central circle. Remove the paper pattern and fix the fabric to the backing on the fourth side.

Fig 6.7a **Main outlines for the 'Blue Rhapsody' design.**

To make the fabric infills for the petal shapes, trace the shape made by the continuous lines (not the dotted ones) in Fig 6.7b and cut out a template from thin card. You will need six of these shapes, so take a large enough piece of medium blue polycotton to accommodate all six and reinforce it with iron-on Vilene interfacing. Use the template to mark on and cut out the shapes from the fabric.

Glue the blue fabric shapes in place within the larger petals (*see* Figs 6.6 and 6.8). You will only need to use a small amount of PVA glue around the extreme edge of the fabric. Cover the join with a line of silvered sesame seeds, adding half a black sunflower seed pod and three cow parsley seeds tipped with one silvered poppy seed for decoration (*see* Fig 6.8).

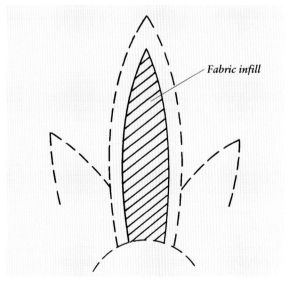

Fabric infill

Fig 6.7b **Outline for the fabric infill shape.**

Millet

Millet

Crane's bill
seed pod

Oriental poppy
capsule lid

Grape hyacinth

Columbine

Sesame

Mazagan canary

Sesame

Blue fabric

Mazagan canary

Millet

Sunflower seed

Glixia stems

Cow parsley

Poppy seed

Love-in-a-mist

Fig 6.8 **Pattern of seeds used for the 'Blue Rhapsody' design.**

Complete the design as shown in Fig 6.8 with silvered mazagan canary, millet and an oriental poppy seed capsule lid in the centre circle. In the smaller petal shapes, position three glixia stems tipped with two crane's bill seed pods plus mazagan canary, millet and sesame seeds.

When the glue is dry, mount on to hardboard covered with medium blue polycotton and frame if desired (I used a black frame for my design).

HELPFUL HINT

Although Vilene helps to protect the polycotton against staining caused by excess PVA glue, it is advisable to test a piece of the fabric before using it in a design to make sure that the results are satisfactory.

EMBELLISHMENT

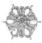

Gilded seeds (*see* pages 24–6) can play an important part in the creation of ecclesiastical embroidery effects in collage and also in the embellishment of other items such as bookmarks and illuminated lettering. Gold painted seeds, seed pods and leaves are the most attractive, but using copper or silver paint as alternatives can sometimes add an extra spark of interest. Practise your gilding skills with the bookmark on page 99, or a gift box such as the one shown in Fig 7.1, and then you can develop the technique as you wish, perhaps with a larger Bible marker for a flower festival, pew ends or, for the adventurous, a full size altar frontal.

Fig 7.1 **Gilded plant material can be used to give a festive air to a plain gift box.**

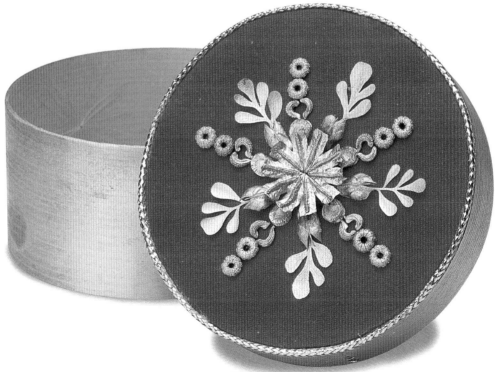

GILDED BOOKMARK

Bookmarks, as you will have seen in earlier chapters, can be decorated in all sorts of ways, and using gilded plant material is another option which can produce a very rich effect without being too complicated. If you are thinking of creating something grand like the Bible marker featured on page 104, it might be as well to try out ideas on a smaller bookmark first.

The bookmark shown in Fig 7.2 has five individual motifs which have been designed to complement each other. They are readily adaptable to other uses and look attractive in various combinations. Details of the five designs are given in Fig 7.3.

MATERIALS

Coloured fabric 45 x 15cm
($17\frac{3}{4}$ x 6in)
Thin white card 30 x 6cm
($11\frac{3}{4}$ x $2\frac{3}{8}$in)
Thin card 25 x 5cm ($9\frac{3}{4}$ x 2in)
PVA glue
Spray paint (gold, silver and copper)

PLANT MATERIAL

SEEDS

Poppy or foxglove
Mazagan canary
Sesame
Lavender
Millet
Common mallow
Allium giganteum
Marigold

Peruvian lily
Rape
Honeydew melon

SEED CAPSULE LIDS

Poppy
Mallow

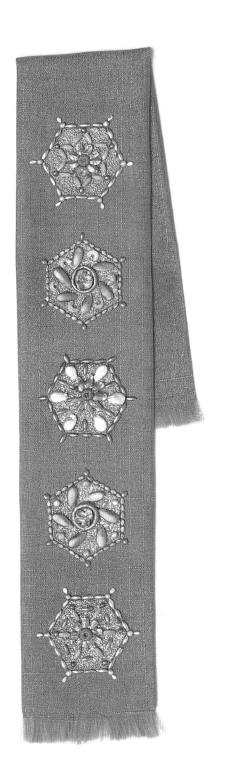

HELPFUL HINT

Two silver decorated hexagons on wide white ribbon would make a decoration for a bride's prayer book as an alternative to carrying a bouquet.

METHOD

Make a basic fabric bookmark as described on page 59.

Decide what size your hexagon shapes are to be and draw five hexagons close together on a piece of thin card. Turn the card on to its reverse side, spread with PVA glue and cover thickly with poppy or foxglove seeds (advice on this technique is given on pages 40–1). When the glue is completely dry (leave overnight if possible) shake off the surplus seeds and spray the seed-covered card with metallic spray paint. Allow the paint to dry, then cut out the hexagon shapes.

Position the shapes an even distance apart on the fabric bookmark and glue on. It is best to leave the glue for about an hour to dry properly before continuing with the collage, and you will find that it is worthwhile weighting the bookmark down with a heavy book to ensure that the hexagons adhere firmly to the fabric.

While the glue is drying, select all the seeds you wish to use to embellish the five hexagons and gild as described on pages 24–6. Then use the diagrams in Fig 7.3 as guidelines for your designs. Remember to lay the seeds out on each hexagon in a 'dry run' before fixing down.

HELPFUL HINT

Do not soak the card with glue, or it may buckle and become uneven when dry.

Fig 7.2 **A bookmark decorated with gilded seeds.**

Sesame

Peruvian lily

Mazagan canary

Lavender

Poppy capsule lid

Rape

Common mallow

Millet

Marigold

Honeydew melon

Allium
giganteum

Sesame

Mallow lid

Fig 7.3 **Patterns and
seed combinations used
for the five hexagonal
designs.**

Mazagan canary

Watermelon

Common
mallow

Poppy capsule lid

Millet

Sesame

Peruvian lily

Honeydew melon

Allium giganteum

Mallow lid

Sesame

Peruvian lily

Lavender

Mazagan canary

Common mallow

Poppy capsule lid

Rape

BIBLE MARKER

It is only a small step to advance from a gilded bookmark to an impressive Bible marker for use with a lectern Bible. I have made several large Bible markers for church flower festivals, but they could, of course, be used all year round.

The decoration on the three Bible markers shown in Fig 7.4 is based in each case on the same, elongated star shape. For the mauve and silver marker the seeds are glued on around a template card which is then removed to allow the design to be finished freehand. For the other two a solid background is made from card covered with gilded seeds, on to which the rest of the embellishment is fixed. Instructions for making the cream and gold marker (*see* Fig 7.5) are given overleaf.

MATERIALS

Thick card 38 x 12cm (15 x 4¾in)
Cream fabric – cotton, or satin for a special
occasion – 75 x 28cm (29⅝ x 11in)
Thin card at least 24 x 10cm (9½ x 4in)
Gold spray paint
PVA glue
Silk tassel (optional)

PLANT MATERIAL

SEEDS	
Poppy	Turnip
Cress	Sunflower
Mazagan canary	Rape
Hollyhock	*SEED CAPSULE LID*
Millet	Poppy

OTHER MATERIAL

Dried spaghetti noodles in floral, ring and T shapes

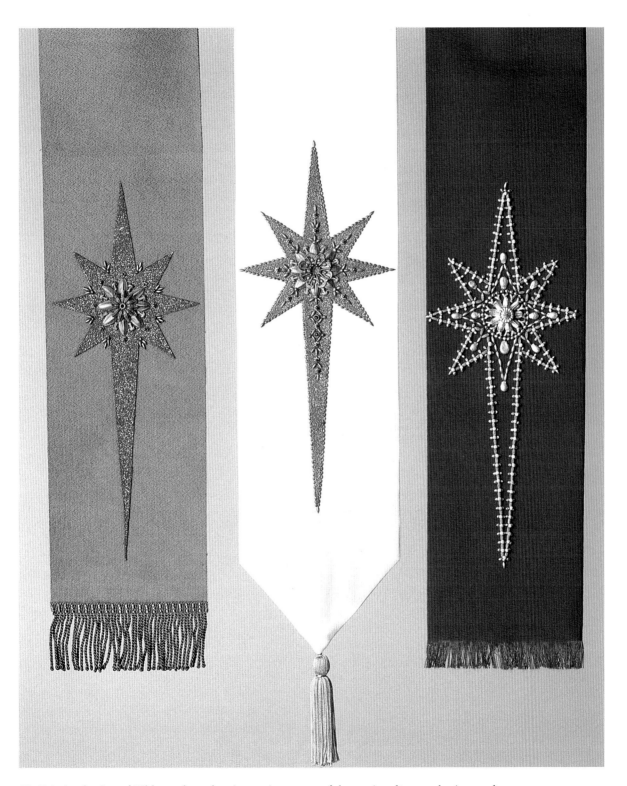

Fig 7.4 A selection of Bible markers showing various ways of decorating the same basic star shape.

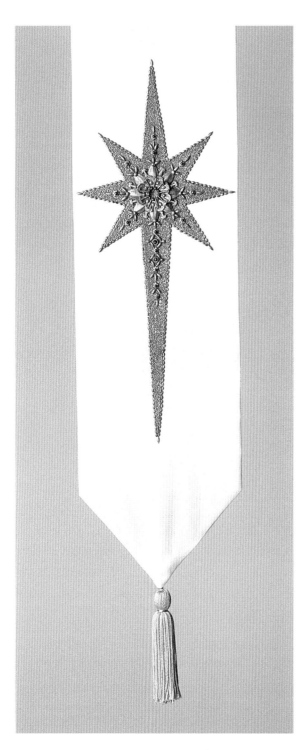

Fig 7.5 **The clean lines of the star design and the opulence of the gilded decoration stand out clearly against the cream background of this Bible marker.**

METHOD

Make the basic fabric backing for the marker in the same way as for a normal-sized fabric bookmark (*see* page 59), fringing the bottom if you want it to be square-ended. As an alternative, you can make a V-shaped end as in Fig 7.5. To do this, fold the fabric in half lengthwise (with the wrong side facing outwards) and sew the two edges together. Press the seam open and then, still with the tube inside out, fold it so that the seam is at the centre back. Stitch a V shape at the bottom end of the marker and cut away any excess fabric. Turn the tube right side out, press flat and slip the strengthening card inside, cut with a matching V shape at the bottom end.

Next copy the elongated star shape (*see* Fig 7.6, and the full-size pattern on page 160) on to the thin card, turn this over to its reverse side and cover with poppy seeds (*see* instructions for covering hexagons page 99, also gilding section pages 24–6). Shake off the surplus seeds when the glue has dried and spray the covered card with metallic gold paint. Once the paint is dry, turn the card back over and cut out the star shape with scissors.

Glue the star shape in position on the fabric marker and leave to dry, weighted down with a heavy book. While this is happening, pick out the rest of the seeds for the collage, plus a large poppy seed capsule lid and the shaped spaghetti noodles, and spray them all with gold paint. The sunflower seeds will need to be split in half before spraying.

When everything is ready, glue gilded cress seeds all the way round the edge of the star shape, with one mazagan canary seed at each apex to give a

HELPFUL HINT

When cutting out the star shape, cut carefully from the apex of each point towards the centre, but watch that you do not cut too far in.

finer point. All the pattern details are shown in Fig 7.6.

Next fix the poppy seed capsule lid in the centre of the star, and surround this with hollyhock seeds, tucked slightly beneath the lid. The centre of the lid can be decorated with millet and turnip seeds. Protruding from the hollyhock seeds around the poppy seed capsule, fix on half sections of sunflower seeds alternating with T-shaped spaghetti noodles. Finally extend the design towards the points of the star using mazagan canary and rape seeds, as well as circular and floral-shaped spaghetti noodles.

If your Bible marker is V-shaped at the bottom, a silk tassel could be stitched to the point of the V as a finishing touch.

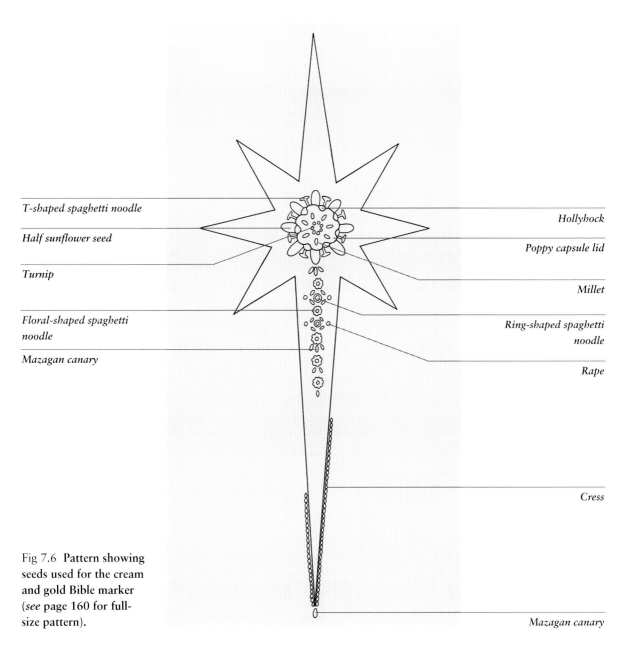

T-shaped spaghetti noodle

Half sunflower seed

Turnip

Floral-shaped spaghetti noodle

Mazagan canary

Hollyhock

Poppy capsule lid

Millet

Ring-shaped spaghetti noodle

Rape

Cress

Mazagan canary

Fig 7.6 **Pattern showing seeds used for the cream and gold Bible marker** (*see* page 160 for full-size pattern).

ILLUMINATED LETTERING

Techniques for achieving attractive, balanced lettering were set out on pages 33–7. Once you have had some practice at the more basic types of lettering, however, you may enjoy splashing out on something rather more elaborate.

Illuminated lettering has been in use from as early as the sixth century AD. Books illustrating calligraphy are available from libraries and excellent examples can be found in old, metal-bound family Bibles.

The inspiration for my own initial J (Fig 7.7) came from a manuscript in the Bayerische Staatsbibliothek in Munich and is just one example of the sumptuous effect that can be achieved. The method is given overleaf, with the components set out in Fig 7.8. From that you will see that there is nothing particularly complicated about it, although the effect is of something highly intricate. For your first attempt, select a simple design from a book of calligraphy and allow your imagination to determine the details rather than trying to make an exact copy. Whichever letter you intend to illuminate, and whether you have in mind a vastly complicated or a simple decoration, it is vital to have the pattern planned out clearly. If this is not done, you risk ending up with an unbalanced letter and top-heavy decoration.

MATERIALS

Thin card, enough to accommodate the letter
Fabric as backing, slightly larger than the card
Scrap of thin card
PVA glue

PLANT MATERIAL

SEEDS		
Foxglove		Millet
		Shoo-fly
		Turnip
GILDED SEEDS		Peruvian lily
Poppy		
Sesame		OTHER
Common mallow		Sweet pea tendrils

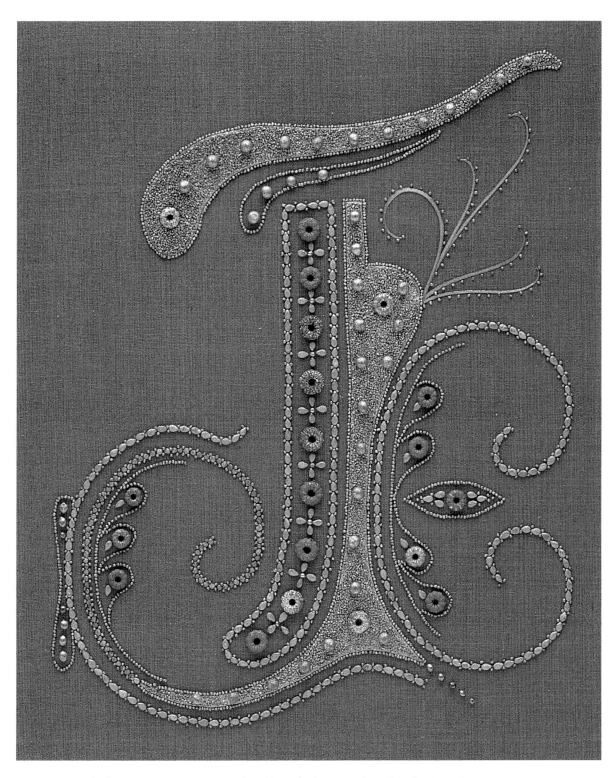

Fig 7.7 **It can be fun to go to town on a single calligraphy letter, such as this illuminated J.**

Peruvian lily

Common mallow

As 'B'

Sesame with
turnip seed centre

As 'B'

Shoo-fly with
poppy seeds

As 'C'

Millet

'A': card covered
with foxglove seeds,
surrounded by
poppy seeds

Sweet pea tendril
edged on one side
with poppy seeds

As 'A'

'B': sesame and
poppy seeds

'C': lines of
poppy seeds

Common mallow

Poppy seeds
around common
mallow and sesame

Millet

METHOD

Design your initial on a piece of white paper (or trace the J from Fig 7.8 or page 161), indicating the areas to be covered with foxglove seeds. Retrace these areas and transfer the shapes to a scrap of thin card, remembering to reverse the shapes. Cover the other side of this card with foxglove seeds, spray with metallic spray paint, leave to dry and cut out the shapes as described on page 99.

Cover the larger piece of card with your chosen fabric, securing on three sides only, and slide the paper pattern underneath the fabric. Glue the shapes covered with foxglove seeds into place, then cover the decorative lines of the initial with your selected seeds, building up a balanced design.

Fig 7.8 Pattern and seed combinations for the illuminated letter J (*see page 161 for full-size pattern*).

HELPFUL HINT

An illuminated letter in the aperture of a greetings card, either on fabric or card in a contrasting colour, would be an imaginative way to send a personal birthday or anniversary message to a friend.

WEDDING PEW ENDS

Decorative pew ends for a wedding, such as the one shown in Fig 7.9, are based on a simplified version of illuminated calligraphy. They are easy to make and look most attractive hung all the way down the church aisle. With the central focus being the initials of the bride and groom, the pew ends make a change from the more usual floral decorations, and have the added benefit that they can be made well in advance and stored to await the big day. The fabric backing could be the same material as the bridesmaids' dresses, or could complement the colours of the bride's bouquet and other planned floral decorations.

MATERIALS

FOR EACH PEW END

Thick card or hardboard 30 x 18cm
(11¾ x 7in)
Fabric to cover
Ribbon or cord for hanging
Thin card
Metallic spray paint
(gold, silver or bronze)
PVA glue

PLANT MATERIAL

Poppy or foxglove seeds
Dried (or silk) flowers

METHOD

First bore two holes in the card or hardboard backing and thread the ribbon or cord through to the back. Then cover the backing with the fabric, using the method outlined on page 30, making sure not to catch the ribbon or cord.

Draw out a pattern for the initials of the bride and groom (*see* Fig 7.9 for an example) and cut out a template either from paper or thin card. For each pew end cut out a piece of thin card large enough to take these initials. On one side of this, place the template **back to front** and pencil round it, remembering to mark any central parts which will need to be cut out.

Turn the card over, spread with glue and cover with the poppy or foxglove seeds (*see* pages 40–1). Shake off the surplus seeds when the glue is dry and spray the covered card with metallic spray paint (gold, silver or bronze, depending on your colour scheme). Once this is dry, turn the card over again and cut out the initials using a craft knife.

Glue the initials in place on the fabric backing. They could be decorated with further seeds according to your taste, patience and the time available, but once the silk or dried flowers have been added, you may be happy with the effect as it stands.

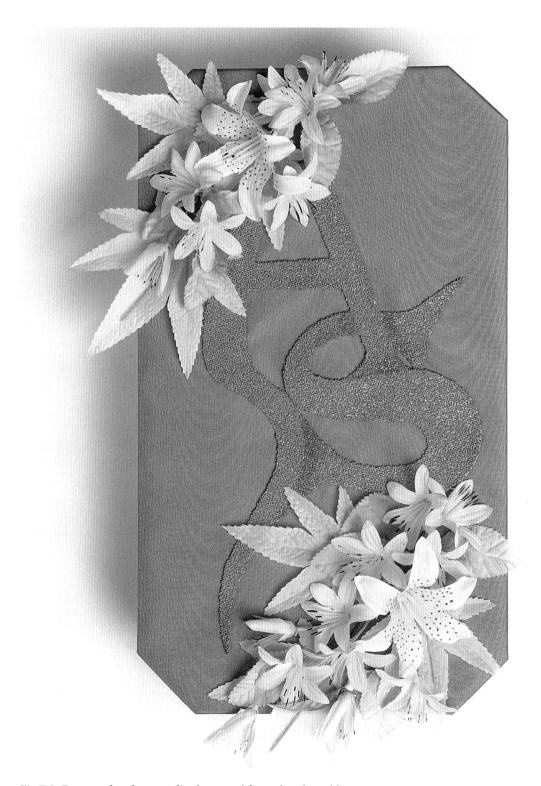

Fig 7.9 Decorated and personalized pew end for a church wedding.

ALTAR FRONTAL

Most of the collages featured so far have been of modest size. Although some might take quite a while for a beginner to complete, most can be completed without trouble in a reasonable length of time. Once in a while, however, there may come a chance to excel yourself, think big and create a collage which will stop people in their tracks.

The altar frontal shown in Fig 7.10 was made for a special church event near King's Lynn in Norfolk and measures 180 x 90cm (6 x 3ft): an enormous challenge. It occupied my dining room table for fifteen weeks!

The cross and the two complementary shapes were made in the same way as the star design for the Bible markers on page 103. Foxglove seeds were used as a covering, then gilded and embellished with seeds including bear's breeches, sunflower, marigold, water melon, goat's beard, cow parsley, hollyhock, millet, mazagan canary, common mallow, sago (to represent pearls) vetch seed pods and Peruvian lily pods.

The super-frontal design consists of a variety of fern leaves, giant hogweed, leyland cypress, *Allium* seed pods, mallow lids, sweet pea tendrils and stylized flowers made from giant hogweed and hollyhock seeds.

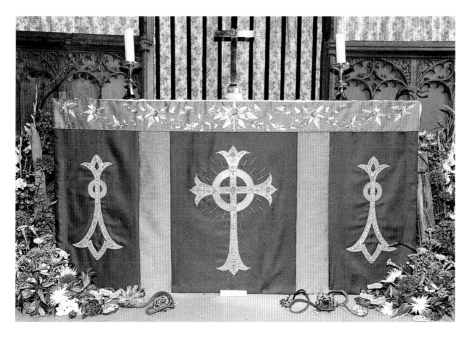

Fig 7.10 **This full-size altar frontal really put my skills with gilded plant material to the test, but demonstrates what stunning effects can be achieved with seeds and leaves easily collected from the garden.**

8

EMBROIDERY
EFFECTS

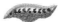

One of my other hobbies is needlework and as I developed my interest in collage, I began to compare the shapes of seeds to the shapes of stitches. I realized that there was a good comparison between the two and instead of using a needle and thread I could use glue and seeds to produce the effect of embroidery.

This led to experiments with combinations of seeds to produce fly stitch, blanket stitch, fan stitch and coral stitch. Some of these seed combinations are shown in Fig 8.1. Further experiments developed my interpretations of lines of embroidery stitches and stitches to edge a contrasting fabric (*see* Fig 8.2).

Ideas for blackwork using naturally black seeds came later (*see* pages 122–9), and I soon discovered that air dried lavender or dyed ampolodermus would give me the effect of zigzag embroidery (*see* pages 130–2). Finally came the Jacobean-style designs (*see* pages 133–45), with the addition of other plant material.

Not all embroidery lends itself to seed collage (for example Hardanger or pulled thread), but many other techniques can be imitated and the possibilities are too numerous to mention. I am continually discovering new methods, techniques and ideas.

HELPFUL HINT

Embroidery transfers can also be used as patterns for collages, but do not iron directly on to the fabric, because any lines not entirely covered by plant material cannot be removed. The best thing is to iron or trace the transfer on to plain white card and treat it as a fibre tip pen line drawing.

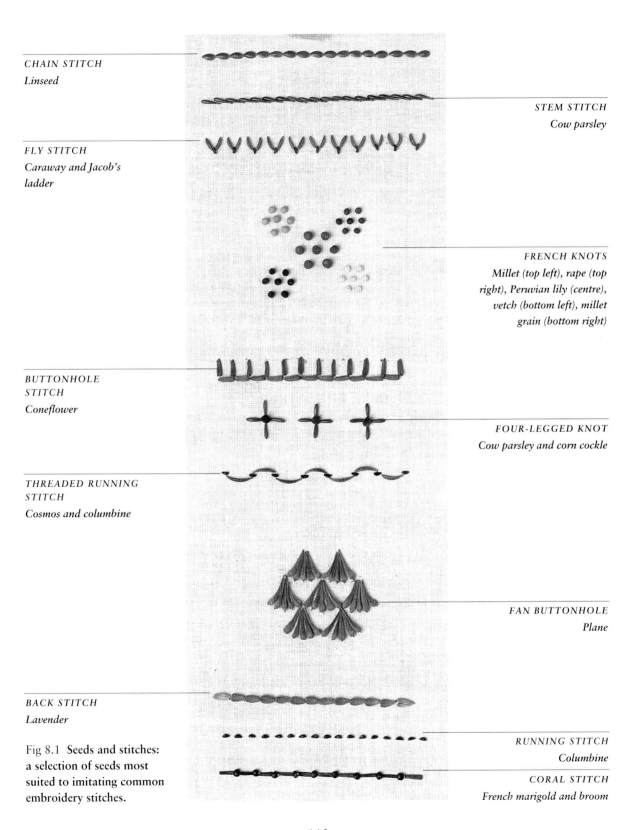

CHAIN STITCH
Linseed

STEM STITCH
Cow parsley

FLY STITCH
Caraway and Jacob's
ladder

FRENCH KNOTS
Millet (top left), rape (top
right), Peruvian lily (centre),
vetch (bottom left), millet
grain (bottom right)

BUTTONHOLE
STITCH
Coneflower

FOUR-LEGGED KNOT
Cow parsley and corn cockle

THREADED RUNNING
STITCH
Cosmos and columbine

FAN BUTTONHOLE
Plane

BACK STITCH
Lavender

RUNNING STITCH
Columbine

CORAL STITCH
French marigold and broom

Fig 8.1 Seeds and stitches:
a selection of seeds most
suited to imitating common
embroidery stitches.

Mazagan canary and millet

Common mallow

Mazagan canary

Long grain brown rice, millet, linseed, shoo-fly

Lavender and poppy seed

Mazagan canary, sesame and rape

Brown sesame, cress and common mallow

Tagetes, *rape and turnip*

Love-in-a-mist and columbine

Cress and shoo-fly

Sesame, poppy and rape

Water melon

Cow parsley and cress

Coneflower and rape

Half common mallow

Half poppy capsule lid, mazagan canary, millet, vetch and sesame

Linseed and shoo-fly

Mazagan canary kernels and cress

Sesame and poppy

Marigold, Peruvian lily, millet, rape and turnip

Mazagan canary and sesame

Fig 8.2 Some examples of how different seeds can be combined to create more elaborate embroidery effects.

GOLD THREAD

One of the earliest examples of English gold thread work still in existence is the stole and maniple of St Cuthbert from Durham Cathedral, made in the eighteenth century. In the courts of that era, women's dresses, men's coats and waistcoats were elaborately embroidered with silk and metal threads, but very little of this work has survived. Metal thread was also traditionally used at that time on naval and military uniforms. Its use on altar frontals and banners followed in the nineteenth century.

The first gold thread to be used was actually made from strands of pure beaten gold, but these days there is a wide range of imitation metallic threads in different thicknesses. Similar luxurious effects can be achieved using gilded seeds, leaves and grasses.

You might like to try out some ideas first on a bookmark like the one shown here (*see* Fig 8.3), or perhaps the lid of a gift box. The 'gold thread' effect really works best, however, on more sumptuous pieces such as the gilded pulpit fall on page 117.

Fig 8.3 **A bookmark decorated with a 'gold thread' effect collage.**

GOLD THREAD BOOKMARK

MATERIALS

Red crepe fabric 27 x 12cm (10⅝ x 4¾in)
Thin card 25 x 5.5cm (9¾ x 2¼in)
Gold spray paint
PVA glue

PLANT MATERIAL

PRESSED

Sweet pea tendrils
Soft shield fern leaflets
Astilbe leaves
Leather fern leaves

SEEDS

Allium pods
Hollyhock
Mazagan canary
Cress

METHOD

All plant material must be gilded and left to dry before use (*see* pages 24–6).

First prepare the basic fabric bookmark as described on page 59. Following the photograph in Fig 8.3 and the pattern in Fig 8.4, position and glue on three *Allium* seed pods an equal distance apart to form the centres of the three motifs.

After fixing the centres, a 'dry run' with the rest of the material is advisable to ensure that three balanced sprays are created. Surround each *Allium* seed pod with five hollyhock seeds to give the impression of a flower, placing the glue only at the tip of each seed. Then select the sweet pea tendrils. You will need to find three tendrils as alike as possible so that matching lines can radiate from each of the three 'flowers'. Add a few soft shield fern leaflets to the tendrils.

Tuck two *Astilbe* leaves side by side beneath the hollyhock seeds on one side of each 'flower', then on the opposite side place two leather fern leaves, embossed with mazagan canary and cress seeds.

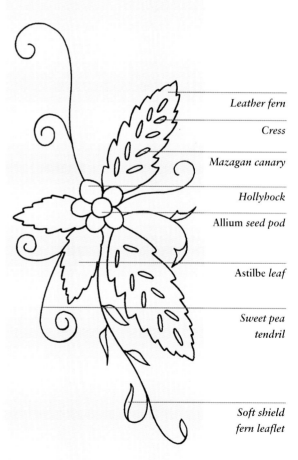

Fig 8.4 **Pattern showing plant material used for 'gold thread' bookmark.**

Leather fern
Cress
Mazagan canary
Hollyhock
Allium *seed pod*
Astilbe *leaf*
Sweet pea tendril
Soft shield fern leaflet

PULPIT FALL

The technique for creating the design on this richly decorated pulpit fall (*see* Fig 8.5) could easily be adapted for other sizeable collages. The idea is to let the shapes and character of the plant material determine the final design, rather than setting out with a pre-determined pattern or template.

While Fig 8.6 shows the plant material components I used for the main design of the pulpit fall, Fig 8.7 sets out the method. I used thread pinned over the fabric as a removable grid to keep the main shape of the design balanced, then chose matching pairs of leaves and so on for the two sides of the collage, working out the design by eye as I went along. Unless you have already had some practice at collage work, this could turn out to be a frustrating experience, but once you have developed an eye for the shapes of the leaves and tendrils, it can be exciting just to start off with a grid and see what happens.

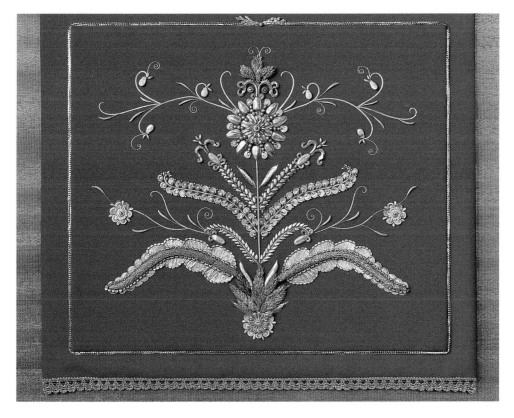

Fig 8.5 'Gold thread' effects in collage are shown off to their best advantage on a lavish piece such as this red and gold pulpit fall.

MATERIALS

Thick card 25 x 30cm (9¾ x 11¾in)
Red crepe fabric 30 x 36cm (11¾ x 14³⁄₁₆in)
PVA glue
All-purpose clear glue
Dressmaking pins
Pale coloured thread
Gold spray paint
Contrasting or matching fabric for background
(*see* page 119)
Gold piping cord
Gold 'lace' or fringing

PLANT MATERIAL

PRESSED

Sweet pea tendrils

AIR DRIED

Cat's-tails
Sycamore wings
Poppy seed capsule lids
Cock's foot
Broom seed pods

SEEDS

Honesty
Sesame
Mallow
Sunflower
Peruvian lily

Hollyhock
Rape
Linseed
Melon
Water melon
Marigold
Mazagan canary
Goat's beard
Poppy
Cress
Turnip
Common mallow

OTHER

Rice

METHOD

Use the photograph (*see* Fig 8.5) and the pattern (*see* Fig 8.6) as guidelines for selecting and grouping the plant material if you wish to follow my design closely or, if it has sparked off ideas of your own, Fig 8.7 will help explain the grid technique and a logical order of work.

All plant material must be gilded and left to dry before use.

Cover the thick card with the red crepe as described on page 30, securing on all four sides. Using dressmaking pins and thread as shown in Fig 8.7, mark out a central vertical line and two evenly spaced horizontal ones (a).

Next cut a thin cat's-tail stem to the length required for the central line of the design (b). Using just a dot of glue at each end, glue the stem in place, taking care not to stick down the marking thread at the same time. Position a cat's-tail on one side at the base of the stem and mark each end with a pin. Do the same to match on the other side (it is essential to build up both sides simultaneously to create a good mirror image). Fix in place with a light application of all-purpose glue.

Trim the tips and seeds from the sycamore wings and glue either side of the cat's-tails, graduating to the use of honesty seeds towards the tip. Edge the wings with sesame seeds and the cat's-tails with mallow seeds.

Remove the lines of thread carefully at this stage. By now they should have done their job of balancing out the early parts of the collage and will only get in the way from now on.

Form a stylized flower at the top of the central stem (c), using a poppy capsule lid surrounded by half sections of sunflower seeds, Peruvian lily, hollyhock and rape seeds. Glue on small pieces of cock's foot above the flower, topped by a flourish of sweet pea tendril. Make a smaller version of the stylized flower positioned just below the base of the central stem.

You now need to select pairs of sweet pea tendrils which are as identical as possible. Pick out however many pairs you think you will need, position them on the collage (d), then mark the position of both ends of each tendril with pins. Glue the tendrils into position (the glue is only needed at each end, not all the way along). Place a matching pattern of linseed, hollyhock seeds or rice along the sides of each pair of tendrils (*see* Fig 8.6).

Complete the collage as you please with a mixture of seeds: I used strategically placed melon, water melon, marigold, mazagan canary and goat's beard seeds, but any combination could be used to good effect.

Pulpits vary considerably in size, so it will be necessary to mount your finished design on to a matching or contrasting background cloth. Make this to fit the measurements of the pulpit, adopting the same principles as for making a basic fabric bookmark (*see* page 59). Your main design can then be glued to the background with a strong, all-purpose glue. As a finishing touch, surround the main design with gold cord and add a gold 'lace' trim or fringe to the lower edge of the background fabric.

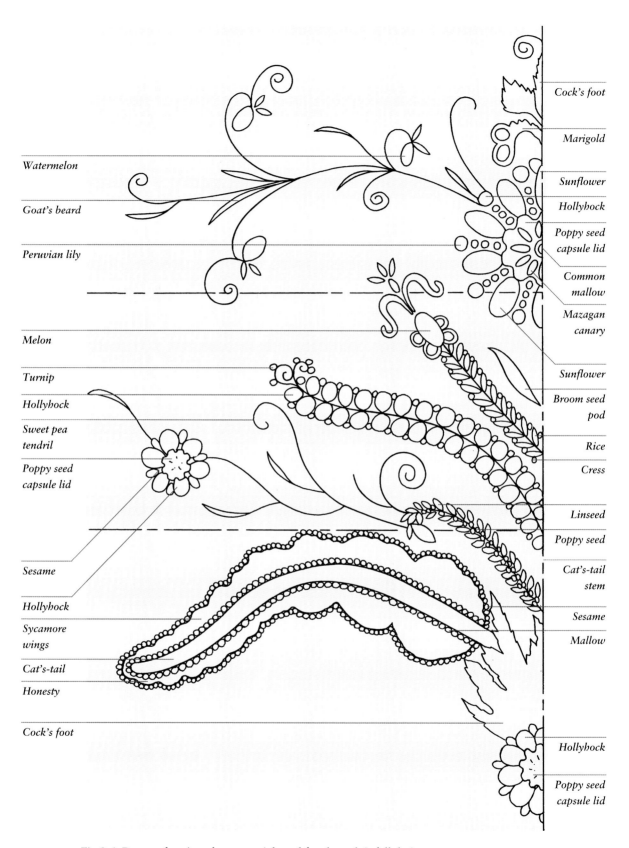

Cock's foot

Marigold

Sunflower

Hollyhock

Poppy seed
capsule lid

Common
mallow

Mazagan
canary

Sunflower

Broom seed
pod

Rice

Cress

Linseed

Poppy seed

Cat's-tail
stem

Sesame

Mallow

Hollyhock

Poppy seed
capsule lid

Watermelon

Goat's beard

Peruvian lily

Melon

Turnip

Hollyhock

Sweet pea
tendril

Poppy seed
capsule lid

Sesame

Hollyhock

Sycamore
wings

Cat's-tail

Honesty

Cock's foot

Fig 8.6 Pattern showing plant material used for the pulpit fall design.

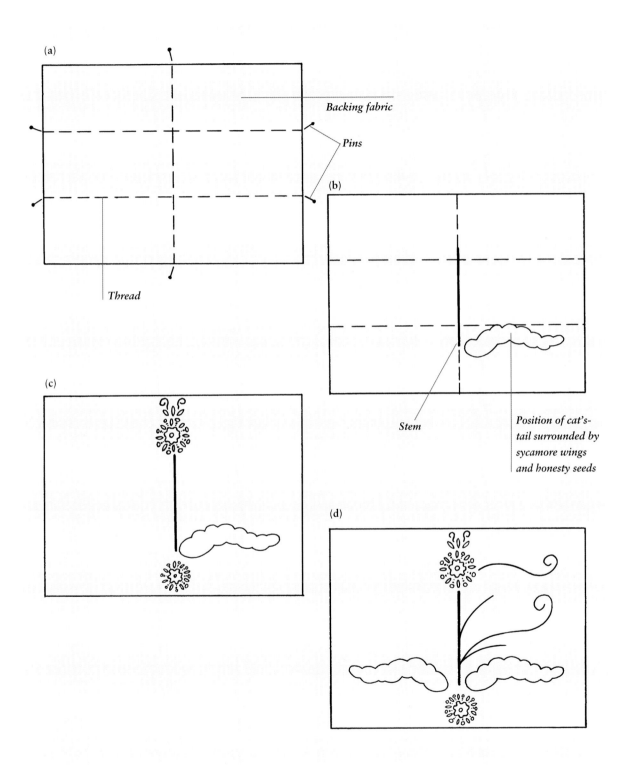

Fig 8.7 Using lines of thread as a grid to guide the placing of the main shapes in the collage.

BLACKWORK

As an embroidery method, blackwork was originally worked in black silk on white linen. In *The Canterbury Tales* (written between 1388 and 1400) Chaucer described the dress worn by Alison, the carpenter's wife, in a way which suggests that it was decorated with blackwork:

Her smock was white, embroidery repeated
its pattern on the collar front and back
inside and out, it was of black and silk.

Although it was already known in England, blackwork only became really popular in Britain after the marriage in 1501 of Arthur Tudor (son of Henry VII) and Catherine of Aragon (who became Henry VIII's first wife after Arthur's death). Catherine probably learned embroidery from her mother, Queen Isabella. Although she may not have worked the blackwork herself, it is known that she had clothing embellished with this embroidery in her trousseau and she must have been responsible for encouraging the fashion for this work. Until about 1530 it was known as 'Spanish work' and is still occasionally referred to by this name. In the sixteenth and seventeenth centuries blackwork was often used to decorate neckbands, cuffs, jackets, hoods, ladies' chemises, men's shirts, nightshirts, caps and also fine household furnishings.

Several garden plants produce naturally black seeds and these can be used very successfully to recreate the effect of blackwork embroidery in collage. Fig 8.8 shows some samples of the 'stitches' which can be imitated. It certainly makes a change from the more usual muted browns, beiges and greens of much preserved plant material, and a blackwork collage can produce stunning effects.

It is important to observe the different shapes of the seeds (*see* Figs 8.8 and 8.11), because it is the different combinations of these shapes which will be used to interpret the blackwork stitches. Love-in-a-mist is pear shaped, columbine resembles a citrus fruit segment, Sweet William has a flower petal shape and grape hyacinth is a small sphere. Although all these seeds are individually very small, the subtle differences in shape have a tremendous impact on the patterns achieved when they are put together.

If you wish to use a particular type of seed because its shape will give you the pattern you want, but the seed is not naturally black, the problem can be solved easily with a can of black spray paint using the same method as for gilding (*see* pages 24–6). Charcoal coloured seeds such as French marigold and field penny-cress can be used in their natural state, as the slight variation of colour between these and the deep black seeds will add depth and contrast to the finished design.

Fig 8.8 Examples of different seed combinations to produce blackwork embroidery effects.

BLACKWORK FLORAL DESIGN

The stylized flower shown opposite (*see* Fig 8.9) is just one example of the kind of designs which can be created using blackwork techniques. Why not try copying this design and then making up something of your own using similar seed combinations?

MATERIALS

Thick white card 17 x 23cm
(6¾ x 9in)
White polycotton fabric 21 x 27cm
(8¼ x 10⅝in)
Hardboard 23 x 25cm
(9 x 9¾in)
Black fabric 28 x 30cm
(11 x 11¾in)
PVA glue
All-purpose clear glue

BLACK SEEDS

Love-in-a-mist
Sweet William
Poppy
Columbine
Grape hyacinth
Field penny-cress

METHOD

Cover the white card with the white polycotton as described on pages 27–30, securing the fabric on three sides only.

Trace the outlines of the pattern shown in Fig 8.10 on to thin white paper and strengthen the lines with a black fibre tip pen. Slip the paper pattern between the white fabric and card. Glue on love-in-a-mist seeds to cover all the outlines of the pattern, remove the paper pattern and secure the final edge of fabric.

Complete the various parts of the design following the suggested uses of seeds shown in Fig 8.11. The letters on the pattern in Fig 8.10 correspond to the different seed patterns (a–h) demonstrated in Fig 8.11. By looking closely at the photograph of the finished piece in Fig 8.9 you will see how the patterns go together to produce the overall effect.

When the collage is completed and the glue is dry, mount it on the hardboard covered with black fabric.

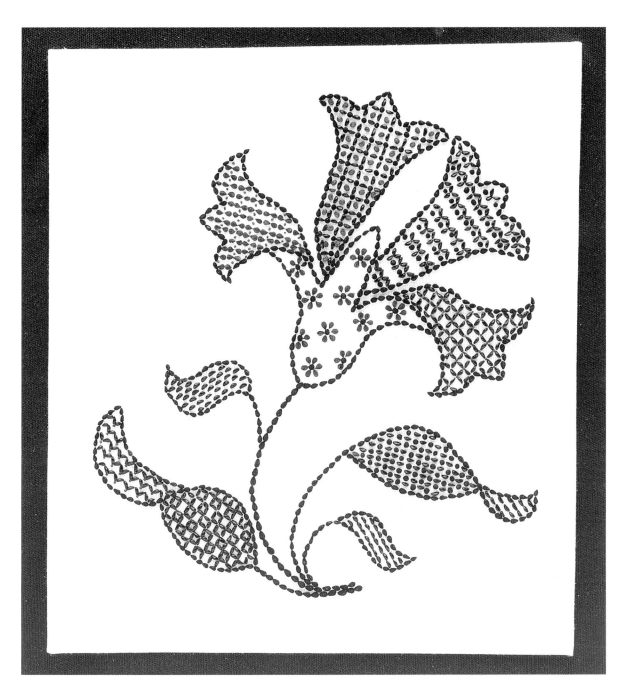

Fig 8.9 **A stylized blackwork flower.**

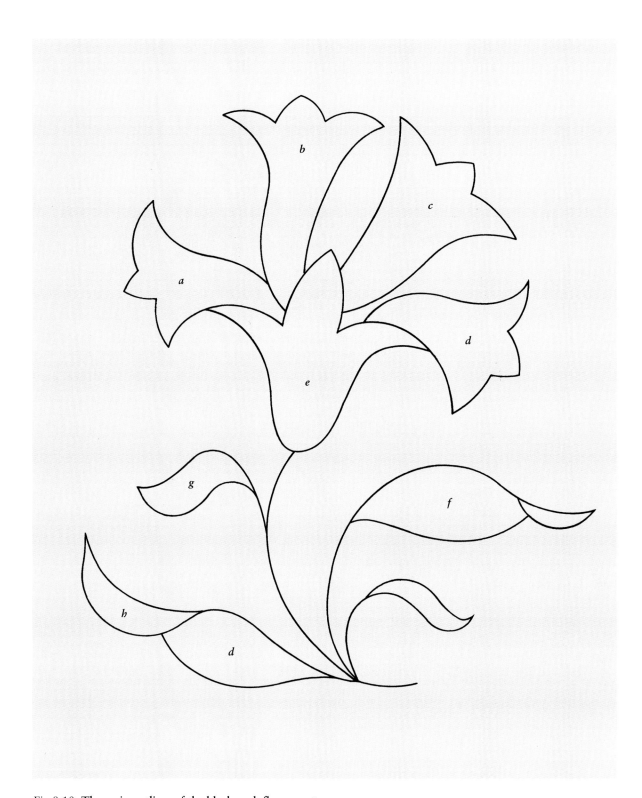

Fig 8.10 **The main outlines of the blackwork flower pattern.**

a Sweet William and poppy

b Columbine, grape hyacinth and field penny-cress

c Columbine and grape hyacinth

d Columbine

e Sweet William and grape hyacinth

f Columbine and grape hyacinth

g Columbine

h Columbine and poppy

Fig 8.11 Suggested combinations of seeds to decorate the different parts of the blackwork flower.

BLACKWORK HANGINGS

Blackwork embroidery effects work very well on larger hangings, perhaps because the black seeds against a simple white background make quite an impact when viewed from a distance as well as close to. Using only black seeds, you need not think about combinations of differently shaded material, but can concentrate solely on creating intricate designs.

As an example of what can be achieved on a larger piece, Fig 8.12 shows a selection of blackwork bell pulls I made for a flower festival. The idea could easily be adapted to other types of hangings for a home rather than a church. You could also move on from simply black seeds on a white background and use a blue or grey background, or even use brown seeds on cream, ivory or pale green for a different effect.

The bell pulls were made from white cotton sheeting using the same principles as for fabric Bible markers (*see* pages 102–5), then decorated with floral blackwork designs, following the method used for the stylized flower on page 125 and incorporating blackwork patterns based on those in Fig 8.11.

Once you have an idea of the basic 'stitches' and patterns and the combinations of seeds which work best, it is possible to build up a collage of any size you wish. Sketch out the outlines of the design you have in mind, and then decide which pattern to use for each different section until you have planned out the whole collage with a balanced variety of stitches. While a large collage of this type may take a considerable time to finish (one bell pull took me up to 60 hours to complete), it is worth trying just once for the sheer sense of achievement and satisfaction it brings.

HELPFUL HINT

For added shading on a larger blackwork collage, a touch of black fabric paint can be judiciously applied. The paint will highlight selected areas and produce a denser colouration than the seeds alone.

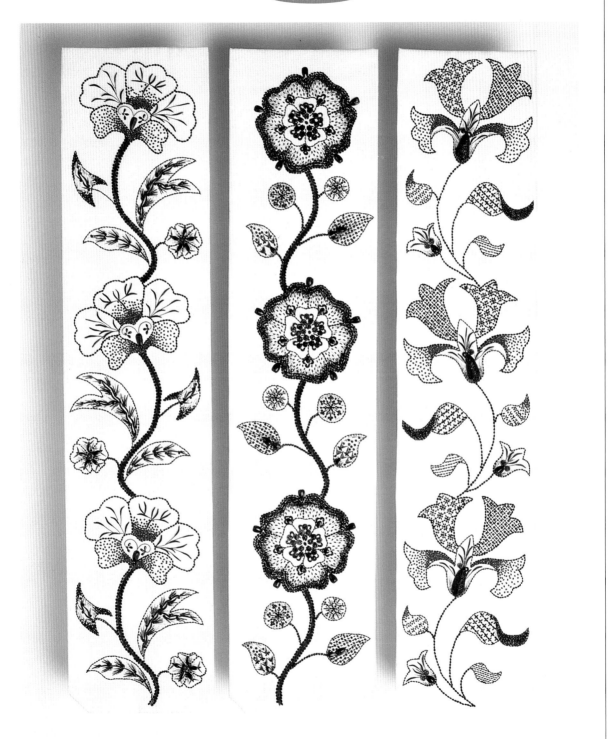

Fig 8.12 Bell pulls decorated with blackwork collage designs.

ZIGZAG STITCHERY

Zigzag stitchery (also known as Bargello or Florentine) is a type of embroidery which forms distinctive repeated patterns, usually worked in many different colours. It is said that the technique was originally brought from Hungary to Florence in the fifteenth century by a Hungarian girl who married a Medici prince.

This embroidery technique was generally used for upholstery and personal items such as handbags or wallets. During the twentieth century it has also been used in the designs of hats, slippers, belts and, occasionally, coats and jackets. The finest collection of zigzag work in England can be seen at Parham House in Sussex, which includes magnificent bed hangings worked during the reign of Charles II. A Queen Anne type of wing chair, dated 1725, is a fine example of this work and can be seen at the Metropolitan Museum of Art in New York, and there is also a set of seventeenth-century chairs in the National Museum in Florence.

Dried lavender or imported ampolodermus are perfect materials for recreating this embroidery style in a plant material collage. The patterns are made by closely packed (but carefully placed) arrangements of the lavender or ampolodermus and some beautiful effects can be achieved. Lavender gives subtle changes in shades, as on the sampler shown opposite, but ampolodermus can offer more varied and colourful possibilities (*see* the examples in Fig 8.13).

(a)

(b)

(c)

(d)

Fig 8.13 **Examples of the beautiful zigzag patterns which can be created using brightly coloured ampolodermus (a and b) and the more muted shades of lavender (c and d).**

ZIGZAG SAMPLER

The evenly shaped pieces of lavender are compatible with the size and shape of the stitches made when using thread to create zigzag embroidery. Lavender ranges in shade from white – through pink – to deep mauve and all these can play a part in creating this interpretation of zigzag stitchery (*see* Fig 8.14).

MATERIALS

Cream calico 45 x 13cm
(17¾ x 5⅛in)
Thin white card 35 x 10cm
(13¾ x 4in)
Two lengths of wooden dowel 14cm
(5½in) long and 1cm (⅜in) in diameter
4 wooden beads
Cream cord 30cm (11¾in) long
PVA glue
All-purpose clear glue
Solid stick glue

PLANT MATERIAL

Air dried lavender in various shades

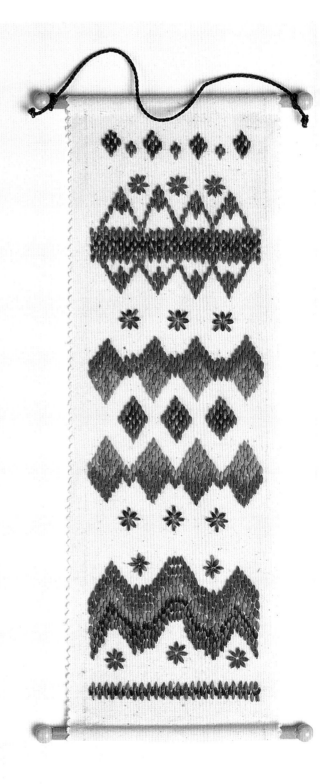

Fig 8.14 **Zigzag sampler made with various shades of lavender.**

METHOD

Cut the two longer edges of the calico with pinking shears and fray. Carefully pull out four threads from each side, approximately 1cm (³⁄₈in) in from the pinked edge, then position the white card on the reverse side of the calico, an equal distance from the top and bottom, and centrally placed between the removed threads. Use solid stick glue to fix the card to the calico.

When the glue has dried, fold the top and bottom of the calico over to the back and glue down the very ends only (using all-purpose glue), leaving enough of a gap to take the lengths of wooden dowel (*see* Fig 8.14).

Begin the design in the centre of the sampler and work three diamond shapes using two shades of lavender. Build the diamonds up as shown in Fig 8.15, starting with the very centre point (a), then two pieces either side of that (b) and then four more pieces at the top and side points (c).

When the diamonds are complete, mark four pencil dots to indicate the starting points for the next row of shapes. Begin by placing one lavender piece at each of the four points (*see* Fig 8.16) and then build up all four shapes simultaneously, keeping the rows of each shade level with each other, just as you would if using needle and thread. In this way you can create patterns with

Fig 8.15 **How to build up a diamond shape.**

sharp angles or with sweeping lines and curves, using as many shades of lavender as you have available (or ampolodermus if you prefer). The patterns on my sampler are only some of the possible designs. Experiment as you go along and decide what effects you like best.

When the sampler is finished, slide the dowel rods into the top and bottom loops, glue a wooden bead at each end and tie the cord to the top dowel so that the sampler can be hung up.

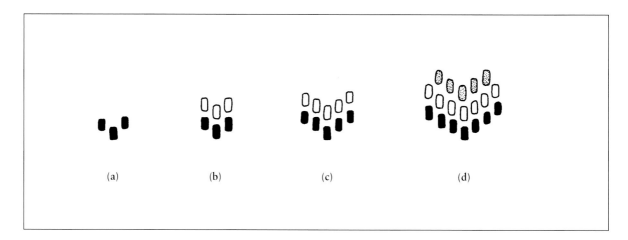

Fig 8.16 **How to build up a zigzag pattern with different shades.**

JACOBEAN EMBROIDERY EFFECTS

◆

The term 'Jacobean' refers to a particular style of heavy wool embroidery which was popular during the latter half of the seventeenth century. The style and inspiration were attributable to the import of richly painted cotton hangings brought into England by expanding trade links with the Far East. The main theme of a large tree trunk with branches springing in all directions, laden with the grotesque shapes of unrealistic leaves and flowers, is thought to represent the Tree of Life.

Whether it is worked in wool, silk or plant material, I find Jacobean embroidery the most exciting technique as you can let your imagination run wild. It is not possible to reproduce the exact stitches in plant material, but with a little creativity an excellent interpretation can be achieved. Satin stitch or long and short stitch can be produced using ampolodermus (*see* page 135), and French knots using a single round seed of mustard, rape or Peruvian lily. The effect of honeycomb filling (*see* page 134) can be recreated with glixia or cat's-tail stems. Alternately placed French marigold and rape seeds produce coral stitch, while cow parsley seeds are ideal for stem stitch. Lavender is excellent for giving the impression of thick tree trunks. Try comparing various stitches with the shapes of different seeds: the likenesses are amazing and a completed Jacobean collage can be very deceptive.

MAKING THE COMPONENT PARTS

The two projects which follow on pages 139 and 143 consist of typical Jacobean-style flowers, leaves and trees, with outlandish shapes and exaggerated features. Creating this style of collage involves some fairly complicated work, so it pays to be familiar with the best methods of 'construction' before you begin.

STEMS, BRANCHES AND TRUNKS

Branches and trunks can be formed with almost any 'straight' seed. Lavender is perhaps the most effective because it offers a good variety of shading, which gives an excellent impression of the rough texture of tree bark.

Fig 8.17 shows the stages. First secure one row of lavender along the entire length of the stem, branch or trunk (a). Place another row of lavender up against the first one, but stagger the pieces to achieve dense coverage (b). Add further rows until the required thickness is reached. The base of a tree trunk can be built up with shorter rows of lavender (c). For thinner branches and stems it is best to use cow parsley seeds (d), which will give an effect very similar to stem stitch.

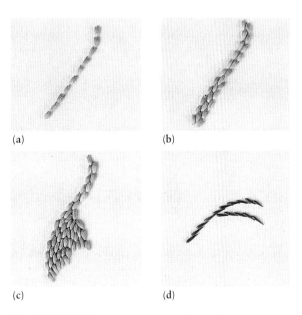

(a)

(b)

(c)

(d)

Fig 8.17 **Building up stems, branches and trunks in the Jacobean style.**

HONEYCOMB FILLING FOR FLOWERS AND LEAVES

Honeycomb filling is formed with straight glixia stems, cat's-tail or hare's-tail grass and a selected seed or seeds. The filling is best fixed on prior to the outlining of the flower or leaf (*see* page 135). A successful honeycomb filling relies on accurate cutting of the stems and careful thought about spacing. Fig 8.18 shows the stages.

HELPFUL HINT

A 'dry run' is vital for honeycomb filling, to make sure that the chosen seeds will fit in the spaces between the stems.

With your pattern placed beneath the fabric as a guide, carefully cut the stems to the required length and fit them exactly within the leaf or flower shape, placed an equal distance apart (a). Fit all the stems going in one direction first, and determine their position before gluing anything down. When you are satisfied that the spacing is correct, dip the ends of each stem lightly into PVA glue and place gently into position.

The simpler version of honeycomb filling is completed by gluing your chosen seeds in the stripes between the stems at this stage (*see* example b in Fig 8.22). Place all the seeds to your satisfaction before gluing them down.

For a more complicated version, cut more stems to fit across the first layer of stems (b), thus forming squares which can then be filled with seeds. To glue down, place a minute dot of glue on the first stems at each point where the second stems will cross over, and press each stem lightly into place. When all the squares are complete, glue the seeds in place (c). A large variety of effects can be achieved by using different colours, shapes and combinations of seeds. Add the outline of the leaf last of all (d).

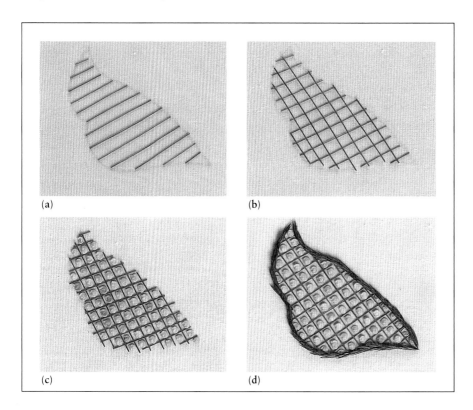

(a)

(b)

(c)

(d)

Fig 8.18 **Creating a honeycomb filling for flowers and leaves.**

OUTLINING AND FILLING LEAVES AND PETALS

Ampolodermus makes the most effective outline for leaves and petals and has the added advantage of being available in many colours, ideal for Jacobean-style collages.

For best results, cut the individual sections from the stems of the ampolodermus as shown in Fig 8.19(a). This will give you much greater flexibility on the curves of any shape, and will enable you to control the density and regularity of the 'stitches'.

To outline a leaf or petal, start at the tip (b) and work down both edges from there. Apply a small dot of PVA glue to the base of each section of grass only. Fix to the design by slightly overlapping the base of the previous piece with the tip of the next section (c). If the sections are simply placed one after the other without any overlap, the result will not be so solid.

When the outlining is complete, the middle section of the leaf or petal could be decorated with a design of hollyhock and cow parsley seeds (or others of your choice).

If you wish to fill an entire leaf or petal with ampolodermus, a smoother finish will be achieved if the shape is not outlined first.

Start at the tip as before, but then fill the whole space in completely as you work towards the base (*see* Fig 8.20), overlapping each section of grass with the one above it. This will give a similar effect to long and short stitch. If you try to fill in the middle part after outlining, it will not be possible to overlap the sections of grass in a consistent way and the leaf or flower will end up looking cramped and uneven.

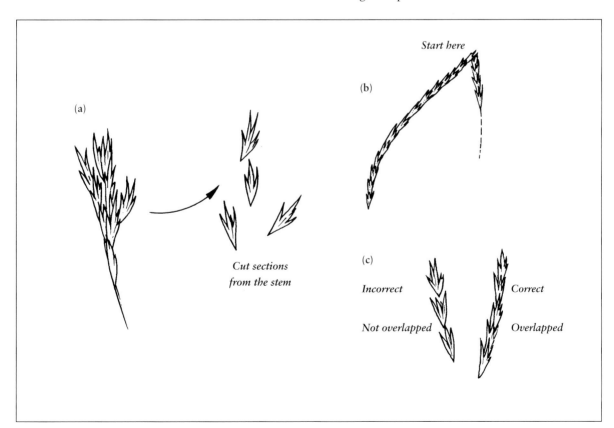

Fig 8.19 **Correct and incorrect ways of outlining a leaf shape with ampolodermus.**

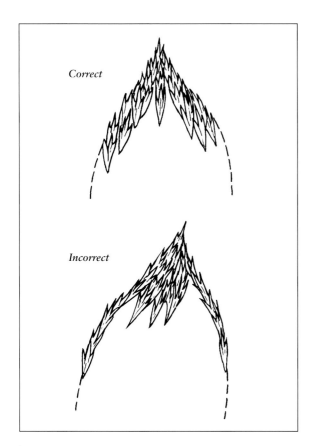

Correct

Incorrect

Fig 8.20 **Correct and incorrect ways of filling a leaf shape with ampolodermus.**

FIXING CAT'S-TAILS

A typical use for cat's-tails within a Jacobean design is shown in Fig 8.21. Fixing cat's-tails in place is much more easily done with an all-purpose glue such as UHU, rather than PVA glue, because a strong and quick-drying glue prevents the cat's-tails from springing immediately out of line.

Cut the cat's-tail to the length required and gently dab a few spots of all-purpose glue all the way along it. Place one end in position, keeping the rest of the cat's-tail raised, and hold for a few seconds until the end is secure. Then gradually ease the rest of the piece into the shape required, press down very lightly and hold for a few seconds until dry.

HELPFUL HINT

Cat's-tails are very strong and springy, so do not release your hold until you are sure that the glue has bonded and the cat's-tail is fixed firmly in place.

Fig 8.21 **A cat's-tail is often used to form one whole side of a leaf.**

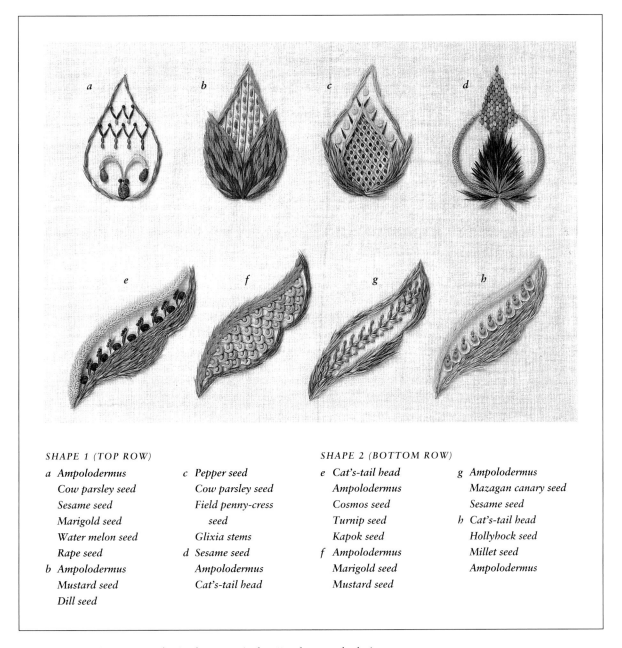

Fig 8.22 **Variations on two basic shapes typical to Jacobean-style designs.**

SHAPE 1 (TOP ROW)

a Ampolodermus	*c Pepper seed*
Cow parsley seed	*Cow parsley seed*
Sesame seed	*Field penny-cress*
Marigold seed	*seed*
Water melon seed	*Glixia stems*
Rape seed	*d Sesame seed*
b Ampolodermus	*Ampolodermus*
Mustard seed	*Cat's-tail head*
Dill seed	

SHAPE 2 (BOTTOM ROW)

e Cat's-tail head	*g Ampolodermus*
Ampolodermus	*Mazagan canary seed*
Cosmos seed	*Sesame seed*
Turnip seed	*h Cat's-tail head*
Kapok seed	*Hollyhock seed*
f Ampolodermus	*Millet seed*
Marigold seed	*Ampolodermus*
Mustard seed	

BASIC SHAPES

As you will see from the projects which follow, many of the flower and leaf motifs are actually variations on just a few basic shapes. While the shapes may be similar, however, they can be formed in any number of different ways, resulting in very varied effects depending on the plant material used.

Fig 8.22 shows examples of two basic shapes, each treated in four different ways. The components of each one are listed to give you an idea of the possible alternatives and which combinations create the best effects. For your own projects, of course, you can experiment with new combinations. Using your imagination is what Jacobean-style collage is all about.

Jacobean-Style Picture

You may wish to start with a simple Jacobean design such as the one shown in Fig 8.23, but do bear in mind that a small design is not necessarily easier to work than a large one. It is the individual components (the flowers and leaves) which determine the complexity. Before starting a structured design, try tracing a few individual shapes and practising with whatever plant material you have to hand.

MATERIALS

Hardboard 30.5 x 23cm (12 x 9in)
Cream cotton fabric 33 x 26cm (13 x 10in)
Plain wooden frame
PVA glue
All-purpose clear glue

PLANT MATERIAL

AIR DRIED

Lavender
Ampolodermus
(various colours)
Glixia stems
Mallow lid

PRESSED

Sweet pea tendrils

SEEDS

Cow parsley
Crown imperial
Hogweed
Sunflower
Pumpkin
Hemp

Caraway
Grape hyacinth
Marigold
Cosmos
Honesty
Goat's beard
Peruvian lily
Sweet pea
Millet
Coneflower
Common mallow
Linseed
Rape

OTHER

Mazagan canary
kernels

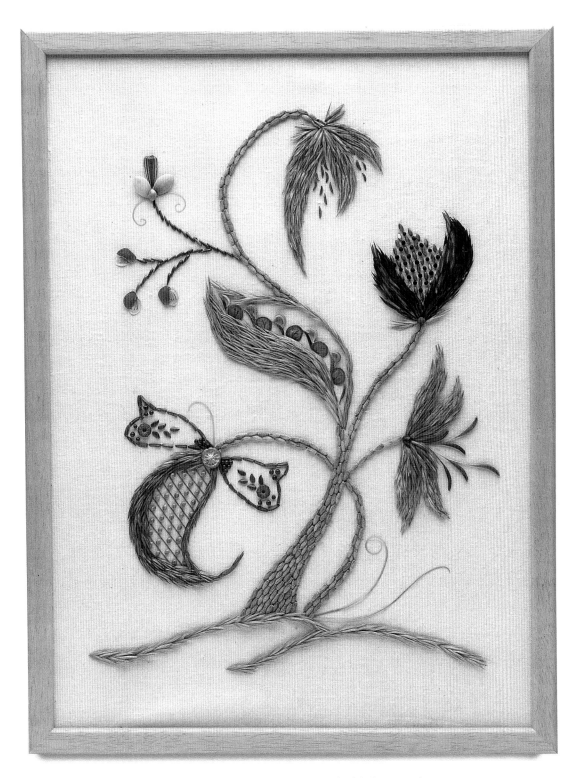

Fig 8.23 This Jacobean-style picture is full of colour and wonderful shapes and textures.

METHOD

Trace or copy the outlines of the design as given in Fig 8.24 (*see* page 162 for full-size pattern) on to white paper and strengthen the lines with a black fibre tip pen. Cover the hardboard with the cream fabric as described on pages 27–30, securing on three sides only, and slip the paper pattern underneath the fabric.

Beginning at Point A (shown in Fig 8.24) cover the branch line down to Point B with one row of lavender. Repeat this from both Points C to Points D at the base of the trunk. Then build up the main tree trunk with lavender as described on page 133.

Make the thinner branches and stems with cow parsley seeds, tipping three of these with crown imperial and hogweed seeds (*see* top left hand corner of design, Fig 8.24) and the topmost tip with half a sunflower seed, two pumpkin and one hemp seed, and two swirls of sweet pea tendril.

Now deal with the petals of the flowers, filling in or outlining with ampolodermus as described on page 135. Begin at the tip of the petal in each case. The pink, blue, green and yellow shapes are filled in entirely (*see* Fig 8.23), but the mauve shape should not be outlined until the honeycomb filling has been created (*see* page 134).

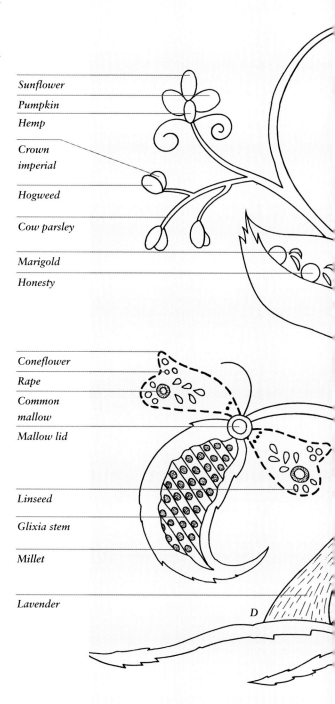

Fig 8.24 **Pattern showing the plant material used for the Jacobean-style picture** (*see* page 162 for full-size pattern).

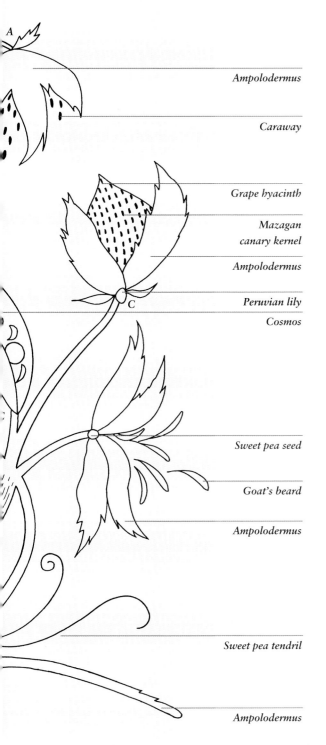

A

Ampolodermus

Caraway

Grape hyacinth

Mazagan
canary kernel

Ampolodermus

C

Peruvian lily

Cosmos

Sweet pea seed

Goat's beard

Ampolodermus

Sweet pea tendril

Ampolodermus

When the petals have been filled with ampolodermus complete their designs, using caraway seeds as stamens for the pink flower (*see* Fig 8.23); mazagan canary kernels and grape hyacinth seeds for the blue; marigold, cosmos and honesty seeds for the green; and goat's beard seeds for the yellow. A Peruvian lily seed adds a finishing touch to the base of the blue flower, with a sweet pea seed doing the same for the yellow one.

Fix on the honeycomb filling using glixia stems and millet seeds for the main shape of the mauve flower, then outline this with ampolodermus. The two smaller petals on this flower are outlined with coneflower seeds, with an inner design of common mallow, linseed and rape. A mallow lid covers the join of the three petals.

Finally add two lines of green ampolodermus at the base of the trunks as a foundation for the whole design, decorated with a few flourishes of sweet pea tendril.

If this is your first attempt at the Jacobean style and some of the filled petals have not turned out to your satisfaction, do not be disheartened! Have another go and try not to hurry: a more even result will come from a steady pace and careful placing of each piece.

JACOBEAN FIRESCREEN

For the adventurous, a project such as the colourful Jacobean-style firescreen in Fig 8.25 is well worth attempting, but be prepared for the amount of time such intricate work will demand. The work could be protected behind glass and will provide lasting colour in an empty fireplace during the summer months.

The design for this firescreen was adapted from an embroidery transfer. I copied roughly the outlines of the flowers, leaves and stems I wanted to use, and then worked these up into a design of my own. You could do the same with the pattern given in Fig 8.26, which shows exactly the components of my firescreen. Take the main shapes which you find attractive, then create your own design around these. For the decoration of each part, you could either copy the elements exactly as shown, or use them (and those featured previously) as a basis for your own original ideas.

MATERIALS

Hardboard or very thick card 65 x 45cm ($25\frac{5}{8}$ x $17\frac{3}{4}$in)
Hardboard or plywood 80 x 60cm ($31\frac{5}{8}$ x $23\frac{5}{8}$in)
Cream cotton fabric 70 x 50cm ($27\frac{5}{8}$ x $19\frac{5}{8}$in)
Contrasting coloured fabric 85 x 65cm ($33\frac{3}{8}$ x $25\frac{5}{8}$in)
PVA glue
All-purpose clear glue
Frame and/or supporting stand if required

PLANT MATERIAL

AIR DRIED	SEEDS		
Lavender	Cow parsley	Masterwort	Cress
Ampolodermus	Goat's beard	Honesty	Shoo-fly
(various colours)	Mustard	Melon	
Statice	Linseed	Pumpkin	GILDED SEEDS
Sycamore wings	Water melon	Field penny-cress	Mazagan canary
Poppy seed	Marigold	Woad	Millet
capsule lids	Millet	Crown imperial	
Cat's-tails	Sesame	Sea holly	OTHER
Glixia stems	Mazagan canary	Cosmos	Brown rice
		Hollyhock	

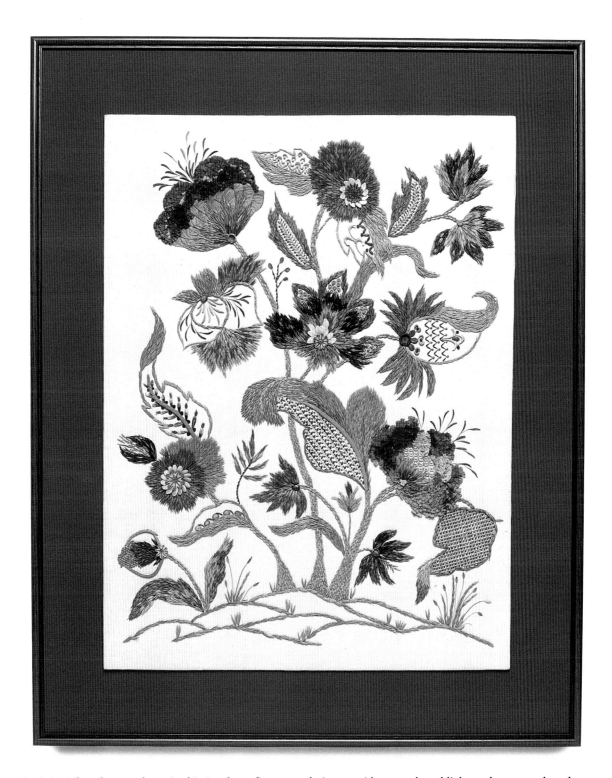

Fig 8.25 The vibrant colours in this Jacobean firescreen design provide warmth and light to the room when the fire is not lit.

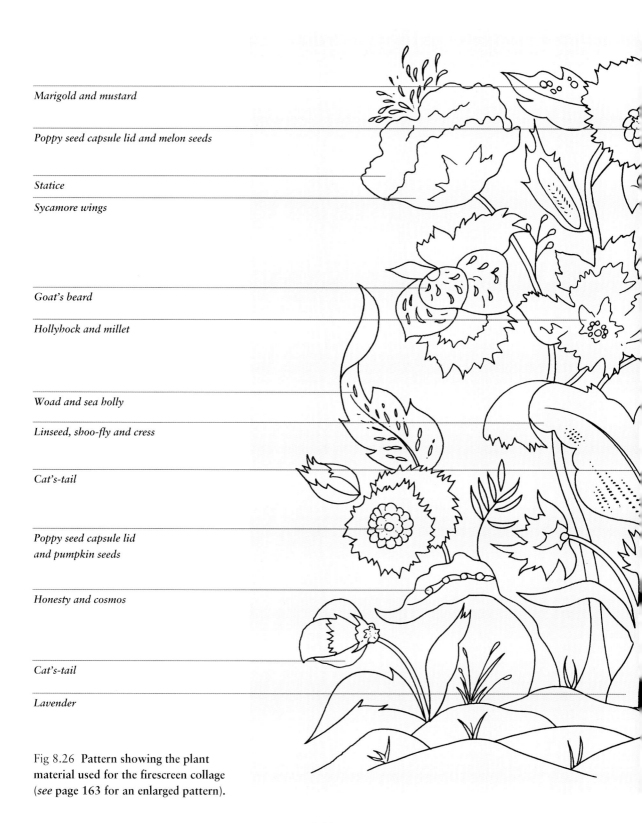

Marigold and mustard

Poppy seed capsule lid and melon seeds

Statice

Sycamore wings

Goat's beard

Hollyhock and millet

Woad and sea holly

Linseed, shoo-fly and cress

Cat's-tail

Poppy seed capsule lid
and pumpkin seeds

Honesty and cosmos

Cat's-tail

Lavender

Fig 8.26 Pattern showing the plant
material used for the firescreen collage
(*see* page 163 for an enlarged pattern).

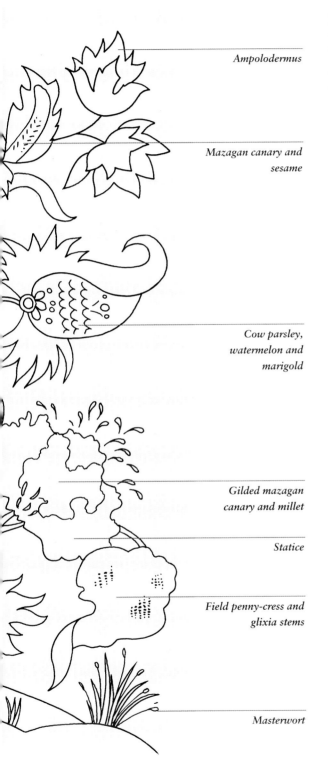

Ampolodermus

Mazagan canary and
sesame

Cow parsley,
watermelon and
marigold

Gilded mazagan
canary and millet

Statice

Field penny-cress and
glixia stems

Masterwort

METHOD

First work up the outlines of your design on a sheet of white paper, either copying from the pattern in Fig 8.26 (*see also* the enlarged pattern given on page 163) or adapting shapes from that or a suitable embroidery transfer. Strengthen the lines with a black fibre tip pen.

Cover the smaller piece of hardboard (or thick card) with the cream cotton fabric as described on pages 27–30, securing the fabric on three sides only to allow the paper pattern to be slipped in.

First glue on one row of lavender from the top of the main stem to the base of the tree, avoiding the areas which are 'hidden' behind a leaf or petal. Gradually add further rows until the required thickness has been reached (*see* page 133).

The design of each flower and leaf can vary considerably according to your personal taste and ideas. The elements shown on the pattern in Fig 8.26 are those used to create my own firescreen, but these are only some of the possibilities which can be followed. Use the basic methods for Jacobean 'embroidery' set out on pages 133–7 to create your own effects.

When the collage is completed, remove the paper pattern and secure the final edge. Spray with a low odour fixative. This may slightly discolour the plant material, but will increase the lifetime of your work by up to ten years. The collage can be kept dust free with a small, soft paintbrush. Mount on the larger piece of hardboard covered with the contrasting coloured fabric. This can be framed and/or mounted on to a supporting stand for a freestanding screen.

HELPFUL HINT

If plywood is used as a secondary backing instead of fabric-covered board, it can be varnished and stained to complement the fireplace.

FANTASIES

This chapter is rather different from the previous, project-orientated chapters. The first collage, 'Rural Kent', was made for my own pleasure right at the start of my interest in collage, but the other four designs were all competitive exhibits for occasions when I have been required to create highly imaginative and totally impractical items to demonstrate the extensive use of plant material. They are included to show just what can be achieved if the imagination is allowed complete freedom from constraints. These 'fantasies' are really just as simple to construct as your very first bookmark, although they will take a little more time to complete.

'RURAL KENT'

I created this collage picture (Fig 9.1) as an adaptation of a logo for a new garden centre in Kent which had caught my eye. The logo was in cream and brown, but I made my picture into a colourful interpretation of the Kent countryside by using more varied and more realistic shades. This was my first attempt at creative collage with plant material and my pleasure at the result led me to experiment with all the techniques and ideas which have been included in this book.

The rich autumn hues of stag's-horn sumach leaves make perfect bricks for the oast house, with trimmed sycamore wings for the roof tiles. Dyed pampas grass and ampolodermus form the two background trees, and the blossom on the apple tree in front is dyed sea lavender. The rhododendron bushes are made up from tiny pieces of dyed pampas grass, ampolodermus, glixia flowers and individual statice florets.

HELPFUL HINT

Sea lavender can be dyed very effectively with diluted red food colouring.

Fig 9.1 **'Rural Kent'**.

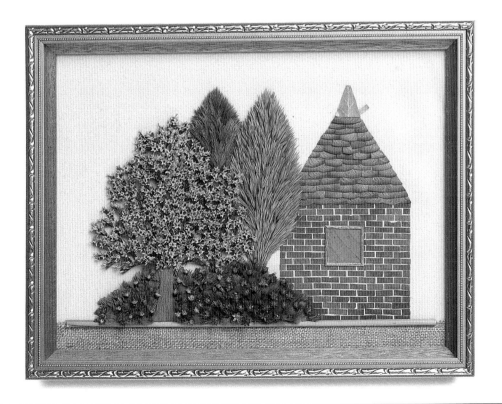

'HOW TIME FLIES'

Every part of this clock (Fig 9.2) is made from plant material! Although I made this for a competition as a decorative collage only and the clock will not actually work, it would be perfectly possible, and rather fun, to decorate a plain working clock mechanism in a similar way.

On this collage the inner circle is card covered with poppy seeds, decorated with a design of carrot leaves, cornflower petals and sweet pea tendrils, and then painted gold. The outer disc containing the numbers is made to resemble mother-of-pearl by gluing on two layers of overlapping honesty seed heads (it is important to use only the inner discs of the seed heads), covered with a clear matt varnish. The numbers themselves are black-painted glixia stems and slices of hogweed stem, mounted on gilded gum tree leaves, with the minute divisions marked by columbine seeds. The hands of the clock are wooden skewers

HELPFUL HINT

For a DIY enthusiast it would not be difficult to transform this design into a working clock: simple clock mechanisms are available from clock or watch repair shops.

decorated with variously sized marigold and common mallow seeds, all painted black. Decorative gilded work in the four corners of the clock face finishes off the design.

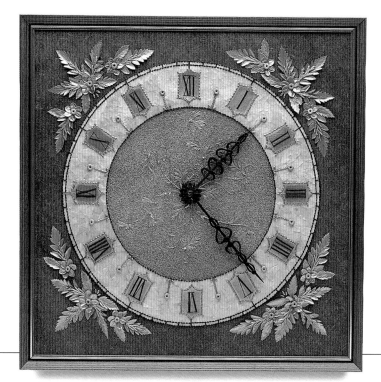

Fig 9.2 'How time flies'.

PATCHWORK CUSHION

If you enjoy patchwork but would relish a slightly different approach, why not try decorating a plain patchwork cushion with plant material (Fig 9.3) instead of simply making one with patterned fabrics? It will certainly raise a few eyebrows, but should only be used for display. This cushion is not for sitting on!

This can be quite a challenging project, because the idea is to use the plant material to simulate the perfectly regular patterns which appear on normal fabrics. You need, therefore, to spend some time carefully picking out all the plant material to suit this purpose.

The first thing to do is to make a full-scale drawing of your intended design, complete with the patchwork shapes. Cut this into sections and use as templates for the fabric patches, which should be stitched together but not filled with wadding at this stage.

Start at the centre of the patchwork and work outwards, using PVA glue

to fix the flowers and foliage to the fabric, to create the effect of shapes cut from patterned fabric. Tiny floral prints can be imitated using lilac florets or elderflower; perfect circles can be clipped from mullein or other leaves with a leather punch; stripes can be cut easily with the aid of a ruler and craft knife. In this case it is often a matter of defying nature to create a successful collage!

When the collage is completed, fill the cushion with wadding, taking care not to disturb any plant material, and secure the final edge.

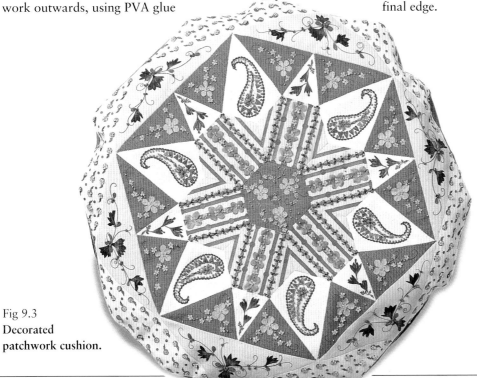

Fig 9.3
Decorated
patchwork cushion.

'DISPATCH BOX'

This wartime dispatch box (Fig 9.4) is not for use, but I had great fun creating it for a competition. You may like to adapt the idea for more practical purposes.

The basic box was constructed from oddments of wood and covered with a variety of large leaves to produce the old battered leather effect. Mullein, cuckoo pint and *Centaurea macrocephala* leaves are perfect for this kind of usage. I then coated the leaves with four layers of varnish.

The badge itself was based on an old wartime embroidery transfer, and I used a variety of seeds, leaves and stems to recreate it (including poppy seeds, Chinese lantern leaves and hogweed stems), gilding each piece

beforehand. Before mounting on the box the badge was coated a final time with gold spray paint.

The handle is a piece of giant scabious stem tucked into halves of gum tree pods, with the locks made from leaves glued to card and a common mallow seed as the key hole. Cat's-tail stems form the hinges. As a finishing touch, 'TOP SECRET' was cut out from leaves painted with red enamel.

Fig 9.4 **'Dispatch box'**.

'SPLISH-SPLASH' MOSAIC

This mosaic frieze (Fig 9.5) was created for a competition. The bird theme was inspired quite simply by watching a bird take a bath in my garden. My understanding of mosaic construction came from a fascination with the intricate patterns in the temples in Bangkok and an unearthed mosaic floor in Cyprus.

The regularity of the design was maintained by using a template for the birds and bird baths, with the main outlines pencilled in on the backing card, along with the positions of border patterns, clouds, branches, etc. Then the real work began. Each 'chip', measuring approximately 2mm (³⁄₃₂in) square, was cut from the leaves with a craft knife and glued on individually.

The rough cream underside of *Elaeagnus pungens* leaves offered a good stone effect for the bird baths, and I used delphinium petals for the water and sky. The birds are formed from Queen Anne's thimble seeds, outlined with a row of poppy seeds. Shrubs and tree branches were made from a variety of leaves

including weeping fig, *Weigela*, grape ivy, dogwood, willow and cherry. To protect the finished collage I sprayed it with three or four layers of low odour fixative, allowing time to dry between each coat.

HELPFUL HINT

This mosaic design was enormously satisfying to create, but it is very time consuming and painstaking work, so be prepared if you decide to attempt a mosaic. This frieze, measuring only 38 x 15cm (15 x 6in) took me 100 hours to complete.

Fig 9.5 **'Splish-splash' mosaic.**

Many of the collages in this book are best framed or mounted on a secondary backing. When selecting a frame for a finished collage, it is worth giving proper consideration to the character of the design and where it is going to be placed. It could be a terrible disappointment to spend hours creating a beautiful collage, only to have its true effect spoiled by an unsuitable frame or mount. Any good commercial picture framer will tell you that the correct framing will draw the eye to the picture rather than distracting from it in an unbalanced way.

There are an infinite number of different mouldings available for use in framing (*see* Fig 1), so you will always be able to find something suitable in the end. If you are uncertain, framing shops are usually more than happy to offer advice.

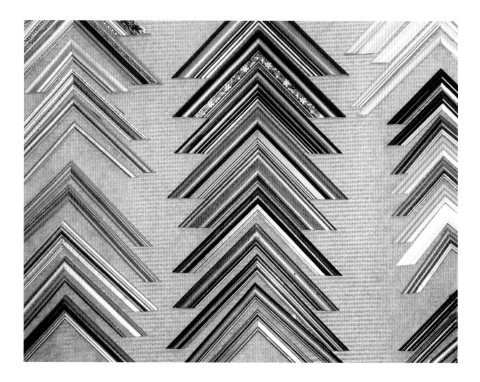

Fig 1 **A selection of wooden frame mouldings.**

RECESSED FRAMES

Most plant material collages have a raised design so, if a glazed frame is to be used, an additional moulding will be needed within the frame to prevent the glass from touching and damaging the fragile collage. These are called boxed or recessed frames (*see* Fig 2) and can be made to order by picture framers, art shops or photographic shops.

They are also available ready assembled from specialist frame makers by mail order, but it is better to purchase these before beginning a particular collage as they usually only come in standard sizes.

FLAT GLAZED FRAMES

Picture frames stocked by high street department stores are generally only suitable for flat collages made with pressed flowers and leaves. For these it is essential for the glass to press closely against the plant material to prevent it from curling.

UNUSUAL FRAMES

More unusual frames can often be found in junk shops, antique shops, jumble sales and so on. It is worth looking, because sometimes an odd frame can spark off a new idea for a collage design.

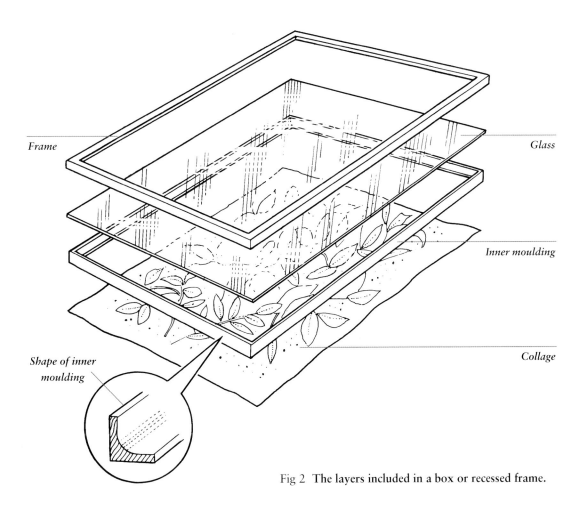

Frame

Glass

Inner moulding

Collage

Shape of inner moulding

Fig 2 **The layers included in a box or recessed frame.**

MOUNTING ON A SECONDARY BACKING

If your collage is more suited to mounting on a secondary backing rather than framing, this is not difficult to do yourself. Fig 3 shows how the mounting is put together.

First select a piece of hardboard, plywood or very thick card and cut it larger than the collage itself. At least 5 to 7.5cm (2 to 3in) each side is probably wise. If the picture is to be hung, you will need to bore two holes and insert picture rings (a) for card or hardboard, or screw eyes for plywood. These should be placed about a quarter of the way down from the top of the picture and a little way in from the sides.

Cover the front of the secondary backing with a piece of fabric which contrasts or tones with the collage design. Turn this over to the reverse side and mitre the corners as described on page 30. Neaten and secure the reverse side by covering with strong paper or thin card (b), cut about 1cm (³⁄₈in) smaller all round than the backing and glued on.

At the front, mark out and cut away a shape from the backing fabric approximately 2.5cm (1in) smaller on each side than the collage itself (b). Using an all-purpose glue, fix the edges of the aperture cut from the backing fabric to the hardboard or plywood behind it. Use a strong glue to secure the completed design centrally on the backing, covering the space cut from the fabric.

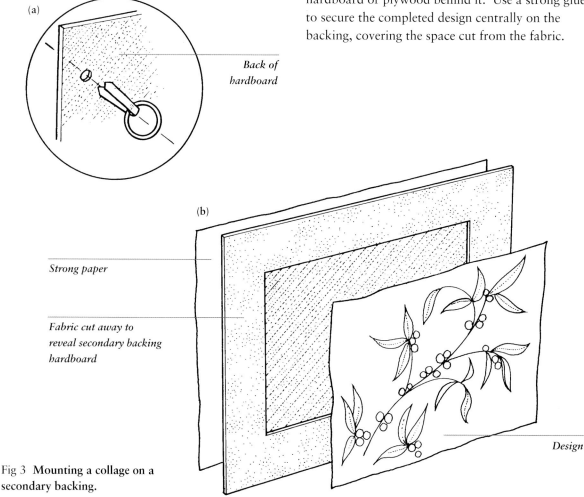

(a)

Back of hardboard

(b)

Strong paper

Fabric cut away to reveal secondary backing hardboard

Design

Fig 3 **Mounting a collage on a secondary backing.**

APPENDIX 2

COMMON AND BOTANICAL PLANT NAMES

COMMON NAMES	BOTANICAL NAMES
Alder	*Alnus glutinosa*
Alexanders	*Smyrnium olusatrum*
Ballota	*Ballota pseudo-dictamnus*
Barberry	*Berberis thunbergii*
Barrenwort	*Epimedium pinnatum*
Bear's breeches	*Acanthus spinosus*
Beech	*Fagus sylvatica*
Blanket flower	*Gaillardia*
Bleeding heart	*Dicentra spectabilis*
Box	*Buxus sempervirens*
Brome	*Bromus*
Broom	*Genista*
Butcher's broom	*Ruscus aculeatus*
Buttercup	*Ranunculus acris*

COMMON NAMES	BOTANICAL NAMES
Butterfly bush *or* Orange ball tree	*Buddleia globosa*
Candytuft	*Iberis amara*
Caraway	*Carum carvi*
Cat's-tail	*Phleum pratense*
Cherry	*Prunus avium*
Chinese lantern	*Physalis franchetii*
Cock's foot	*Dactylis glomerata*
Columbine	*Aquilegia*
Common mallow	*Malva sylvestris*
Coneflower	*Rudbeckia*
Copper beech	*Fagus sylvatica* 'Cuprea'
Coral flower	*Heuchera*
Coriander	*Coriandrum sativum*

COMMON NAMES	BOTANICAL NAMES	COMMON NAMES	BOTANICAL NAMES
Corn cockle	*Agrostemma githago*	Grape ivy	*Rhoicissus rhombifolia*
Cornflower	*Centaurea cyanus*	Gum tree	*Eucalyptus*
Cosmos	*Cosmea*	Hare's-tail grass	*Lagurus ovatus*
Couch grass	*Agropyron repens*	Heartsease	*Viola tricolor*
Cow parsley	*Anthriscus sylvestris*	Heather	*Erica*
Crane's bill	*Geranium ibericum*	Hogweed	*Heracleum sphondylium*
Cress	*Lepidium sativum*	Hollyhock	*Althaea rosea*
Crown imperial	*Fritillaria imperialis*	Honesty	*Lunaria annua*
Cuckoo pint	*Arum italicum* 'Pictum'	Ivy	*Hedera helix*
Curry plant	*Helichrysum angustifolium*	Jacob's ladder	*Polemonium caeruleum*
Dill	*Anethum graveolens*	Japanese aralia	*Fatsia japonica*
Dogwood	*Cornus*	Jerusalem sage	*Phlomis fruticosa*
Elderflower	*Sambucus nigra*	Kapok	*Ceiba pentandra*
Feverfew	*Chrysanthemum parthenium*	Lady's mantle	*Alchemilla mollis*
Field penny-cress	*Thlaspi arvense*	Larch	*Larix*
Forget-me-not	*Myosotis*	Larkspur	*Delphinium consolida*
Foxglove	*Digitalis*	Lavender	*Lavandula*
Foxtail grass	*Alopecurus pratensis*	Leather fern	*Asplenium adiantum-nigrum*
French marigold	*Tagetes patula*	Leyland cypress	*Cupressocyparis leylandii*
Giant hogweed	*Heracleum mantegazzianum*	Lilac	*Syringa vulgaris*
Giant scabious	*Cephalaria gigantea*	Linseed	*Linum usitatissimum*
Globe thistle	*Echinops ritro*	Love-in-a-mist	*Nigella damascena*
Goat's beard	*Tragopogon pratensis*	Lupin	*Lupinus*
Golden chain	*Laburnum anagyroides*	Mallow	*Lavatera trimestris*
Golden rod	*Solidago*	Marigold	*Calendula*
Grape hyacinth	*Muscari*	Marrow	*Cucurbita ovifera*

COMMON NAMES	BOTANICAL NAMES	COMMON NAMES	BOTANICAL NAMES
Masterwort	*Astrantia*	Shoo-fly	*Nicandra physaloides*
Melon	*Cucumis melo*	Silverweed	*Potentilla anserina*
Montbretia	*Crocosmia*	Snakeweed	*Polygonum bistorta*
Mullein	*Verbascum bombyciferum*	Snowball bush	*Viburnum opulus* 'Sterile'
Mustard seed	*Sinapis alba*	Soft shield fern	*Polystichum setigerum*
Orange ball tree *or* Butterfly bush	*Buddleia globosa*	Stag's-horn sumach	*Rhus typhina*
Oriental poppy	*Papaver orientale*	Statice	*Limonium sinuatum*
Pampas grass	*Cortaderia selloana*	Stinking hellebore	*Helleborus foetidus*
Pansy	*Viola wittrockiana*	Strawflower	*Helichrysum bracteatum*
Pearl everlasting	*Anaphalis*	Summer hyacinth	*Galtonia candicans*
Pepper	*Capsicum annuum*	Sunflower	*Helianthus annuus*
Peruvian lily	*Alstroemeria*	Sweet pea	*Lathyrus odoratus*
Pieris	*Pieris formosa*	Sweet William	*Dianthus barbatus*
Pittosporum	*Pittosporum tenuifolium*	Sycamore	*Acer pseudoplatanus*
Plane	*Platanus acerifolia*	Tamarisk	*Tamarix*
Poppy	*Papaver*	Tobacco plant	*Nicotiana*
Pumpkin	*Cucurbita maxima*	Tree heather	*Erica arborea*
Pyrethrum	*Chrysanthemum coccineum*	Turnip	*Brassica rapa*
Quaking grass	*Briza media* and *Briza minor*	Vegetable pea	*Pisum sativum*
Queen Anne's thimbles	*Gilia capitata*	Vetch	*Vicia cracca*
Rape	*Brassica napus*	Wallflower	*Cheiranthus*
Rubber plant	*Ficus elastica*	Weeping fig	*Ficus benjamina*
Rye grass	*Lolium*	Willow (fasciated)	*Salix sachalinensis* 'Sekka'
Sea holly	*Eryngium maritimum*	Woad	*Isatis tinctoria*
Sea lavender	*Limonium latifolium*	Wormwood	*Artemisia nutans*
		Yarrow	*Achillea filipendulina*

APPENDIX 3

FULL-SIZE PATTERNS

You may wish to trace the exact shapes of some of the more complex patterns shown in the Projects section of the book. For reasons of space, some of the annotated diagrams for the projects appear at less than their full size. In this Appendix these diagrams are reproduced as large as possible, and without annotation, to make tracing easier. For your own use you could also enlarge the diagrams on a photocopier (particularly the pattern for the Jacobean firescreen, given on page 163, which cannot be shown to its exact size in this book).

Top

'Patience' (*see* pages 90–2).

Bible marker star template (*see* pages 102–5).

Illuminated letter J (*see* pages 106–8).

Jacobean-style picture
(*see* pages 138–41).

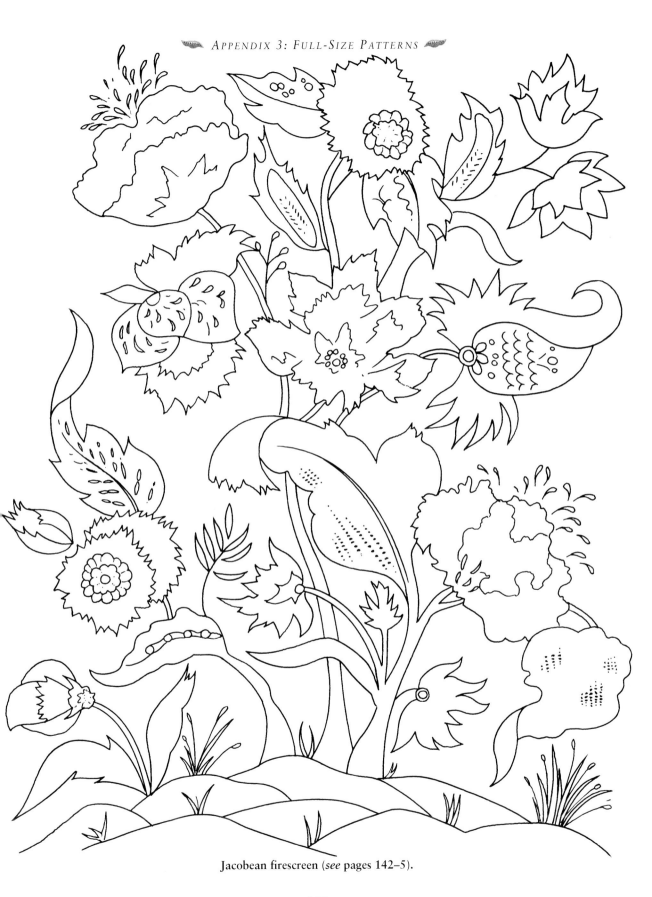

Jacobean firescreen (*see* pages 142–5).

FURTHER READING

Brown, Pauline, *The Encyclopedia of Embroidery Techniques*, Headline, 1994

Burgess, Renee and Derbyshire, Jane, *Dried and Pressed Flowers*, Hamlyn Publishing Group, 1975

Carter, Patricia, *Illuminated Alphabets*, Search Press, 1991

Foster, Maureen, *Creating Pictures with Preserved Flowers*, Pelham Books, 1971

Foster, Maureen, *Making Animal and Bird Collages*, Pelham Books, 1980

Geddes, Elisabeth, *Blackwork Embroidery*, Mills & Boon, 1965

Harlow, Eve (ed.), *The New Anchor Book of Crewel Stitches and Patterns*, David & Charles, 1989

Harlow, Eve (ed.), *The New Anchor Book of Free-style Embroidery Stitches*, David & Charles, 1987

McDowall, Pamela, *Pressed Flower Collages and Other Ideas*, Lutterworth Press, 1971

Miles, Sally, *Natural Collage*, Ebenezer Baylis & Son Ltd, 1973

Readers Digest Needlecraft Guides – Embroidery, Readers Digest, 1995

Russell, Pat, *Decorative Alphabets throughout the Ages*, Bracken Books, 1988

SUPPLIERS

Note: the silica gel mentioned on page 16 is available from:

Mrs Maureen Foster
Flora International
The Fishing Lodge Studio
77 Bulbridge Road
Wilton
Salisbury
Wilts. SP2 0LE

Other silica gel is available from:

Moira Clinch
The Greenhouse Studio
10 The Green
Mountsorrel
Leics. LE12 7AF

INDEX

*References in italics
indicate illustrations
without accompanying
text*

Acacia 69, 71
air drying 13–16
alder cones 12, 69, *70*,
77, 79
alexanders 9, *89*
alfalfa 12
Allium 11–12, *100*, *101*,
111, 116
altar frontal 111
alum 16, 19
ampolodermus *10*, 112,
130, 133, 135–7,
140–1, *145*, 147
annual statice 8, *14–15*,
144–5, 147
apple pips 9
Astilbe 22, 56, 116

barberry 18, 22, 63,
73–5
barrenwort *49*
basketware 76–9
bear's breeches *11*, 26,
111
beech nuts 12, 77, 79
bell pulls 128–9
Bible marker 102–5
blackberry leaves 22
blackwork 122–9
blanket flower 22–3, *84*
bleeding heart 22
bookmarks 44–6,
59–63, 98–105, 116
borax powder 16, 19
botanical names 155–7
box leaves 8, *20*, 77, 79
broom *113*, *120* (see
also butcher's broom)
buckler fern *25*
butcher's broom 62,
65–6, 77, 79
buttercup 22, *49*
butterfly bush 18

candytuft 7, *49*
caraway seeds *11–12*,
113, 141
carrot leaves 22, *25–6*,
73–5, 148
cat's-tail grass *9–10*, 88,
92, *119–21*, 133–4,
136–7, *144*, 150
Ceanothus 61–2
Centaurea macrocephala
12–13, 150
cherry leaves 151
Chinese lanterns 16,
150
Christmas card 65–7
chrysanthemum 8, 22,
26
clock design 148
cock's foot *119–20*
columbine 11, 94, 96,
113–14, 122, 127, 148
common mallow see
mallow
coneflower 11, *84*,
113–14, 140–1
cones 12–13, *17*, 69–70,
77, 79
copper beech 69–70
coral flower 18
coriander 12
corn cockle *113*
cornflower 8, 22, *49*,
56–7, 148
cosmos seeds *113*, *137*,
141, *144*
Cotoneaster 8, 21–2,
49, 55–7
couch grass 9
cow parsley 9, 11, *95–6*,
111, *113–14*, 133,
137, 140, 145
crane's bill 81–2, 96
cress *11–12*, 104–5,
114, 116, *120*, *144*
crown imperial *84*, 140
cuckoo pint 150
curry plant *13*
cushion 149
cypress cones 12–13

delphinium 8, *22*, 77–8,
151
desiccants 16–19
dill seeds 92, *137*
dispatch box 150
dogwood 151

Eleagnus 22, 50, *52*,
151
elderflower 18, 149
embellishment 97–111
embroidery effects
112–45
equipment 3–5

fabrics 6, 27–31
fenugreek 12
fern leaves 22, *25–6*,
49, 63, 81–2, 111,
116
feverfew 22, *25–6*
field penny-cress 9, *11*,
84, 122, *127*, *137*,
145
firescreen 142–5
fixing 38–40
flat collage 44–57
flowers 7–8, 38–9
forget-me-not 18, 22,
46, *49*, 55–7, 81–2
foxglove seeds 40, *84*,
99, 108–9, 111
foxtail grass 9
framing 27, 29, 152–3
French marigold 7, 9,
11, 18, *113*, 122, 133

geranium 7
giant hogweed 111
giant scabious 12, *84*,
150
gift boxes 53, 97
gilding 24–6, 97–101
glass topped tray 54–7
glixia *10*, 66–7, *88–9*,
96, 133–4, *137*,
140–1, *145*, 147–8
globe thistle 12–13
glue 5–6, 38–40

glycerine 9, 19–21
goat's beard 9, *11*,
61–2, 111, *119–20*,
141, *144*
gold thread 115–17
golden chain 77–8
golden rod 63
grape hyacinth 9, *11*,
18, 92, 94, 96, 122,
127, 141
grape ivy 151
grasses *9–10*, 38–9 (see
also cat's-tail grass)
greetings cards 47–52,
64–7
gum tree 69, *71*, 148,
150

hangings 128
hare's-tail grass 134
heartsease *18*
heather 63
Hebe 63
hemp 12, 140
hogweed *84*, 111, 140,
148, 150
hollyhock 9, *11*, *84*,
105, 111, 116,
119–20, *137*, *144*
Holodiscus discolor 63
honesty seeds 9, *11*,
119–20, 140, *144*, 148
honeydew melon seeds
100–1
hyacinth see grape
hyacinth; summer
hyacinth

illuminated lettering
106–8
ivy 18

Jacobean embroidery
effects 133–45
Jacob's ladder *113*
Japanese aralia 8, 20–1
Jerusalem sage 12, *13*

kapok seed *137*

lady's mantle 20
landscape scenes 50–2
larch cones 12, 13, 77, 79
larkspur 8, *22*, *25–6*, *46*, *50–2*
laurel 21
lavender 8, *13*, *100–1*, 112–14, 130–3, 140–1, *144*, 145
leather fern 116
leaves 8–9, 38
lettering 33–7, 106–8
leyland cypress 8, *20*, 77–8, 111
lilac 81–3, 149
linseed *11*–12, 26, 39, 88–9, *92*, 113–14, 119–20, 140–1, *144*
lobelia *49*
Lonicera nitida 63
love-in-a-mist 11–13, *84*–5, 88–9, 93–4, *96*, *114*, 122, 124
lupins 12

Mahonia 8, *20*
male fern *25*–6
mallow 9, *11*, *25–6*, *84*, *92*, *100–1*, *108*, 111, *114*, 119–20, 140–1, 148, 150
marigold 9, *11*, 23, *25–6*, *100*, 111, *114*, 119–20, *137*, 140, *144–5*, 148
marrow seeds 9, *25–6*
masterwort 7, *18*, *22*, *49*, 54, 56–7, *145*
mazagan canary seed *11*–12, *84*, 88–9, *96*, *100–1*, 104–5, 111, *114*, 116, 119–*20*, *137*, 141, *145*
melon seeds 9, *11*, *100–1*, 119–20, 144
millet *11*–12, 88–9, *92*, 96, *100–1*, 105, *108*, 111, 113–14, *137*, 140–1, *144–5*

mitred corners 30
monkey puzzle seed heads *12*
mosaic 151
mounting 153
mullein 149, 150
mustard seed 26, *84*, 133, *137*, *144*

napkin rings 72–3

orange ball tree *18*
oriental poppy 96

pampas grass 147
pansy 7, *22*
patchwork cushion 149
patterns 27–32, 158–62
paw-paw seeds *11*
pearl everlasting 8
pepper seeds 9, *11*, *84*, *137*
Peruvian lily *11*–12, 26, *84*, *92*, *100–1*, *108*, 111, *113–14*, 119–20, 133, 141
pew ends 109–*10*
picture frames 68–71
pictures 146–7
pieris *84*
pincushion 80–2
pine cones 12, 13
pinks 8
pittosporum 8, *20*, 21, 69–*70*
place cards 72, 74–5
plane tree seed (heads) *12*, *113*
pods 12–13, *17*
poppy *11*–12, *25*–6, 39–40, *84*, 88–9, 95–6, 99–*101*, 104–5, *108*–9, *114*, 119–20, *127*, *144*, 148, 150–1
preserving 13–26
pressing 8, 23–4
protected species 7
pulpit fall 117–21

pumpkin seeds 26, 140, *144*
pyrethrum 50–2

quaking grass 9
Queen Anne's thimble 151
quinces 9

raised collage 58–82
rape seed *11*–12, 26, 81, *92*, *100–1*, 105, *114*, 119–20, 133, *137*, 140–1
red millet *92*
rice *84*, *114*, 119–20
roses *18*–19, *49–50*
rye grass 9

sago *84*, 111
scabious 12, *84*, 150
sea holly 12–*13*, *84*, *144*
sea lavender 8, 65–7, 69–70, 147
seed collage 83–96
seed heads/pods 12–13, *17*
seeds 9, *11*–12, 26, 38–41
sesame seeds *11*–12, 39, *92*, 95–6, *100–1*, *108*, *114*, 119–20, *137*, 145
shoo-fly 9, *11*–12, *84*, 88–9, *92*, *108*, *114*, *144*
Sidalcea *84*
silica gel 16
silver sand 16, 19
silverweed 23
snakeweed *18*
snowball bush *46*, 55–7
soft shield fern *22*, *25*–6, *49–52*, 63, 81–2, 116
spaghetti noodles 104, 105
Spirea bumalda 63
spruce cones 13
stag's-horn sumach *22*, 147

statice 8, *14–15*, *144–5*, 147
strawflower 8, *14–15*
summer hyacinth *88*
sunflower seeds *11*, *25–6*, *89*, 95–6, 104, 111, 119–20, 140
sweet pea 8, 12, *22*, *49–50*, 54, 57, 63, 74–5, 81, *84*, *108*, 111, 116, 119–20, 140–1, 148
Sweet William *22*, *49*, 122, *127*
sycamore wings 26, 119–20, *144*

Tagetes *114*
tamarisk *18*
tapioca 12
templates 31–2
tools 3–5
tray 54–7
tufted vetch 12
turnip seeds *92*, 105, *108*, *114*, 120, *137*

vegetable pea tendrils 8, *49–50*, 55–7
vetch 12, 111, *113–14*

wallflower *22*
watermelon seeds *11*, *25–6*, 88–9, *101*, 111, *114*, 119–20, *137*, *145*
wedding pew ends 109–*10*
weeping fig *22*, 50, 52, 151
Weigela 151
white millet *92*
willow 151
woad *84*, *144*
wormwood 23, *46*

yarrow 8, *13*

zigzag stitchery effects 130–2

TITLES AVAILABLE FROM
GMC Publications

BOOKS

WOODWORKING

40 More Woodworking Plans & Projects	*GMC Publications*
Bird Boxes and Feeders for the Garden	*Dave Mackenzie*
Complete Woodfinishing	*Ian Hosker*
Electric Woodwork	*Jeremy Broun*
Furniture & Cabinetmaking Projects	*GMC Publications*
Furniture Projects	*Rod Wales*
Furniture Restoration (Practical Crafts)	*Kevin Jan Bonner*
Furniture Restoration and Repair for Beginners	*Kevin Jan Bonner*
Green Woodwork	*Mike Abbott*
The Incredible Router	*Jeremy Broun*
Making & Modifying Woodworking Tools	*Jim Kingshott*
Making Chairs and Tables	*GMC Publications*
Making Fine Furniture	*Tom Darby*
Making Little Boxes from Wood	*John Bennett*
Making Shaker Furniture	*Barry Jackson*
Pine Furniture Projects for the Home	*Dave Mackenzie*
Routing for Beginners	*Anthony Bailey*
Sharpening Pocket Reference Book	*Jim Kingshott*
Sharpening: The Complete Guide	*Jim Kingshott*
Space-Saving Furniture Projects	*Dave Mackenzie*
Stickmaking: A Complete Course	*Andrew Jones & Clive George*
Test Reports: *The Router* and *Furniture & Cabinetmaking*	*GMC Publications*
Veneering: A Complete Course	*Ian Hosker*
Woodfinishing Handbook (Practical Crafts)	*Ian Hosker*
Woodworking Plans and Projects	*GMC Publications*
The Workshop	*Jim Kingshott*

WOODTURNING

Adventures in Woodturning	*David Springett*
Bert Marsh: Woodturner	*Bert Marsh*
Bill Jones' Notes from the Turning Shop	*Bill Jones*
Bill Jones' Further Notes from the Turning Shop	*Bill Jones*
Colouring Techniques for Woodturners	*Jan Sanders*
The Craftsman Woodturner	*Peter Child*
Decorative Techniques for Woodturners	*Hilary Bowen*
Essential Tips for Woodturners	*GMC Publications*
Faceplate Turning	*GMC Publications*
Fun at the Lathe	*R.C. Bell*
Illustrated Woodturning Techniques	*John Hunnex*
Intermediate Woodturning Projects	*GMC Publications*
Keith Rowley's Woodturning Projects	*Keith Rowley*
Make Money from Woodturning	*Ann & Bob Phillips*
Multi-Centre Woodturning	*Ray Hopper*
Pleasure and Profit from Woodturning	*Reg Sherwin*
Practical Tips for Turners & Carvers	*GMC Publications*
Practical Tips for Woodturners	*GMC Publications*
Spindle Turning	*GMC Publications*
Turning Miniatures in Wood	*John Sainsbury*
Turning Wooden Toys	*Terry Lawrence*
Understanding Woodturning	*Ann & Bob Phillips*
Useful Techniques for Woodturners	*GMC Publications*
Useful Woodturning Projects	*GMC Publications*
Woodturning: Bowls, Platters, Hollow Forms, Vases, Vessels, Bottles, Flasks, Tankards, Plates	*GMC Publications*
Woodturning: A Foundation Course	*Keith Rowley*
Woodturning: A Source Book of Shapes	*John Hunnex*
Woodturning Jewellery	*Hilary Bowen*
Woodturning Masterclass	*Tony Boase*
Woodturning Techniques	*GMC Publications*
Woodturning Tools & Equipment Test Reports	*GMC Publications*
Woodturning Wizardry	*David Springett*

WOODCARVING

The Art of the Woodcarver	*GMC Publications*
Carving Birds & Beasts	*GMC Publications*
Carving on Turning	*Chris Pye*
Carving Realistic Birds	*David Tippey*
Decorative Woodcarving	*Jeremy Williams*
Essential Tips for Woodcarvers	*GMC Publications*
Essential Woodcarving Techniques	*Dick Onians*
Lettercarving in Wood: A Practical Course	*Chris Pye*
Power Tools for Woodcarving	*David Tippey*
Practical Tips for Turners & Carvers	*GMC Publications*
Relief Carving in Wood: A Practical Introduction	*Chris Pye*
Understanding Woodcarving	*GMC Publications*
Understanding Woodcarving in the Round	*GMC Publications*
Useful Techniques for Woodcarvers	*GMC Publications*
Wildfowl Carving – Volume 1	*Jim Pearce*
Wildfowl Carving – Volume 2	*Jim Pearce*
The Woodcarvers	*GMC Publications*
Woodcarving: A Complete Course	*Ron Butterfield*
Woodcarving: A Foundation Course	*Zo Gertner*
Woodcarving for Beginners	*GMC Publications*
Woodcarving Tools & Equipment Test Reports	*GMC Publications*
Woodcarving Tools, Materials & Equipment	*Chris Pye*

UPHOLSTERY

Seat Weaving (Practical Crafts)	*Ricky Holdstock*
Upholsterer's Pocket Reference Book	*David James*
Upholstery: A Complete Course	*David James*
Upholstery Restoration	*David James*
Upholstery Techniques & Projects	*David James*

TOYMAKING

Designing & Making Wooden Toys	*Terry Kelly*
Fun to Make Wooden Toys & Games	*Jeff & Jennie Loader*
Making Board, Peg & Dice Games	*Jeff & Jennie Loader*
Making Wooden Toys & Games	*Jeff & Jennie Loader*
Restoring Rocking Horses	*Clive Green & Anthony Dew*
Scrollsaw Toy Projects	*Ivor Carlyle*
Wooden Toy Projects	*GMC Publications*

DOLLS' HOUSES AND MINIATURES

Architecture for Dolls' Houses — *Joyce Percival*
Beginners' Guide to the Dolls' House Hobby — *Jean Nisbett*
The Complete Dolls' House Book — *Jean Nisbett*
Dolls' House Accessories, Fixtures and Fittings — *Andrea Barham*
Dolls' House Bathrooms: Lots of Little Loos — *Patricia King*
Dolls' House Fireplaces and Stoves — *Patricia King*
Easy to Make Dolls' House Accessories — *Andrea Barham*
Make Your Own Dolls' House Furniture — *Maurice Harper*
Making Dolls' House Furniture — *Patricia King*
Making Georgian Dolls' Houses — *Derek Rowbottom*
Making Miniature Gardens — *Freida Gray*

Making Miniature Oriental Rugs & Carpets — *Meik & Ian McNaughton*
Making Period Dolls' House Accessories — *Andrea Barham*
Making Period Dolls' House Furniture — *Derek & Sheila Rowbottom*
Making Tudor Dolls' Houses — *Derek Rowbottom*
Making Unusual Miniatures — *Graham Spalding*
Making Victorian Dolls' House Furniture — *Patricia King*
Miniature Bobbin Lace — *Roz Snowden*
Miniature Embroidery for the Victorian Dolls' House — *Pamela Warner*
Miniature Needlepoint Carpets — *Janet Granger*
The Secrets of the Dolls' House Makers — *Jean Nisbett*

CRAFTS

American Patchwork Designs in Needlepoint — *Melanie Tacon*
A Beginners' Guide to Rubber Stamping — *Brenda Hunt*
Celtic Knotwork Designs — *Sheila Sturrock*
Collage from Seeds, Leaves and Flowers — *Joan Carver*
Complete Pyrography — *Stephen Poole*
Creating Knitwear Designs — *Pat Ashforth & Steve Plummer*
Creative Embroidery Techniques
 Using Colour Through Gold — *Daphne J. Ashby & Jackie Woolsey*
Cross Stitch Kitchen Projects — *Janet Granger*
Cross Stitch on Colour — *Sheena Rogers*
Designing and Making Cards — *Glennis Gilruth*
Embroidery Tips & Hints — *Harold Hayes*

An Introduction to Crewel Embroidery — *Mave Glenny*
Making Character Bears — *Valerie Tyler*
Making Greetings Cards for Beginners — *Pat Sutherland*
Making Hand-Sewn Boxes: Techniques and Projects — *Jackie Woolsey*
Making Knitwear Fit — *Pat Ashforth & Steve Plummer*
Needlepoint: A Foundation Course — *Sandra Hardy*
Pyrography Designs — *Norma Gregory*
Pyrography Handbook (Practical Crafts) — *Stephen Poole*
Tassel Making for Beginners — *Enid Taylor*
Tatting Collage — *Lindsay Rogers*
Temari: A Traditional Japanese Embroidery Technique — *Margaret Ludlow*
Theatre Models in Paper and Card — *Robert Burgess*

THE HOME

Home Ownership: Buying and Maintaining — *Nicholas Snelling*

Security for the Householder: Fitting Locks and Other Devices — *E. Phillips*

VIDEOS

Drop-in and Pinstuffed Seats — *David James*
Stuffover Upholstery — *David James*
Elliptical Turning — *David Springett*
Woodturning Wizardry — *David Springett*
Turning Between Centres: The Basics — *Dennis White*
Turning Bowls — *Dennis White*
Boxes, Goblets and Screw Threads — *Dennis White*
Novelties and Projects — *Dennis White*
Classic Profiles — *Dennis White*

Twists and Advanced Turning — *Dennis White*
Sharpening the Professional Way — *Jim Kingshott*
Sharpening Turning & Carving Tools — *Jim Kingshott*
Bowl Turning — *John Jordan*
Hollow Turning — *John Jordan*
Woodturning: A Foundation Course — *Keith Rowley*
Carving a Figure: The Female Form — *Ray Gonzalez*
The Router: A Beginner's Guide — *Alan Goodsell*
The Scroll Saw: A Beginner's Guide — *John Burke*

MAGAZINES

WOODTURNING ◆ WOODCARVING ◆ FURNITURE & CABINETMAKING
THE DOLLS' HOUSE MAGAZINE ◆ CREATIVE CRAFTS FOR THE HOME
THE ROUTER ◆ THE SCROLLSAW ◆ BUSINESSMATTERS

◆

The above represents a full list of all titles currently published or scheduled to be published.
All are available direct from the Publishers or through bookshops, newsagents and specialist retailers.
To place an order, or to obtain a complete catalogue, contact:

GMC Publications,
Castle Place, 166 High Street, Lewes, East Sussex BN7 1XU, United Kingdom
Tel: 01273 488005 Fax: 01273 478606

Orders by credit card are accepted